The Paraglyph Mission

This book you've purchased is a collaborative creation involving the work of many hands, from authors to editors to designers and to technical reviewers. At Paraglyph Press, we like to think that everything we create, develop, and publish is the result of one form creating another. And as this cycle continues on, we believe that your suggestions, ideas, feedback, and comments on how you've used our books is an important part of the process for us and our authors.

We've created Paraglyph Press with the sole mission of producing and publishing books that make a difference. The last thing we all need is yet another tech book on the same tired, old topic. So we ask our authors and all of the many creative hands who touch our publications to do a little extra, dig a little deeper, think a little harder, and create a better book. The founders of Paraglyph are dedicated to finding the best authors, developing the best books, and helping you find the solutions you need.

As you use this book, please take a moment to drop us a line at **feedback@paraglyphpress.com** and let us know how we are doing and how we can keep producing and publishing the kinds of books that you can't live without.

Sincerely,

Keith Weiskamp & Jeff Duntemann
Paraglyph Press Founders
4015 N. 78th Street, #115
Scottsdale, Arizona 85251
email: **feedback@paraglyphpress.com**
Web: **www.paraglyphpress.com**
Phone: 602-749-8787

Recently Published by Paraglyph Press:

Degunking Windows
By Joli Ballew
and Jeff Duntemann

Degunking Your Mac
By Joli Ballew

3D Game-Based Filmmaking: The Art of Machinima
By Paul Marino

Windows XP Professional: The Ultimate User's Guide, Second Edition
By Joli Ballew

Jeff Duntemann's Wi-Fi Guide, 2nd Edition
By Jeff Duntemann

Visual Basic .NET Core Language Little Black Book
By Steven Holzner

Monster Gaming
By Ben Sawyer

Game Coding Complete
By Mike McShaffry

Mac OS X 10.3 Panther Little Black Book
By Gene Steinberg

Windows Admin Scripting Little Black Book, 2nd Edition
By Jesse M. Torres

To camera phone photographers everywhere—keep on clicking!

About the Author

Peter G. Aitken has been writing about computers, programming, and technology for over 15 years and has some 40 books and hundreds of magazine and Web articles to his credit. His books include *Digital Camera Design Guide*, one of the first digital photography books to be published, as well as books on Visual Basic, XML, web development, and Microsoft Office. Peter is the proprietor of PGA Consulting, providing application programming, web development, and technical writing since 1991. He lives in Chapel Hill, North Carolina, with his wife Maxine.

Acknowledgments

When exploring a brand new field such as camera phones, there are not many established authorities you can turn to. Therefore, my first thanks go to the thousands of camera phone photographers, bloggers and mobloggers, web site authors, journalists, and others whose material I scoured for facts, ideas, and inspiration while writing this book. You people are the real cell phone culture!

I also extend my heartfelt thanks to the people at Paraglyph Press who provided help and inspiration at every stage of the process: Keith Weiskamp, publisher; Ben Sawyer, technical editor; Judy Flynn, copy editor; Kim Eoff, production manager; Kris Sotelo, cover designer; Cynthia Caldwell, proofreader; Dan Young, indexer, and Steve Sayre.

Last but not least, you will enjoy some really funny camera phone-related cartoons that were skillfully drawn by Ben Towle.

Finally, I thank my wife Maxine for her support and encouragement.

Contents at a Glance

Chapter 1	The Camera Phone Revolution	1
Chapter 2	Getting the Camera Phone Setup That Meets Your Needs	23
Chapter 3	Photography Basics for Camera Phone Users	47
Chapter 4	Processing Your Photos with Software	65
Chapter 5	Printing Your Photos	97
Chapter 6	Sharing Your Photos	117
Chapter 7	Moblog Madness	141
Chapter 8	Moblogs Step-by-Step	155
Chapter 9	Camera Phone Legal Concerns and Etiquette	183
Chapter 10	Cool Projects You Can Do with Your Camera Phone	199
Appendix	Camera Phone Resources	225

Contents

Introduction .. xvii

Chapter 1
The Camera Phone Revolution .. 1
Digital Photos for the Masses 3
Hey, You're a Photographer! 6
But Is It Art? 9
Bad Specs = Art? 10
In the Field: Is It Art? The SixSpace Gallery Says Yes 11
Join the Avant-Garde 12
Artistic Journalism 13
The Camera Phone Culture 14
Digital Shopping (and Shoplifting) 14
Moblogs 16
Camera Phone Postcards 16
Cellcerts 17
News Photos 18
Fighting Crime 18
Scavenger Hunts 19
Invasion of Privacy 19
Your First Projects 20
Wrapping It Up 22

Chapter 2
Getting the Camera Phone Setup That Meets Your Needs 23
Not Your Father's Digital Camera 23
 Pixel Resolution 24
 Display 27
 Video Clips 28

Zooming 29
Flash 29
Night Mode 30
Picture Capacity 31
Form Factor 32
Connectivity Options 32
Service Providers and Plans 33
Making Your Decision 35
Coverage 40
Service Plans 42
In the Field: Camera Phones—A Threat to National Security? 43
Going Shopping 45
Wrapping it Up 46

Chapter 3
Photography Basics for Camera Phone Users .. 47
Simple Is Good When It Comes to Phone Camera Photography 47
Features You Can Use 48
Focus 48
Exposure 50
Blur and Motion Effects 52
In the Field: Is There a Doctor on the Camera Phone? 53
Camera Phone Photography Dos and Don'ts 54
Move In Close 55
Watch the Lighting 56
Use Your Zoom—Not! 57
Movement and Blurry Photos 57
Pay Attention to Composition 58
Use the Highest Resolution and Quality 61
Avoid Backlight 62
Wrapping It Up 64

Chapter 4
Processing Your Photos with Software .. 65
Manipulating Your Photos 65
File Formats 69
Understanding Resolution and Image Size 71
Changing Image Size 73
Resizing by Resampling 74
Resizing without Resampling 76

To Resample or Not—That Is the Question 77
Cropping 78
Color Balance 80
Brightness and Contrast 83
In the Field: Camera Phones and Barcodes 84
Other Adjustments and Manipulations 85
Converting an Image to Monochrome 86
Rotating Images 87
Framing a Photograph 88
Special Effects 90
Specialized Graphics Programs 95
Wrapping It Up 96

Chapter 5
Printing Your Photos ... 97
The Do It Yourself Approach 97
Selecting a Printer 97
The Printer Buyer's Checklist 102
Paper 103
Settings for Printing 106
In the Field: Camera Phone Photos Used in Racism Charges 110
Using an Online Print Service 111
Using Ofoto 112
Using Shutterfly 113
Other Print Services 114
What, No Computer? 115
Wrapping It Up 116

Chapter 6
Sharing Your Photos ... 117
Sharing Photos from Your Phone 117
In the Field: Calling all Paranoids 120
Moving Photos to Your PC 121
Sharing Photos from Your PC 123
Email 124
Websites and Online Albums 126
Distribute Your Photos on a CD 132
Online Photo Sharing Services 133
An Online Sharing Tutorial 134
Specialty Sharing Software 139

Wrapping It Up 140

Chapter 7
Moblog Madness .. 141
Why a Moblog? 141
The Culture of Moblogging 144
How Do Moblogs Work? 144
 Public versus Private 145
 In the Field: Moblogs and Activism 146
 Choosing a Moblog Service 147
 Roll Your Own? 150
Wrapping It Up 153

Chapter 8
Moblogs
Step-by-Step .. 155
Using Textamerica 155
 Creating Your Basic Moblog with Textamerica 157
 Customizing Your Moblog with the Control Panel 162
 Interacting with Other Users 164
 Working with Favorites 165
 Using Templates 167
 In the Field: Receiving Webcam Pictures on Your Handset 169
Using Yafro 169
Using Mlogs 173
Using Flickr 178
Setting Up Your Own Moblog System 180
Promoting Your Moblog 181
Wrapping It Up 182

Chapter 9
Camera Phone Legal Concerns and Etiquette 183
What Are the Legal Concerns? 183
 Where Can You Take Photos? 184
 What (and Who) Can I Photograph? 186
 What Can I Do with My Photos? 189
 Private Use 189
 First Amendment Use of Images 190
 What about Model Releases? 190
 In the Field: The Ban Marches On 191

Camera Phone Etiquette 192
 Privacy Concerns 194
 Digital Stealing 197
Wrapping It Up 198

Chapter 10
Cool Projects You Can Do with Your Camera Phone .. 199
Camera Phone 199
Personalized T-Shirts 201
 Using a Commercial Printer 203
 Using Transfer Paper 203
Panorama Shots 204
 Framing the Photos 205
 Using Panorama Factory 206
 Creating a Panorama with Paint Shop Pro 208
Refrigerator Magnets 213
Fund-Raising 216
Create a Photo Diary 217
Greeting Cards 218
Wrapping It Up 224

Appendix
Camera Phone Resources ... 225

Index .. 245

Introduction

You are probably aware that many cell phones that are sold today have a small digital camera built in. Heck, you may even own one yourself. But is this just another neat little technology toy that won't have any real impact? My answer to that question is a resounding "no!" The premise of this book is that camera phones are having a totally unexpected impact, offering people new ways to see, photograph, and communicate.

If you don't believe me, try this. Go to Google and do a search for "camera phone." You might expect to get a few hundred or maybe a few thousand hits, right? Guess again—there are almost 8 *million* hits for "camera phone." Yahoo! finds even more—almost 12 million! There is definitely something going on with camera phones, and it's surprising a lot of people.

Cell phones have been around for years, and so have digital cameras. So what's the big deal when the two are combined—particularly given that the cameras you find in most cell phones aren't of the best quality? The combination of digital imaging with wireless communication seems to have sparked one of those unexpected synergies in which the whole is more—a lot more—than the sum of its parts. There's something powerful about the fact that, with a camera phone, you can talk about something with a friend and then show them what you're seeing. The immediacy of a shared experience, via a camera phone, has created a new technology obsession—and you probably already have friends who carry their camera phones everywhere with them because they have so much fun sharing what they see with their phone friends.

This book is the result of my exploration of the camera phone phenomenon. You'll find a wide variety of material here, from the technical to the speculative. Most interesting in my opinion is the perception of a developing *camera phone culture*—a fundamental change in the way society does and thinks about certain things.

The combination of having a camera that you carry with you everywhere, along with the ability to quickly send photos and text via a wireless network at any time, has prompted thought and debate in areas as diverse as photographic aesthetics, personal privacy, and industrial espionage. Does this sound far-fetched? Then read on!

My goal for writing this book is to give you a real sense of what the camera phone obsession is all about. If you are like me, you are probably hooked on your camera phone. It's probably your all-time favorite gadget. In this book I cover a range of topics that will be important to all camera phone users. This includes technical topics such as selecting a camera phone and service provider, printing, sending, and sharing your photos, and using software for photo manipulation. I also delve deeply into the culture of camera phones, dealing with areas such as aesthetics, etiquette, and privacy. The following special elements are used throughout the book:

- Resources: Over one hundred online resources that will be of interest to camera phone users are scattered throughout the book and pulled together in Appendix A.
- Gallery: Each chapter contains a selection of my own camera phone photos to show you the kinds of photos that are possible with these devices.
- In the Field: Real-world stories about how people are using and abusing camera phones.

So if you're obsessed with your camera phone, or you know people who are, then read on. I think you'll enjoy this book, regardless of whether you own a camera phone or just have legions of friends who do.

Peter G. Aitken
Chapel Hill, North Carolina
July 2004

Chapter 1

The Camera Phone Revolution

Hold on a minute. I really love my camera phone, and I bet you love yours too, but a *revolution?* And why are we all quickly becoming so *obsessed* with our camera phones? It's difficult for me to step out of the house even for a few minutes without mine. The words *revolution* and *obsession* might seem like pretty strong words to use for a small, inexpensive device that lets you take, send, and share digital photos. Sure, we've all had separate cell phones and digital cameras for many years now, so why should combining the two make such a difference? Why are camera phones turning the culture of taking and sharing photos inside out? Well, perhaps the best way to understand what is going on is to not just look at the devices themselves but at the effect they are having in our world. Here are a few examples:

- According to a report in *Middle East Online,* the Kingdom of Saudi Arabia has not only banned the import of camera phones but is cracking down on merchants who sell illegally imported ones. Why is this secretive, repressive government worried?

- *Time Magazine* named the camera phone as a runner up for "coolest invention" of 2003.

- Ohio University's legal department is exploring the ramifications of camera phones and trying to establish guidelines for their use.

- When approached by a would-be abductor, a 15 year old boy in New Jersey used his camera phone to photograph not only the person but also his car's license plate, leading to an arrest.
- A fire department in Scotland is using camera phones to send photos of injuries ahead to the hospital so the doctors can evaluate the situation and be ready to provide the best treatment as soon as the patient arrives.
- Some cities around the country are considering passing laws to prosecute over-ambitious cell phone photographers who sneak into places like the local gym to photograph their friends in the locker room and post the photos on the Internet.

These are the kind of stories that show how the technology of camera phones and the culture for using them are colliding. Camera phones are really different, and they are causing a lot of changes in our day-to-day lives. Most of these changes are good, I think, but some are less desirable. In this first chapter we'll take a look at the what, why, and how of the camera phone revolution.

Can I put you on hold? I have to take this photo.

Digital Photos for the Masses

Have you noticed that nearly everyone seems to have a cell phone these days? They are nearly ubiquitous—too much so, some might say! Cheaper phones, cheaper service, and better coverage have helped to fuel this growth, but it's also true that having a cell phone is expected these days. People don't ask if you have a cell phone, they just ask for your number! Equally important, people tend to take their phones with them wherever they go. Some people would sooner go out without their pants than without their phone! I was recently at the Atlanta airport and a business traveler who was talking on his cell phone with his girlfriend caught my attention. He walked into the restroom, went about his business, and at the same time carried on his heated conversation. He didn't miss a beat, which made me wonder if the person he was talking to had a clue about what he was doing.

Introducing the Camera Phone Photo Gallery

This is the first of many camera phone photos you'll find throughout the book. I call it the Camera Phone Photo Gallery—a wide sampling of the different kinds of photos that you can take with your camera phone. They are not related to the text or chapter contents in any direct way, but are included simply as a visual treat that will perhaps motivate your picture taking.

Even an ordinary avocado can look very cool as it's snapped with your camera phone!

What Kinds of Photos Are Camera Phone Users Taking?

It might be better to ask what kinds of photos *aren't* they taking; I think it would be an empty list! Here are just a few examples of camera phone photos. These are photos that might not have been taken with a regular film or digital camera:

- Last night's restaurant meal
- Graffiti in the subway
- Items on the shelf at a drugstore
- A fellow passenger on a bus
- The weird screw or latch that you saw on a building and want to take to the hardware store to try to locate
- An office associate's desk chair at work
- The lady in the car next to you at a red light
- The house you walk by that gives you some landscaping ideas you want to steal
- Some stranger using (or abusing!) a phone booth
- A scene taken at a concert where you snuck in your camera phone

What is being photographed is not as important as *how* an image or scene is being photographed. The spontaneity and freedom of camera phones is fueling the revolution, the obsession. Just as the switch, 80 years ago, from bulky tripod mounted cameras to handheld cameras had a huge impact on photography, the current move from traditional cameras to camera phones is opening up whole new vistas for the creative artist.

Cell phones are very different from stand-alone digital cameras. Although digital cameras are becoming more and more widespread, they are not nearly as common as cell phones. And who takes their digital camera everywhere they go? You would take it only when you are expecting to take some photos, such as on vacation, to a wedding, and so on. When you go grocery shopping, pick up your daughter at school, or visit the dentist, you don't typically bring along your digital camera.

What happens, then, when a significant proportion of cell phones become camera phones? (See the sidebar for some interesting stats.) All of a sudden millions of people are walking around with a digital camera in their pocket or purse. Why do these people buy a camera phone rather than a non-camera phone? My guess is

that very few of them specifically want or need a camera phone. Rather, the camera feature is an intriguing one that costs only a little extra, so why not get it? Motivation aside, the bottom line is that wherever you are, there is likely to be someone nearby with a camera, and whatever you do or whatever happens may end up in a photograph and may even be displayed on a very public website for the world to see.

Phone Stats

- Over half a billion—that's right, *billion*—cell phones were sold worldwide in 2003. Of those, 84 million were camera phones.
- Nokia predicts that camera phone sales for 2004 will top 140 million (all brands).
- As of October 2003, two thirds of households in the United States owned at least one cell phone. That number can only have gone up since.
- In 2004, 25 percent of all cell phones sold in the United States are predicted to be camera phones. In Japan that figure is closer to 90 percent.
- Makers of traditional digital cameras are worried that camera phones will eat into the lower end of their market and are considering adding wireless capabilities to their cameras.

Resources for Camera Phone Information:

Reiter's Camera Phone Report at www.cameraphonereport.com provides an opinionated view of the entire camera phone field. The site includes news, tutorials, equipment reports, and links to other resources. Some of the statistics in this chapter were taken from this site.

Some people, including me, think that the wide acceptance of digital photography was the first real revolution in photography since the advent of color more than 60 years ago. I think there were four factors that contributed to this:

- *Digital photos are free.* You can take as many photos as you like without paying one cent extra.

- *Digital photos are easy to manipulate.* Software lets you make almost any change to a photo, from the simple, such as removing red-eye, to the complex, such as adding people and changing backgrounds.

- *Digital photos can be transferred and viewed electronically.* Not having to print photos to share them with others really saves a lot of money. Also, as photos are taken and shared digitally, they become much more immediate and accessible.
- *Digital photos can easily be incorporated into any type of document or publication.* From simple electronic scrapbooks to printed brochures, digital photos can easily be dropped in and sized. This has really opened the door for hobbyists and amateur and professional photographers to use their photos in new ways.

Camera phone photography has all these features, so why is it creating yet another revolution in photography? My take is that there are two new factors:

- People tend to have their camera phone with them almost all the time.
- Photos taken can be sent almost anywhere *immediately.*

Are these two things enough to spark a second revolution? I think so, but you'll have to judge for yourself.

Hey, You're a Photographer!

One reason camera phones are having such a big impact can be summed up in a single sentence: A camera phone can make anyone a photographer. That may sound rather obvious on the surface, but there's more to it.

Spur-of-the-moment photos are a specialty of camera phones.

To me, a "photographer" is not just someone who takes photographs. A photographer, as opposed to what I'll call a "snap-shooter," has developed a special awareness of the visual world. It may be conscious or it may be unconscious, but it seems to involve a different way of looking at things. A photographer is almost always looking for that next photo. Some part of their brain is processing the visual input and asking the question, "Would *this* look good squished into two dimensions and cropped to a rectangle?"

Unlike a stand-alone camera, a camera phone is a ubiquitous presence that somehow makes it easier to take pictures. After all, it seems less invasive to point a phone at someone than to point a regular camera! When you always have a camera phone with you, it invites a different kind of visual awareness to the world around you. You become more aware of everyday things and events that are photo-worthy. You are, in short, a photographer.

I certainly am not suggesting that all photographers look at the world in the same way. Each person has, at least potentially, their own unique point of view. As you progress, you will develop and fine-tune your visual sensibilities. You may totally change your approach to photographs, or you may simply gain skill, taking more photos that are keepers and fewer that call for the Delete button.

The $64 question—just what *is* this?

At its core, photography is about visual communication. Human beings are very visual creatures, and the old saying "A picture is worth a thousand words" is as true today as it ever was. Maybe it's just a photo of a broken pipe under your sink that you will show to the guy at the hardware store. Maybe it's a snap of a breaking news event that you will email to the local newspaper. Perhaps it's a photo of your just-born daughter that you will send to your mother. It could also be an "art" shot that you will email to yourself, print, and tack up on the wall at home. It's this immediacy and connectedness of camera phones that makes them so much more than the sum of their parts.

Your camera phone also introduces a level of experimentation that other types of cameras typically don't. It's easy to be a little bolder and imaginative with a camera phone because you can hide your phone and you don't have to take yourself too seriously. Who knows. That photo you take of your friend having a big plate of ribs for lunch might just turn out to be a real photo gem (but just make sure that your friend doesn't mind being the subject of your artistic creation).

Resources for the Future of Camera Phones:

Check out this interesting article in ZoneZero Magazine on the future of camera phones. The article is by Julián Gallo, who teaches in the journalism program at the Universidad de San Andres in Argentina. By equipping journalists with camera phones, the program permitted instant online publication of the images. www.zonezero.com/magazine/articles/fotomovil/fotomovil.html

How Do You Know If You Are Really Obsessed by Your Camera Phone

Here's how you can tell if you are becoming obsessed with your camera phone:

- You go to concerts (even concerts you don't like) just so you can hold up your camera phone and occasionally sneak and take a photo (see the section on cellcerts later in this chapter).
- Your monthly credit card bill starts going down because your are spending more of your time digital shoplifting than you are actually buying things at the mall.
- Your car insurance company sends you a cancellation notice for your policy because over the past six months you've been in too many accidents, which were caused because you were trying to take photos and drive at the same time.
- While halfway en route to a destination, you realize that you forgot your camera phone and you have to return home to get it—and not because you don't want to miss any calls, but because you don't want to miss a photo opportunity.

- Your Internet service provider starts sending you threatening notices because you keep clogging up their servers with the hundreds of digital photos that you send to your friends.
- The local police department in your small town has just presented you with an award for helping to catch more criminals and muggers (than anyone on the police force has caught) ripping off ATM customers because of your I-Spy camera work.
- You spend more time emailing the pictures that you take and putting them up on your personal website than you do at your job and your boss is really starting to notice.
- You've upgraded your camera phone four times over the past year because new features keep coming out that you can't live without.
- Your friends are avoiding going out with you because they know that you'll bring along your camera phone and possibly take photos of them doing things they will regret later on.
- Your hard drive becomes so gunked up with your digital photos that you don't have any more space to store your other files.

Okay, these are offered with tongue firmly in cheek, but with some degree of seriousness too!

But Is It Art?

There's no doubt that camera phones are useful for many practical tasks, ranging from documenting damage in a car crash for the insurance company to sending snapshots to friends and relatives. But can camera phone pictures go beyond the practical and enter the realm of art? Of course they can! Let's look at the connection between art and photography.

A photograph is, at least in theory, an objective record of whatever was in front of the camera when the photo was taken. Many photos are interesting only because of what's in them. News photos often fall into this category, as do many family snapshots. Let's face it, you're not *really* interested in looking at photos of some stranger's kids, are you? But some photos go beyond being simply a record of people, places, and things. They are interesting not because of the subject matter (although that may be interesting too) but rather because of the way the photo was visualized and taken by the photographer.

As an example, consider Ansel Adams, who is probably the best-known photographer of all time. His beautiful photographic images of nature hang in dozens of museums and attract many art collectors, commanding very high prices. Now let's face it; you, I, or your Aunt Minnie could go to Yosemite National Park and snap a few photos of Half Dome, but the results would *not* be the same (trust me on this.) Adams's photos are considered art because of the way they visualize and represent the subject and not because of the subject itself.

It should go without saying that a photo does not have to be carefully planned and visualized, as Adams's photographs are, to be artistic. Many wonderful photographs are taken spontaneously or even accidentally. From the perspective of the viewer, it's the result that counts, not the photographer's intentions. And that's one reason why camera phones are having such an impact: they provide an easy and spontaneous outlet for the artist/photographer that lurks within you.

Bad Specs = Art?

Another aspect of camera phones that I believe is related to their popularity for taking creative photographs is their poor specs. Camera phones come off pretty badly when compared with stand-alone digital cameras in terms of technical specifications such as number of pixels (I cover this in more detail in Chapter 2). But aren't good specs what everyone wants?

For the most part, yes. Digital photographers sometimes seem to be obsessed with pixels, sharpness, and resolution. A photograph cannot be too sharp or too detailed for them. By contrast, photos taken with today's camera phones look almost pitiful, with low resolution and detail that users of a stand-alone digital camera would never accept. But here's the hidden advantage: the low resolution and other technical shortcomings of camera phone photos can make them look less like a photograph and more like a painting or a drawing.

Figure 1.1 shows an example. Had I taken this photograph with a stand-alone digital camera it would be clear, sharp, and relatively uninteresting. By using my camera phone, the result is very different and, in my opinion at least, a lot more interesting.

Camera phone photos look *different* from other digital photos, and that difference can set them apart and make them more interesting—more "artsy" if you will. Combined with the spontaneity of camera phones, the "painterly" characteristics of the resulting photographs can provide some wonderful results.

Figure 1.1
Camera phone photographs can look more like a painting or a drawing than a photograph.

In the Field: Is It Art? The SixSpace Gallery Says Yes

Camera phone users are known for taking photos of the ordinary such as an unmade bed or a newspaper lying in the gutter. These are not exactly the sort of images that are usually considered to have any artistic merit or that you would expect to see in a gallery. Or would you? SixSpace Gallery in Los Angeles (**www.sixspace.com**) hosted a show earlier this year which argued that such images can be art and should be shown in galleries. The show, called Sent, was co-curated by Xeni Jardin, better known as a co-editor of the leading techno-culture blog BoingBoing (**http://boingboing.net/**).

The show has two parts. At the gallery, prints by established artists and photographers were hung on the walls. In addition, digital photos contributed by the public were displayed on flat screen plasma screens in the gallery. The professional artists and photographers were given camera phones so they could try their hand at this new kind of photography. Anyone was permitted to contribute by emailing a photo to the show, and the images were refreshed regularly so that at any moment gallery visitors would see a random assortment of photos on the plasma screens. The show embodied the "take it and send it" psychology that is a central part of the camera phone culture. You'll find an online version of the show at www.sentoline.com.

We're likely to see more galleries and art shows like this as camera phones increase in popularity.

Join the Avant-Garde

In the art world, the newest and most interesting work is almost always done by people who are breaking the rules, throwing out the old standards and techniques in favor of their own personal mode of expression. This certainly fits most camera phone users! One way to do things differently is to stop thinking of your photographs as individual, separate images. If you start thinking that multiple images can be part of a whole, connected by space, time, or theme, you'll open up a world of creative possibilities. What exactly do I mean?

Images connected in space are taken of the same scene. Rather than step back and take a single photo of the entire scene, you can move in close and take multiple images of parts of the scene, perhaps in a checkerboard pattern. Then later you can combine the individual images to create a composite image that presents the subject in a new light.

Images connected in time are taken of the same subject at different times. The images may be mere seconds apart, or perhaps minutes, hours, or days. Here are some ideas:

- A series of your friend Charlie showing off his repertoire of funny faces. This sort of series that shows people doing things can be thought of as a kind of performance art.

- The Thanksgiving turkey, featuring the bird from supermarket shelf to being unwrapped, trimmed, stuffed, tied, roasted, carved, served, and finally made into soup.

- Your grow-a-beard experiment, from clean-shaven to five o'clock shadow, then to scruffy, then to bushy (and back to clean-shaven).

- A tree in your backyard, from winter through spring, summer, and autumn and back to winter again.

The third type of series is connected by theme—in other words, subject matter. The possibilities here are almost endless. You could, for example, take a photo of every hamburger you eat, or every T-shirt that you own, or the left feet of all your friends. One fellow did a series of every toilet he used (no kidding). Let your imagination run wild. Sometimes you cannot tell what will be interesting until you have tried it out.

Artistic Journalism

Most people think about journalism as *news* – important (or sometimes not-so-important) happenings such as crimes, accidents, natural disasters, and the like. You can certainly use your camera phone for that kind of journalism if you happen to be on the scene. But camera phones also lend themselves to another kind of journalism that I call *artistic journalism*. What do I mean?

At its heart, journalism is a record or account of events that have occurred. It doesn't have to be something that is of general interest to the world at large, or to anyone else for that matter. It only has to be of interest to *you*. Sometimes this is called *personal journalism*. All you need is some event or activity that interests you; heck, it can even be your own day-to-day life. All you need is the willingness to pay attention and document your life with your camera phone.

One great way to approach personal journalism is by means of storytelling. We all have adventures now and then. You might have a big adventure, like moving across the country to start a new job. More often your adventures are small, but you still likely have a story to tell. With your camera phone, you can document your adventure as seen by you, from the inside. No one else will have the exact same adventure and no one else sees things the way you do.

Move in close to get a new perspective on familiar objects.

Photographs and Words

If you are trying to tell a story, words and photographs together can be a lot more interesting and powerful than either item by itself. You might want to keep this in mind as you work on a personal journalism project. Your final goal could be to not just create a set of photographs, but photographs combined with captions and narration that will help tell a story. This task can be simplified by the "voice notation" feature that is present in many handsets. You can press a button and record a short voice message and then play it back later. This saves you the hassle of taking written notes. Recording your impressions or pertinent facts at the same time you take a photo can bring an extra sense of immediacy to your project.

The next time you are in a greeting card shop, take a close look at the cards you see that use photos with captions. You can get some really good ideas here, especially by looking at the humorous ones. I'm often amazed by how photographers can take basic photos and combine them with just the right text to create very funny or powerful messages. If you see a good idea, try to improve on it to make it your own. If you are looking for ideas of how ordinary family photos can be combined with humorous captions, check out the Mik Wright line of cards at **www.mikwright.com**.

The Camera Phone Culture

I'll finish this chapter with a look at some of the cool things that people are doing with camera phones, and a few not-so-cool things!

Digital Shopping (and Shoplifting)

Lots of people like to get their friends' opinions when shopping. "Do you think this hat (shoes, shirt, dress, and so on) looks good on me?" but, if your friends can't tag along, it is still possible to get their opinion by sending them a picture of the item with your camera phone and then waiting for their reply by phone call or text message. What are friends for if not to keep you from buying a really ugly hat or a dress that fits badly?

Unfortunately, some people have been taking this idea too far. In Japan, young women have been using their camera phones to take photos of hair styles in a magazine while still in the store and then showing the photos to friends for advice on how to have their hair done. Hold on, ladies. The magazine is for sale and you are supposed to buy it if you want to use the images it contains! It seems that some

people think this is okay because no physical item is being taken, but it still amounts to digital shoplifting. The same is true for photographing magazine articles for later reading.

Where someone might see a crime, others see an opportunity. In England, the Toni&Guy chain of upmarket hair salons lets customers download pictures of hairstyles to their phones from a large online gallery of photos. Then, the theory goes, they can discuss their potential new look with family and friends before making a decision.

To "Click" or Not to Click

In Korea, a law has been proposed to require that camera phones make a noise when a picture is taken. This would make it a lot more difficult to sneak a photo without people around you being aware of it. Is this a good idea? In some situations, sure it is, but in others it is not. Being able to take a photo secretly is essential for candid, unposed photos; it does not necessarily mean that something sneaky or underhanded is going on.

While you are out and about digital shopping don't forget to take photos of anything else that might interest you.

Moblogs

First came *blogs*, short for web log, an online journal whose owner, or *blogger* in web-speak, keeps text entries of things that are of interest to them, whether it be personal life, politics, travel, you name it. A blog is essentially an online public diary, if you will. Blogging has become very popular, and a few blogs are even interesting! Some blogs have even become so popular that they have even been featured in the national media like National Public Radio. There are even a few lucky bloggers who have figured out ways to make money off of their blogs.

The next evolution of blogs is *moblogs*, short for mobile blog. They are different from a regular blog in that the content is posted from a mobile device such as a phone or PDA. Moblogs got their start in Japan, which was the first country to have widespread use of camera phones. With the spread of camera phones, moblogs have become wildly popular. Use any web search engine and you'll find dozens, if not hundreds, of moblogs covering every conceivable topic. Here are just a few examples:

- The Bento Moblog is a Japanese mother's record of the daily school lunches she makes for her children (**http://mito.typepad.com/photos/bento/**).
- Southern California Wildfires shows photos of wildfires as they are happening (**http://fire.textamerica.com/**).
- The Planetary Photojournal shows photos from what are perhaps the ultimate mobile devices, the Mars rovers. (**http://photojournal.jpl.nasa.gov/targetFamily/Mars**)

While moblogs are not limited to photos taken with camera phones, that is certainly the most popular picture taking method. As moblogs have become more popular, a variety of free and low-cost moblog services have sprung up. Basically, once you have an account at one of these services, you simply email your photos to the service and they are placed in your moblog. I'll be covering moblogs in great detail in Chapter 8.

Reference: History of Moblogging

Joi Ito's site presents a history of moblogging along with some other useful resources. http://radio.weblogs.com/0114939/outlines/moblog.html

Camera Phone Postcards

Not everyone is as connected as you are. Some people don't have cell phones, hard as that may be to believe. Some don't even have computers or email. If you want to

send a photo to such people you can use one of the new postcard printing services. Here's how it works.

First you must have the software on your camera phone. It may be preinstalled by your service provider; otherwise, you'll have to download the postcard application to your handset. Not all handsets are supported, so you'll have to check to see if your handset is compatible with the software.

Once the software is installed you are ready to go. You then take your photo and enter a message and postal address, and the software sends the information to the postcard service provider. The service provider prints the postcard—photo on one side, address and message on the other—adds postage, and mails it for you. The charge typically shows up on your cell phone bill.

Even if your friends and family are connected it can be nice to send a real postcard instead of an electronic image. After all, what are refrigerators for except to hang postcards on? Perhaps the first postcard printing service is offered by SnapnPrint at **www.snapnprint.com**.

Cellcerts

Made by combining the words *cell phone* with *concert*, *cellcert* can be traced back to the way concertgoers would hold up their cigarette lighters and sway to the music. Sometimes called "the Zippo moment," this reportedly originated with the concert fans of rock legends such as Aerosmith and Led Zeppelin in the early 1970s.

Someone got the idea that a cell phone's brightly lit screen could replace the lighter, and the cellcert was born. Pretty soon people were also playing their ringtones and calling a friend so they could listen to the concert over the phone (great fidelity no doubt!) The circle seemed to be complete when bands, most notably the Finnish group Nylon Beat, started releasing their songs as downloadable ring tones. Finally, as camera phones became more common, taking and sending pictures of concerts became part of the cellcert phenomenon.

But aren't cameras banned at concerts? They sure are, most of the time. But surprisingly, there are almost no reports of cellcert participants being hassled by security personnel. Perhaps there are too many to deal with, or maybe the concert promoters figure this is good publicity. In any case, it is certainly a growing phenomenon, as a quick search for cellcert on Google will reveal.

I am always looking for compositions with simple and strong graphical elements.

News Photos

News photos are perhaps one of the most obvious uses for camera phones. What's the probability that there will be a professional news photographer on hand for that plane crash, robbery, fire, or whatever? Just about zero, right? A passerby with a camera phone, however, is a lot more likely to be nearby.

You see more and more instances of camera phone news photos published in newspapers and magazines. For example, the BBC set up a moblog on its website in February 2003 to display camera phone pictures of the antiwar demonstrations, and the moblogging host TextAmerica has dedicated moblogs to the 2003 blackout in the northeast and to the wildfires in San Diego. Some news organizations have created special phone numbers and email addresses that the public can use to submit photos that they think are newsworthy.

Fighting Crime

There's nothing quite like a photograph to identify a "perp." Quick-thinking camera phone owners have used their cameras in numerous incidents to grab photos that led to arrests. One example is a woman living near Atlanta, Georgia. When a man exposed himself to her in a parking lot, she grabbed her camera phone, not to call the police but to take a photo. The result was the arrest of a local high school principal on indecency charges. Likewise, a convenience store clerk in Sweden took a photo of a robber that was used to help identify and arrest the individual.

It has been argued that the mere existence of camera phones can help to deter crime. The chance of being caught in a picture may make potential criminals think twice. There's no real data on this, but it is an interesting possibility.

Scavenger Hunts

Many of us have participated in traditional scavenger hunts. Each team is given a list of items and the team that is first to find the items and bring them in is the winner. Camera phones introduce a whole new approach to this activity. You still need to find the items in the list, but then all that is required is to take a photo and send it in. There are various ways to keep score; points can be awarded for the number of items found or the speed with which they are found. The advantage of the camera phone scavenger hunt is that the list can include items that could not be physically brought in. A hunt can last a few hours or a few weeks. There are a lot of creative ways to arrange a camera phone scavenger hunt. For example:

- Photos of the team in specified locations: a junkyard, seafood market, dairy farm, or exercise room.
- Photos of team members doing things, such as playing a trumpet at the county courthouse or wearing a lampshade hat in a restaurant.
- Photos of specified people (not team members) such as a police officer, dog catcher, or mailman.

A free, public camera phone scavenger hunt is hosted at **www.dodgeball.com/biggames/index.php**.

Invasion of Privacy

The most common and serious uncool things that camera phones are being used for involve invasion of privacy. A regular camera, even a small, one, looks like a camera and is likely to attract a lot of unfriendly notice if pulled out in a locker room, changing booth, or restroom. A camera phone, on the other hand, does not look like a camera; it looks like a phone. This has permitted some unscrupulous people to take photos where they should not be taking photos, and when the images later turn up on the Web, people get very angry and embarrassed. This is also a practice that has potential for criminal and civil liability. Chapter 9 discusses the legal and moral issues that camera phone users face, but a little common sense and sensitivity goes a long way. When other people are involved, be cool. If you have any doubt, ask. Just because you *can* take a photo does not mean it is okay to do so.

Because of privacy concerns, many public and private enterprises have started to post signs to indicate that camera phones are not allowed. Some store owners, for example, don't want you to come in and snap photos of their merchandise and some nightclubs don't want you to take photos of the customers. Always be mindful of your surroundings and look for signs.

Your First Projects

You are probably itching to get started taking photos with your camera phone. Maybe you have already, but sometimes it's good to have a specific project to focus on. Here's a good one because it's simple and it's fun. Make sure your handset is charged up and keep it with you at all times (okay, not in the shower!). Then, every time you see something that makes you laugh or smile, take a photograph of it. After a few days you will hopefully have a collection of images—maybe just a few, maybe a lot, it doesn't matter. Then display them all together. My bet is that you'll have a pretty interesting bunch of photos!

How Do I Display My Photos?

If you are just getting started, you may not be sure how to go about displaying a bunch of photos together. I'll be covering these topics in later chapters. If you want to jump ahead, here are some pointers:

- Print the photos and tack them to a bulletin board or put them in an album. Printing is covered in Chapter 5.

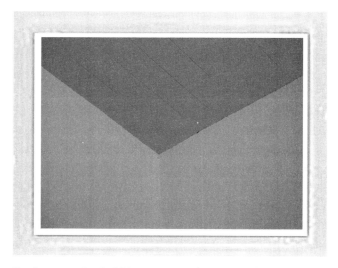

Don't recognise this? I bet you see a dozen every day!

- Put the photos in an online album or web gallery for viewing on-screen. This is covered in Chapter 6.
- Put your photos in a moblog for viewing by you and others. Moblogs are covered in Chapters 7 and 8.

You certainly do not need a project to have fun with your camera phone, but sometimes having a specific plan of action can help you to focus your creative energies. Here's a good starter project that has as its subject the most interesting person in the world—you. The project's title is A Day in the Life.

You need two things for this project. The first of course is your camera phone (fully charged I hope). The second is the determination to see it though. Next, pick your day. It can be an ordinary day when you go to school or work as usual, or a special day such as the start of your vacation. Then all you need to do is use your camera phone to document your day. You should capture what you see, who you talk to, what you do. Don't be shy because people take photos in public all the time so I doubt your project will raise any eyebrows. You should respect other people's privacy, of course, but when in doubt I have found that simply asking in a friendly way almost always works.

What should you photograph? The only rule is that there are no rules. Here are some things I snapped when I tried this project for the first time:

- Self-portrait while eating breakfast and reading the paper.
- While stopped in traffic, an unusually decorated car in the next lane.
- When I arrived at work, my office with all the work piled up on my desk.
- The fish and chips I had for lunch.
- The 70 year old cashier with pink hair at the fish and chips joint.
- Some interesting graffiti in the mens' room.
- My coworker Donna imitating the boss's sour face.
- My office at the end of the day with even more work piled up.

Well, you get the idea. If it's interesting to you, take it; your interest is all that matters.

How can you take photos of yourself? Camera phones have a wide enough angle of view so that holding the handset at arm's length works for many shots. You can photograph yourself in a mirror as well. Otherwise, you can always ask a friend or passerby to take the photo.

Depending on the photo capacity of your handset, you may need to email some photos to yourself to make room for new photos. At the end of the day sit down and look at what you have. You may get some ideas for how to do things better next time. In any case it's your life so enjoy it.

Wrapping It Up

If you are really obsessed, then you have already used your camera phone to take a photo of yourself reading this book! Okay, maybe not, but I hope that you are feeling the excitement and energy surrounding the camera phone community. There are so many great things you can do with these devices, and when you let your mind and creativity run free, I bet you'll come up with new ideas that I have never even thought of.

Chapter 2
Getting the Camera Phone Setup That Meets Your Needs

Perhaps you have decided that you want to get into camera phones and share in the excitement. Or, maybe you already have a camera phone and you are thinking about upgrading to something better. This chapter provides an overview of camera phone hardware and, equally important, the service plans that go with them. Things change pretty fast in this field so I don't want to shortchange you by just recommending specific camera phones, providers, or service plans. I can, however, clue you in as to what you should be looking for. Along the way I'll try to provide you with a set of tips to help you match up your real needs with the types of cameras and service providers that are currently available.

Not Your Father's Digital Camera

If you are at all familiar with the world of stand-alone digital cameras, you'll see right away that camera phones are very different. Today's digital cameras are feature laden, with multiple-megapixel sensors, wide-range optical zoom lenses, huge memory capacity, powerful flashes, and automatic focus.

Camera phones are by contrast very simple and feature poor. I don't think that anyone would buy a stand-alone camera with the specifications of a typical camera phone. Of course, that's not really the point, since the simplicity of camera phones is one of the things that makes them special. Despite this simplicity, you will have some choices to make when shopping. Let's take a look.

Camera Phones and Service Providers

Unfortunately you cannot separate shopping for a camera phone from choosing a service provider. Phones are set up to work with a specific provider's service, so you cannot, for example, buy a phone at Verizon and use it with a Cingular service plan. Each service provider offers a limited selection of phones, and you may find that the provider with the best service plan does not have the phone you want. There's no getting around this. Perhaps some day you'll be able to use any phone with any service provider, but I think that won't be anytime soon.

In the second part of this chapter I'll provide you with a strategy and a number of tips to help you assess your needs and match them up with a camera phone and a service provider. The most important part about this process, as you'll see, is that you need to do a little research up front and try to think through your short-term and longer-term needs. Because camera phones are relatively new and the industry is in a state of rapid expansion, not everyone you ask for advice will be up on the latest features and technology.

Pixel Resolution

Digital photographs are made up of pixels, or dots of color. You normally do not see the pixels in a photo because they are quite small and your eye blends them together into a smooth image. You will see them, however, if a digital photo is enlarged too much. Any digital camera has a *pixel resolution* that is the size, in pixels, of the photos it takes. For example, if a photo is 200 pixels wide and 150 pixels high, the resolution is 200 by 150 pixels (usually written as *200x150*). Often the resolution is expressed as the total number of pixels, which is simply the width times the height. Thus, a 200x150 resolution can be expressed as 30,000 pixels.

In digital photography, it is an article of faith that more pixels—that is, higher resolution—is better. There's good reason for this belief. Higher resolution results in pictures that capture more detail and can be enlarged more while still looking good. Stand-alone digital cameras have resolutions starting at 1 or 2 megapixels (1 megapixel = 1 million pixels) for the smallest, cheapest models and up to 5, 8, or even more megapixels for the high-end prosumer and professional models.

Does this mean you want the maximum resolution possible in your camera phone? Not necessarily, and here's why. The higher the resolution of a photo, the bigger the file required to store and send it. With stand-alone cameras this is usually not

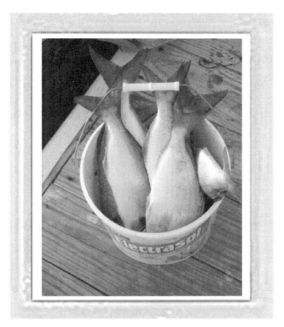

Because of the mobility I have with my camera phone, I can take great photos whenever I come across something that grabs my attention.

an issue, but with camera phones it most definitely is. Most camera phone pictures are sent over the wireless network, either as part of an email message or as a multimedia message to another phone. When it comes to sending large amounts of data, the wireless cell phone networks are not very fast and larger, high-resolution photos would really slow things down. Let's look at an example.

My camera phone has a resolution of 352x288, or approximately 100,000 pixels, fairly typical of current camera phones. It can take anywhere from 15 seconds to a minute and a half to send a photo by email. Suppose the camera phone had a resolution of 3 megapixels, which is common in low- to mid-level stand-alone digital cameras. That's 30 times as many pixels, which means a photo would take 15 to 45 *minutes* to send from the camera phone. Clearly this would not be acceptable, particularly since service providers charge for sending data over the network!

Tip: The VGA Resolution Label
Some camera phones advertise "VGA resolution." This is simply geekspeak for 640x480 pixel resolution, or 307,2000 total pixels. This is a fairly high resolution by today's camera phone standards.

As I write this, megapixel camera phones are simply not available in the United States (although they are common in Japan and Korea). Current offerings are largely limited to resolutions in the 70,000 to 100,000 pixel range. Things are changing, and it won't be long before the U.S. camera phone enthusiast has a lot more to choose from. What's more, faster wireless networks will eventually make it practicable to send multi-megapixel photos from your phone, but that day is not here yet.

Takes photos, internet access, calendar, multimedia - that's great, but can I make phone calls?

New Camera Phones

Nokia just announced a 1 megapixel phone costing over $600, and Siemens has unveiled a 1.3 megapixel phone. Samsung also reportedly has one in the works, as does Pantech and Curitel. There are sure to be more by the time you read this. Unfortunately, phones that are available in Europe and Japan are often not sold in the United States.

Don't reject a megapixel camera phone just because of the transmission time problem. For one thing, most camera phones let you transfer your photos without sending them over the wireless network by means of a connection to your computer via a cable or Bluetooth (a standard for wireless short-range connectivity between a computer and peripherals such as printers and keyboards). These options will limit how you can use your camera phone photos. For example, you cannot email your photos directly from your phone to a friend or moblog but you can avoid the slow transmission and data transfer charges of the wireless network. Furthermore, megapixel camera phones will offer a variable resolution setting; you will not have to use the maximum resolution, but will be able to take photos at a lower resolution that is better suited to sending over the wireless network.

Faster Wireless

Current wireless cell phone networks are pretty slow and do not come close to the speed that many of us are used to on broadband Internet connections such as cable modems and DSL. Faster wireless is on the way, however. For example, a technology called Evolution Data Optimized (EvDO) is being offered by Verizon in limited areas at present and is promised for much wider availability by the end of 2004. EvDO offers transmission speeds theoretically as high as 2.4 megabits/second. (Note that this is mega*bits* per second. You must divide by 8 to get the more commonly used mega*bytes* per second, in this case 0.3 megabytes or 300 kilobytes per second.) Also, real-world tests show that this theoretical maximum is never attained, with more typical speeds of 600 kilobits/second (75 kilobytes/second) for receiving and 140 kilobits/second (17.5 kilobytes/second) for sending. That's not exactly blindingly fast, but it will allow sending a 1 megapixel picture in about 30 seconds—a significant improvement over the current network.

Display

All camera phones have a color display that is used as a viewfinder when taking pictures and also as a screen for viewing pictures you have already taken. Camera phones differ in both the size and quality of the screen width. As you would expect, more expensive handsets tend to have nicer screens. Size and brightness are easy enough to evaluate, but you also need to think about color depth—that is, the number of colors the screen can display. Some low-end camera phones are limited to about 4,000 colors, while better models have 65,000 or more colors. For simply framing your shots and doing a quick review, this may not be critical, but

Think out of the box when photographing people

generally having a display with more colors is preferred. Note, however, that larger, brighter screens put more drain on the handset's battery, so there is a tradeoff.

Add-On Cameras

Some cell phones offer a camera as an add-on accessory. Rather than being integrated into the handset, the camera module either clips onto the handset or attaches via a cable. The Nokia 7210 is one such phone. In my opinion, an add-on camera is not a good idea. Remember, one thing that really sets camera phones apart from other types of cameras is that you will likely have it with you almost all the time. If the camera is an accessory and not integrated into the phone, you may forget it or lose it. Also, it's just one more thing to clutter up your pockets or purse. Buying an add-on camera for your current cell phone may be an economical alternative for some people, but otherwise I'd avoid it.

Video Clips

Some camera phones let you take short video clips as well as still photographs. The video includes whatever sound the handset is picking up at the time. Videos can be sent via email as part of a multimedia message. This is essentially the same thing you can do with a still photo. As you might expect, capturing video really eats up memory, and sending a video via wireless can take quite a while. Still, there are times when a still photo just won't do but a video is perfect.

Video clips add a new dimension to the idea of using camera phones to catch people in the act. For example, in Japan, a student in the Gyeonggi-do school district used his camera phone to capture a clip of the teacher assaulting a female student in the classroom. As reported in the English edition of the *Chosun Ilbo*, the clip was posted on the Web and resulted in a flood of angry messages and calls to the district officials demanding the teacher's firing.

My suggestion is that if you like to take video clips with your camera phone, first transfer the clips to your PC and then send them from your PC. In the end, this will save you a lot of time and transfer costs because of the large size of the video clips.

> ***Resources for Camera Phone Video Clips:***
>
> You'll find interesting collections of camera phone video clips at these two websites: **www.ericsson-mini-movies.php/** and **www.nokia-mini-movies.co.uk/**. For a compendium of general video clip resources, see Mobile Phone Video Clips at **www.moremobile.co.uk/mobile-phone-video-clips/**.

Zooming

While almost all film cameras and stand-alone digital cameras have zoom capability, this feature is not easy to find on camera phones. I am talking about optical zoom, in which the lens adjusts to make your subject seem closer to you or farther from you. Many camera phones have digital zoom, which is not at all the same. Digital zoom works by extracting the central part of the picture and enlarging it electronically. The problem is that the quality of the image gets degraded by this process, so it's not really very useful. You are better off taking the picture without digital zoom and then using an imaging program on your computer to "zoom in" on the subject. You'll learn more about this in Chapter 4.

Flash

Almost all camera phones do not provide a flash. There's good reason for this—the addition of a flash adds size and weight and shortens battery life. Remember, a camera phone is first and foremost a phone and a camera second (although some of us photo-obsessed users might reverse that order)! There are a few handsets available with a flash, so if you think that will be important for your picture taking, you can check them out. Be aware that the "flash" on a camera phone is not

the same as a flash on a regular camera, at least the models I have seen. Rather than being a true flash that emits a very brief and very bright burst of light, a camera phone "flash" is more like a small flashlight that comes on for a second or so as the photo is taken. If you do want a flash, check the handset specs to see what the range is. In other words, how far away can the subject be and still get a good flash photo.

What about Battery Life?

Camera phone manufacturers rate a handset's battery life in terms of two factors: standby time (when the phone is on but not in use) and talk time. Sending photos counts as talk time. Other activities, such as taking photos or viewing them on the screen, also eat up power but just how much is not known because manufacturers do not provide ratings on these aspects of battery use. To play it safe, you can keep an extra charged battery with you. Whether you have one battery or two, here are some tips for maximizing battery life and minimizing the chance that you'll find yourself with a dead handset:

- When you first get the phone, follow the manufacturer's instructions for the initial battery charge, which sometimes requires up to 16 hours. You should charge for the full specified time even if the handset's battery indicator says that the battery is fully charged. This long first charge is required to initialize the battery and ensure that it will take the maximum charge in the future.
- Keep the camera turned off when not in use. More power is used when the camera is on and the image is displayed on the handset's screen.
- Don't spend a lot of time reviewing your photos on the handset's screen. Wait until you have transferred them to your computer to do this.
- Keep Bluetooth and/or infrared turned off unless you are using them.

Night Mode

Many camera phones have a setting called night mode or something similar that can substitute for a flash in some situations. In night mode, the camera phone's sensitivity to light is increased, allowing you to take photos in darker places. This feature comes with a trade-off, however—night mode can make your photos grainier and not quite as sharp as they would be if you used regular mode, but it is still very useful when the light is low.

People's faces are not the only thing you can snap.

Picture Capacity

Each photo that you take is stored in your handset's memory. When the memory is full, you will have to delete photos to make room for more. If you want to save the photos, you have to transfer them first before deleting them, which can be time-consuming or, depending on where you are, impossible.

If you are a casual shooter and take at most a few photos a day, capacity limitations may not be a concern. For others, however, it is important. When selecting a camera phone, find out the capacity and decide what best suits you. Higher capacity is usually found in more expensive handsets.

Some newer handsets are offering expandable memory using one of the removable memory technologies such as memory sticks or compact flash. This lets you solve the photo capacity limitation; simply swap an empty memory unit for the full one and keep shooting. Removable memory has some disadvantages, however. At least with current technology it is more expensive, slower, and consumes more power than integrated memory. Handsets with removable memory have been introduced by the major manufacturers in Europe and Japan and should be a available in North America by the time you read this.

Transferring Photos to a PDA

Some personal digital assistants (PDAs), such as Palms or Pocket PCs, offer Bluetooth wireless connectivity. If your handset has Bluetooth also, you may be able to transfer

photos to your PDA, permitting you to delete them from the handset to make room for more picture shooting. A PDA typically has a lot more memory than a camera phone, so this can be a useful option for people who shoot a lot of photos, particularly when it is impossible to offload photos using email.

I suggest using a system like this when you are traveling. Instead of having to lug your PC around, you can just bring your PDA and transfer photos to your PDA when your handset gets full. If you travel to a city that has Internet cafes, you can always transfer the photos from your PDA to a computer and then email them to family, friends, or to yourself so that you can store them. This is a good way to travel light but still be able to take as many photos as you want.

Form Factor

Form factor refers to the physical layout of the phone. There are three basic layouts, albeit with some minor variations:

Clamshell. The handset is hinged and flips open for use and closed when not in use. This style of handset tends to be compact and often, but not always, at the more expensive end of things.

Slide. The handset consists of nested inner and outer sections that slide partially apart for use and slip together when not in use

Basic. The handset neither flips nor slides; it is simply a more-or-less rectangular box with the keys and screen on one side and the lens on the other. This style tends to be less expensive but has the disadvantage that the keys and screen are not protected when the phone is not in use.

Connectivity Options

A camera phone is by definition connected via the wireless cell network, but many handsets offer more options for sending and transferring your photos. Let's take a look:

- Emailing. Email is the most common form of connectivity, and as far as I know it is universally available with camera phones. You address an email, attach a photo to it, and send it over the wireless network. This method is very flexible because it lets you send a photo to anyone who has email and also lets you submit photos to moblog services. I'll be covering these services in Chapter 7.

- Multimedia messaging. Different service providers refer to this feature by different names, but the idea is the same. You can create a message on your phone that includes one or more items such as text, a sound clip, or a photo. Then the message is sent to a phone number. If the recipient has a compatible phone, they will see your photo along with the other message elements. However, this technique is best designed for letting someone else see your photo, not for saving it.

- Cabled connection. Some handsets provide a cable connection to a computer, usually via a USB port. You can use this connection to transfer photos from the handset to the computer. Cables work fine, but they seem a bit old fashioned in today's wireless world.

- As mentioned earlier in this chapter, some camera phones support removable memory such as memory sticks or compact flash. If you have a memory card reader on your computer, you can remove the memory from the handset, insert it in the card reader, and transfer your photos to your hard disk.

- Bluetooth is a wireless technology for short-range communication. It is commonly used for wireless keyboards, mice, and printers. Some camera phones have Bluetooth capability, and you can use this to transfer photos to a Bluetooth-capable computer. Some computers have Bluetooth built in. If not, you can buy a key-fob sized adapter that plugs into a USB port.

- Infrared is another wire-free photo transfer method supported by some camera phones. Of course, your computer must be set up for infrared as well. Infrared requires a direct line of sight between the sending and receiving units.

Obviously you will select your transfer options based on your own needs and preferences. I advise most camera phone users to get at least one of the handset-to-computer transfer options, such as Bluetooth. Emailing a lot of photos to yourself can get expensive because service providers charge extra once you go above your monthly allocation.

Service Providers and Plans

A camera phone is useless without a service plan—an agreement with one of the cell phone companies to connect your phone to a network. Selecting a service plan is an important part of your buying decision. Things are complicated by the fact that some phones are offered only by certain service providers, so your final choice may be a balancing act between the best phone and the best service plan.

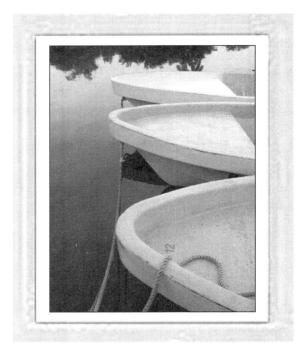

I always keep my eyes open for interesting shapes and patterns.

Most advertising for service plans concentrates on use of the phone for phone calls (it *is* a telephone too, remember, not just a camera). I can't help you here; you'll have to choose the voice part of your service plan based on your own needs. Unfortunately, the vendors seem to be determined to make it as difficult as possible for you to determine exactly what you are getting and how much you'll pay for it. If you plan to use your camera phone a lot to take and send photos, you need to look at the different service plans that are available to you very carefully. Be on the lookout for hidden charges that could end up costing you a lot of money! Don't be seduced into a plan that seems to offer a low monthly rate but is loaded with extra fees. Service providers are really smart about making their package deals look very attractive but when you inspect them closely you might find otherwise.

Number Portability—What's It Mean?

Recent changes in cell phone regulations mean that you can keep your existing phone number when you change service providers. There are some geographical limitations. For example, you cannot transfer your Colorado cell phone number to a new account in Florida. Generally, however, number portability is a real boon to consumers because

you can shop for a new and better service provider without worrying about having to give all of your friends and business associates your new phone number. This may come in handy if you have been bitten by the camera phone bug and want to upgrade to a handset and service plan for wireless photography.

From the perspective of a person using the phone for a camera, things are different. Transfer of photos using the wireless network—that is, sending emails and multimedia messages—is a separate item in your service plan. For example, the plan I currently use gives me up to 8 megabytes of transfer a month for a flat fee of about $12. Above 8 megabytes, I pay on a per-kilobyte basis. Eight megabytes is about 160 photos, so I can email an average of about 5 photos a day without extra fees.

Of course, you need to evaluate how you will use your camera phone. For example, I almost always return home and transfer my photos to my computer using Bluetooth. If I want to email a photo I usually do it from the computer, not from the handset. As a result, most of my 8 megabyte monthly allocation goes unused. But if I go on vacation and am away from the computer for a week or more, I am sure to email a lot more photos to myself and others.

The bottom line is that you have to select a service plan based on how you plan to use the camera phone. Remember that service providers are always willing to let you upgrade your plan, so you might want to start with a low data transfer allocation and then increase it if needed.

What about Prepaid Plans?

You may hear people raving about the advantages of a prepaid cell phone service plan. They do offer real advantages for some people, particularly those who use the phone only occasionally and do not want to be locked into a long contract. For us camera phone buffs, however, they just won't work. As far as I know, there are no prepaid plans that offer the digital data transfers and Multimedia Message Service (MMS) messaging services that are essential for wireless photography.

Making Your Decision

While I cannot tell you which camera phone and service plan you should get, I can provide you with some advice and pointers. This section walks you through the process of choosing a handset and a service provider and a plan. By following these steps, you should be able to settle on a camera phone setup that is suited to you.

Camera Phone Obsession

Doesn't everyone give their French horn a bath once in a while?

Step 1: Gather Information

It's impossible to make an informed decision without information. Fortunately there is plenty of information available—too much, some people might say! Let's look at information about the handsets first.

Perhaps the best source of information is the manufacturers themselves. No one knows the features and capabilities of a handset better than its maker. In addition, the manufacturer's website will have information about new phones that aren't released yet and also about accessories for its handsets. Table 2.1 lists the web addresses for all the manufacturers of camera phone handsets.

Be aware that just because a manufacturer lists a camera phone on its website does not mean it will be available from service providers in your area. Before getting your heart set on a handset that is not available in your area, you may want to do some investigating of service plans (covered later in this chapter) and limit your handset researches to those models that are available. Remember also that some service providers will give you selected phones free or at a steeply discounted price if you sign up with them. With this in mind, you should probably combine looking at service plans with selecting a handset. A $300 camera phone that meets all your needs may not seem so attractive if you can get one that's almost as good for free!

Table 2.1 Camera phone handset vendors.

Company	URL
Audiovox	www.audiovox.com
BenQ	www.benq.com
Danger	www.danger.com
Hitachi	www.hitachi.com
Kyocera Wireless	www.kyocera-wireless.com
LG Electronics	www.lgmobilephones.com
Motorola	www.motorola.com
NEC	www.nechdm.com
Nokia	www.nokia.com
PalmOne	www.palmone.com/us/products/smartphones
Panasonic	www.panasonic.com
Pantech & Curitel	www.curitel.com
Samsung	www.samsung.com
Sendo	www.sendo.com
Siemens	www.siemens-mobile.com/cds/frontdoor/0,2241,hq_en_0_23076_rArNrNrNrN,00.html
Sony Ericsson	www.sonyericsson.com
Tu-Ka Group	www.tu-ka.co.jp

Another good source of information is the service providers themselves. As I have mentioned, each service provider offers a limited selection of handsets. They will have information about these handsets on their web sites and also in their stores. I'll list the web addresses for service providers later in the chapter. If you live near any service provider storefronts, it's a good idea to visit, look at the handsets, talk to the sales people, and get some brochures (you'll be checking out their service plans at the same time, of course). But remember, sales people may have ulterior motives, and while I'd like to think they have the customer's interests at heart, this is not always the case. They may be more interested in selling you a handset that is overstocked or with the largest commission than one that best suits your needs.

Often, some manufactures will have models that they really want to sell and they will offer very attractive incentives such as rebates. These programs are fine just as long as the camera phone you are buying really fits your needs. Don't be talked into buying something just because it seems like you might be getting a good deal. On the other hand, if you do your research and decide which camera phone you want and you are able to purchase it as part of a promotional program, you'll be one step ahead.

Step 2: Decide on Features

Once you have a feel for what's available, it's time to decide on the features you want in your camera phone. Here's my take on which features are most useful. But keep in mind that these are my suggestions only and that you should not feel any need to follow my advice! The ability to send and receive email and MMS messages is taken for granted.

- Pixel resolution. On the low end, I wouldn't go much below 100,000 pixels. At the high end, anything above VGA resolution (640x480) is probably overkill.

- Voice recording. This feature is very nice to have even if you use it only once is a while.

- Bluetooth. In my opinion, this is the best method for getting your photos to a computer. If all you'll be doing is sending photos by email and MMS, then of course Bluetooth is irrelevant.

- Infrared. I prefer Bluetooth, but if your computer is already set up for infrared, it is a reasonable alternative.

- Cable connection. So yesterday! To be avoided unless you have no choice.

- Video clips. I never use them but you might love them. This is really a personal choice.

- Display quality. This is important. The brightness is a concern when taking pictures in bright light. The only way to really evaluate a display is to try the handset.

- Form factor. I prefer the plain handsets so there is no flipping or sliding required to take a photo—actions that might draw attention to what you are doing and spoil the moment.

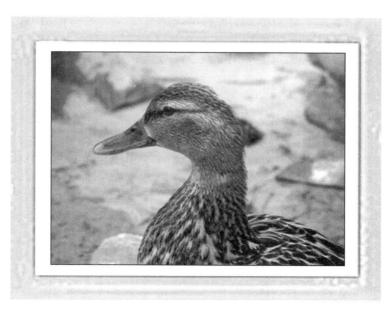

If it walks like a duck and quacks like a duck....

- Night mode. Camera phones usually do not do well in low-light situations. While a night mode setting does not solve this problem, it does improve matters, so I think it is a good feature to have.

Now that you have a good idea of what handset features you want, let's move on to the next step.

Step 3: Check the Reviews

Unfortunately, a camera phone's specs do not tell the whole story. Not all phones are created equal, even when they have the same technical specifications. Most important for our purposes, picture quality can vary. There are three main reasons for this:

- The lens. In many camera phones, the camera is added on almost as an afterthought. The manufacturer wants to keep the price down so they opt for a cheap, poor-quality lens.

- The sensor. The sensor is the device that converts light into the electrical signals that create the final digital image. Less-expensive sensors are less sensitive to light and therefore require a longer exposure time to capture the image. Just as with a slow shutter speed in a film camera, this can result in a blurred image if the subject moves or the photographer's hand is not rock-steady.

- JPEG compression. Camera phones save their images as JPEG files. This is a compressed format, and there's a trade-off between the amount of compression and the image quality. More compression produces smaller files but the files will be of poorer quality. To permit the camera phone to store more images, the manufacturer may design it to use too much compression, resulting in loss of image quality.

Unfortunately, there's no way to evaluate a handset's image quality without actually trying it. Since that's difficult to do yourself, you will have to rely on published reviews. You may not be able to find reviews of newly released handsets, but you should try. Table 2.2 lists some sources of reviews. Some of these are more generally cell phone oriented and do not focus specifically on camera phones, but they can still be useful sources of information.

Table 2.2 Sources for reviews of handsets.

www.textamerica.com/asp/reviews.asp

www.mobileburn.com/archive.jsp?ST=1&source=MENU

www.techworthy.com/Categories/Phones/index.htm

www.letstalk.com/reviews/reviewhome.htm

www.mobiledia.com

www.ratings.net/communications.cfm

cellphones.about.com

www.mobile-phones-review.co.uk/

Step 4: Compare Carriers and Service Plans

Selecting a carrier (service provider) and a service plan can be a thankless experience. I sometimes think that the providers try to make things as confusing as possible. But with the advice presented here and some perseverance, you should be able to find the plan that best suits your needs and is affordable.

Coverage

The most basic consideration when choosing a carrier is coverage, where you can and cannot use your phone. Coverage falls into three categories:

- In network. You are within your carrier's service area. No extra charges apply.
- Out of network, or roaming. You are outside your carrier's service area but can connect using another carrier's network. Extra charges usually apply.

- No coverage. You cannot use the phone at all.

Obviously you must select a service provider that has coverage where you are. The extent of coverage elsewhere that you need will depend on your travel habits. A service provider will have maps that show their coverage areas, both in network and roaming. Look at these maps closely because you don't want any surprises later on. Also be wary of providers who tell you that they don't currently have coverage in a specific area but they will soon. This might encourage you to sign up for a plan and regret it later because the service is too slow in coming.

And just because you are within a carrier's service area on a map does not mean you are home free. There are two more things to consider The first is the quality of coverage. Signals from cell phone towers are not the same strength everywhere, and just because you technically have coverage at a specific location does not mean it will be good coverage. A weak signal can mean static and poor quality on voice calls and slow transmission and dropped signals for data transfer. As you move from place to place you probably will not be able to avoid these weak signal areas, but you do want to make sure that the places you use your phone the most—typically your home and workplace—do not have this problem. You can test for this as I'll explain soon.

The second potential problem is the type of service in your area. Early cell phones used an analog technology that is suited for voice only and not data transfer. You'll still find analog coverage in some locations, almost always rural. The service providers are rapidly upgrading their networks to current technology and it is unlikely that you'll run into this problem, but it's worth knowing about just in case. If you travel in rural areas frequently and want to maximize coverage for voice usage, you can get a phone with dual digital/analog capability.

Testing for Quality of Coverage

How can you test for the quality of reception and transmission at your home and other important locations? The best way is to sign up for a service plan that offers a trial period. You can try out your handset, making calls and data transfers at various locations to see how good the coverage is. Make sure you also try the services as different times during the day. If you get lots of static and dropped calls, or if data transfer is very slow and prone to error, you may want to consider another service provider. All handsets have some visual indicator of how strong the network signal is—one bar for a weak signal, three for an average signal, five for a strong signal, for example. This can give you some objective measure of the quality of coverage in your area.

What if the service plan you want does not offer a trial period? In this case your best bet is to find a friend or coworker who uses the same service provider. They can help you out by seeing how well their phone works in locations that are important for you.

Moving in close was the best way to photograph this flower.

Service Plans

Choosing a service plan carefully can make a big difference, especially in your monthly bill. You have to choose a plan for both your voice needs and your data needs. Since most cell phone customers are interested only in voice use, this is the aspect of plans that is most widely advertised. Data capability, required for sending and receiving emails and MMS messages, is usually an add-on. Typically you will pay a flat monthly fee for a certain amount of transfer. For example, you might pay $4.95 a month for up to 4 megabytes. Then additional data transfer over and above this amount is billed on a per-kilobyte basis.

In the Field: Camera Phones—A Threat to National Security?

In May of 2004, the United States Secretary of Defense, Donald Rumsfeld, imposed a ban on all camera phones in U.S. Army installations in Iraq, according to a report in *The Business* newspaper. Stand-alone digital and video cameras are banned as well, and there are hints that the ban will be extended throughout the entire military in the near future. Do these devices pose a threat to the troops or the conduct of the war? Or, is the ban more the result of the recent prisoner abuse scandal that hit the front pages when photos taken at Abu Ghraib were made public—some of which were reportedly taken with a camera phone?

There's no doubt that some restrictions on photography in military settings are well justified. A complete ban such as this one, however, suggests to many people that someone is trying to hide something. Can anyone doubt that certain officials would have preferred if those prison photos were never taken?

Camera phones and other compact and easily concealable imaging devices have made it easy to take photos almost anywhere without detection. This can be a powerful tool for good, but it can also lead to unwarranted invasions of privacy. You may never find yourself in this situation, but if you do, you'll have to rely on your own sense of right and wrong to decide whether sneaking photos is justified.

As you shop for a service plan, here are some things to keep in mind. Paying attention can save you a lot of money!

- What's the duration of the plan? Most carriers encourage you to sign up for a 1- or 2-year plan. There can be advantages to this, such as lower monthly fees and discounts on a phone, but if you are unhappy with the service or want to change carriers for some other reason, you will pay a stiff penalty for ending your service early. Be sure to ask what the early termination fee is. My recommendation is that you sign up for the shortest plan you can get away with. The plans change often and rates keep coming down, especially for the special services like data transfer. A shorter plan might help you save money in the long run because after your plan expires, you can switch over to a plan that better fits your needs and is less expensive.

- Is the service plan ever extended automatically? Some contracts have a rather nasty detail in the fine print: If you make the slightest change to your plan, such as upgrading to a better handset or signing up for more voice minutes or more data transfer capacity, the contract is automatically extended for another one or two years from that date. Avoid plans like this!

- Is there a trial period? This is important because it gives you some time, typically 30 days, to try out the phone and service and see how it suits you. If it doesn't, you can return the phone and cancel the service, paying only for calls and data transfer you have used.

- Are you charged for incoming as well as outgoing calls/data? Some people are surprised that receiving MMS messages and other data transfers is charged against their data allocation just as sending is.

- Are there special rates for calling/messaging other people who use the same carrier as you? If multiple family members and friends are using the same plan and you are expecting to transfer photos to these family members and friends, you can save some money here.

One place to get information about each service provider's coverage area and service plans, as well as the handsets they offer, is the company websites. The addresses for the major cell phone service providers are listed in Table 2.3. There are many other sources of information and I'll cover them in the next section.

Table 2.3 Web addresses of cell phone service providers.

Alltel	www.alltel.com
AT&T Wireless*	www.attwireless.com
CellularOne	www.cellularone.com
Cingular	www.cingular.com
Liberty Wireless	www.libertywireless.com
Nextel	www.nextel.com
Sprint	www.sprint.com
T-Mobile	www.tmobile.com
Verizon	www.verizon.com

* Will probably be merged with Cingular by the time you read this.

Going Shopping

Once you have some idea of the features of the handset and service plan that you want, where do you go shopping? There is certainly no shortage of options! Let's take a look at them.

All of the service providers have storefront operations where you can see all the phones they offer, get details on service plans, shop for accessories, and get technical help. Staff members are usually very knowledgeable and willing to answer questions about handset features and service plan details. Of course these shops carry only their own products, so they are not good places to comparison shop for service plans.

Other kinds of stores, in particular office supply stores such as Staples and Office Depot, will carry several lines of service plans and phones. This is helpful when you want to comparison shop, but the employees may not have the expertise to answer all your questions.

You have numerous online shopping options as well. For example, Amazon.com has a phone shop that lets you browse and compare by phone manufacturer and by carrier (go to www.amazon.com and follow the Phones link). Other online outlets have tools to help you select a service and phone plan based on your needs, although these are aimed at voice users and not camera phone users. Each online outlet will offer a selection of carriers and phone manufacturers, but few if any offer all, so you still will have to do some hopping around to compare all the plans. While online shopping can offer a lot of choices and attractive prices, there are the usual disadvantages: you can't hold and try the phone, ask questions of a real person, or have somewhere to go for service and assistance if you later have technical problems.

Resources for Online Sales:

Here are some online stores that, in addition to selling phones and service plans, provide assistance with making your choices: www.wirefly.com, www.longdistanceworld.com/cellular-phones/, www.cellphonecarriers.com/, www.1st-in-cell-phones.com/, www.unbeatablecellphones.com/.

The slight blur in this photo of a dancer gives it a nice sense of movement.

Wrapping it Up

For an aspiring camera phone photographer, choosing a handset and service plan can be a daunting task. There are so many choices available. New handsets are introduced regularly and service plans change on what seems like a daily basis. For a camera phone you need to attend primarily to the resolution, display quality, picture capacity, and connectivity options. When considering service plans, pay attention to coverage, data transfer costs, and contract length.

This chapter has provided you with the information you need to make an informed decision. By understanding what features are available in handsets and service plans, and how they relate to your activities as a photographer, you can find your way through the thickets of information to find the camera phone setup that's best for you.

Chapter 3
Photography Basics for Camera Phone Users

Part of the appeal of camera phones is their spontaneity. Rather than fretting over lighting, posing, and the like, you just take the picture. Of course you need to take it before it gets away! Many of the best photos taken with camera phones have this wonderful fresh, vibrant quality. Even so, having some background in the basics of photography can be a benefit. That's the topic of this chapter.

Simple Is Good When It Comes to Phone Camera Photography

Sometimes complexity and too many options can just get in the way of creativity. For example, I have a top-of-the-line stand-alone digital camera that has an amazing assortment of buttons, jog wheels, switches, menus, and options. In over a year I doubt I have used more than a third of them. These options come in handy at times, to be sure, and I will immodestly say that I have created some terrific photos with that camera, but sometimes all those options just get in the way.

Camera phones by their very nature are very simple. When it comes to taking photos, they just don't have any options, or at most very few. You are freed from fussing with your camera and able to concentrate on the scene in front of you. I love this approach to photography, and more and more often my big digital camera stays home while my camera phone hangs from my belt.

Silhouettes can make simple yet effective photos.

Features You Can Use

Many camera phone users have previous experience with photography, either with film cameras or stand-along digital cameras. This background may serve you well as you explore your camera phone because some of the techniques for taking good photographs are the same no matter what kind of camera you are using. Yes, I know that I have been emphasizing the fact that camera phones are different from regular cameras, but even so, you do not want photos that are blurry or too dark (unless of course you are taking such pictures intentionally for the effect).

Some aspects of your past photographic experience will be irrelevant when you are using a camera phone. This is because camera phones are so simple and most of the adjustments and settings you need to think about with a traditional camera just don't come into play.

Perhaps you have no previous experience taking photos. That's just fine because you'll bring a fresh new eye to your photography and because the basics of taking pictures are so simple you'll be able to get going in no time.

Focus

Or, more accurately, what focus? Camera phones just don't have any focusing adjustment and they don't need them. When you take a picture with a regular camera, you focus on the subject (or the camera focuses automatically). In the

resulting photo, the subject is in focus as are objects at some distance in front of and behind the subject. This range of distances where objects are in focus is called *depth of focus* (or sometimes *depth of field*). This concept is illustrated in Figure 3.1.

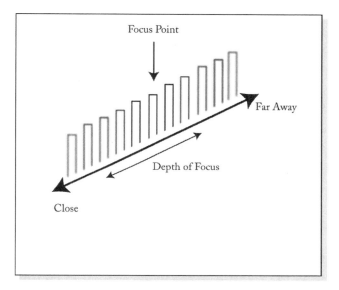

Figure 3.1
Every photograph has a depth of focus.

The extent of the depth of focus depends on several factors, the most important of which is the aperture of the lens (the hole through which the light enters the camera). Small apertures give a large depth of field, and large apertures give a small depth of field.

Camera phones all have extremely small apertures, which results in a very large depth of focus. In fact, the depth of focus for a camera phone extends from pretty close in front of the camera—perhaps a foot or two—to infinity. This means that everything in your picture will be in focus without you having to worry about it. Be happy, don't worry!

Of course you may not want everything to be in focus. Some terrific photographs have the foreground subject, such as a person, in sharp focus while the background is out of focus and blurry. An example of this technique is shown in Figure 3.2, which was taken with a stand-alone digital camera. When you are using a camera phone, you simply cannot do this because the background will always be

Figure 3.2 With a traditional camera, you can use a large aperture to get the subject in focus while blurring the background.

in focus. If I had taken the photo in Figure 3.3 with a camera phone, the trees in the background would be in sharp focus.

If you like to take photos close up, you may want to figure out just how close you can get to your subject and still stay in focus. It's easy to do this by putting some objects on a table at specific distances from the edge—one foot, one and a half feet, two feet, and so on. Take a photo with the camera phone at the edge of the table and then look at the resulting photo—preferably enlarged on your computer screen—to see what's in focus and what's not.

Tip: Focus and Motion Blur
Movement of the camera or the subject can sometimes result in a blurry photo that looks like it is out of focus. With a camera phone, any blur in the photo is almost surely caused by motion and not by focus problems, with the one exception being objects that are really close to the camera.

Exposure

To take a decent photograph, one that is not too light or too dark, the camera must allow the proper amount of light to hit the film (in traditional cameras) or the electronic sensor (in digital cameras, including camera phones). Since some scenes are brighter than others—think of outdoors on a sunny day versus indoors

at night—the camera needs some way to control the amount of light. This is done in two ways:

- By controlling the amount of light that enters the camera. This is done by changing the size of the hole in the lens, or aperture, through which light enters.
- By controlling the length of time that light hits the film or sensor. In traditional cameras, this is done with a mechanical shutter; in digital cameras it is done by electronically turning the sensor on and off.

Camera phones do not have adjustable apertures, so they are limited to using the second method for exposure adjustments.

In most modern cameras the exposure is automatic, although some cameras offer manual adjustments for special situations such as nighttime or backlighting. Camera phones are, in my experience, essentially completely automatic, so there's really nothing you can do about exposure. The only exception I have seen is a setting called *Night Mode* on my camera that is intended for taking photographs at night. Basically, you can just forget about exposure; the camera phone is going to do what it thinks is right.

The fact that camera phones have automatic exposure does not mean that they can take photos under any lighting conditions. They are at their best in bright light and don't do so well when you have dim lighting conditions. It's impossible

I was going to use those cucumbers in a salad!

to give any firm guidelines because different models of handsets are not the same in their ability to handle dim lighting conditions. All I can tell you is to try out your camera phone in a variety of lighting conditions and see how the photos turn out. You'll soon learn when you can take a photo and when you cannot.

Working with Backlighting and Flash

Technically, the term *backlighting* refers to situations in which the main source of light is coming from behind a subject. More generally it is used when the subject is not as bright as the background, such as when you are taking a photo of a person standing in shade under a tree with a sunlit field in the background. The camera "sees" the entire scene and adjusts the exposure accordingly, usually resulting in a properly exposed background and an underexposed—too dark—subject. When a camera has a backlighting setting, it works by increasing the exposure to make the subject exposure correct. Unfortunately, I have yet to see a camera phone with this option.

A few camera phone models have a built-in flash that can help you to take a photo in dark situations. It's not the same kind of flash you find on stand-alone cameras; it's more of a small flashlight that comes on briefly when the photo is being taken. In my experience they are pretty feeble and do not help unless the subject is fairly close to the camera. They also speed battery drain.

Blur and Motion Effects

In theory, a camera captures an instant in time. In reality, it is not quite an instant but is some small fraction of a second. If the subject or the camera moves during this brief period, the result will be a blurry photo. It's important for photographers to keep this in mind, not only for avoiding blur but also for using it as a creative tool.

In my experience, the most common cause of blur is camera movement. Even a small camera jiggle can blur your whole photograph, particularly in low light conditions when the exposure time is longer. Hold the handset steady and do not suddenly mash the shutter button because this is almost sure to jiggle the camera. In low-light conditions when the change of motion blur is highest, you can steady the handset by leaning against a wall or lamp post or placing it on a flat surface.

Is There a Doctor on the Camera Phone?

Camera phones are not just for fun anymore. Physicians down under in Syndey, Australia's Nepean Hospital completed a two month trial in which they used their mobile cameras to take photos of hand injuries, sometimes including photos of X-rays. Dr. Tai Khoa Lam, who headed the study, said that there were 27 cases in the emergency room during this period, including injuries such as fractures, burns, and loss of fingertips.

The images were then sent to off-site specialists who were consulting on the case. Usually, when an emergency room doctor consults a specialist, it is by phone, and the specialist has to rely on a verbal description of the injury. By receiving actual images of the injury on their phone, the consultants were able to be more confident in their treatment advice. Consultants are often very busy and hard to contact, and the procedure for getting photos to them through normal channels can be very slow—too slow to be much use in many cases.

The relatively low resolution of camera phone photos might seem to preclude them from being useful in these settings, but this was not found to be the case. Ease of use, speed of transmission, and low cost were all positive factors that helped make the experiment a success.

Dr. Lam's findings were published in a recent journal of *ANZ Journal of Surgery* and were also reported on

ABC Science Online. This is not the first time that camera phone images have been used n a medical setting. Physicians in Finland and Japan have used camera phones to send images of CT scans and X-rays, and doctors in the United Kingdom have used the devices for evaluation of burn patients.

Subject motion is something you usually cannot control. A waterfall, for instance, is always in motion and there's nothing you can do—it's almost sure to be a bit blurred in the final photo. In many cases, such as moving water, some blur is okay because it imparts a sense of motion to the photograph. In other cases, the subject is moving against the background, such as a soccer player running down the field or a race car on the track. To prevent subject blur, you can *pan*, moving the camera to follow the subject while taking the picture. The background may be blurred but the subject will be sharp, which is another way to impart a sense of movement.

Camera motion can be used to obtain some interesting effects. Because blur suggests motion, a blurred subject can impart a sense of dynamics to a photograph. A scene

with bright lights, such as neon signs at night, can make for an interesting photo when the camera is moved. Figure 3.3 shows an example of this, with the static scene on the left and a blurred version created with camera motion on the right.

Figure 3.3
A scene of bright lights at night can make a more interesting photo when the camera is intentionally moved during the exposure.

Camera Phone Photography Dos and Don'ts

The remainder of this chapter explores some tips for getting the best possible photos from your camera phone. Some of these relate to specific handset features that are not present on all camera phones.

I encourage you to take these dos and don'ts as suggestions rather than as rules. As you gain experience you'll develop a feel for when to follow them and when to break them. Your creativity is the most important thing, and you should never let a set of rules constrain you. Even so, it's good to know these and follow them when appropriate.

When in Doubt, Experiment!

Remember, it doesn't cost you a single cent to take a photo with your camera phone. You can experiment to your heart's content, and I strongly encourage you to do so. Try out all of your handset's settings. There are few if any photo-related settings on most camera phones, but you should see what effects they have, not just read the description in the manual. Try moving the camera while taking a picture, getting in too close, tilting the camera. There's no good way to tell what will result in an interesting photo without actually trying it.

Always be on the lookout for the unusual and unexpected.

Move In Close

This is probably the most important piece of advice I can give you. When you are taking a picture of something, whether it be a person, an animal, a sign, a tree, or whatever, you don't want your subject to be a small speck in the middle of the photo. It's much better if the subject fills up most of the frame, and in many situations the only way to do this is to move closer. Camera phones do not offer telephoto or zoom lenses; your feet are the only zoom!

Figure 3.4 shows a good example. The first photo was taken while I was standing about 10 feet from the subject (my daughter Claire). It's not bad, really, but I knew it could be improved. For the next photo I moved in to a distance of about 5 feet. Much better!

Figure 3.4
The photo on the left is okay, but moving in closer results in a much better image, as shown on the right.

The good thing about camera phones is that you can move in without being too obnoxious. Camera phones seem like toys to many people and thus your subjects don't seem to get as intimidated if you get in close. In many cases, you can get close-ups without your subject even realizing that you are taking a picture. With a little practice, you can take photos without even looking at the view screen. I've gotten a lot of interesting photos by holding the camera phone in my hand at waist level and snapping away.

How to Sneak Photographs

Some of the best people photographs are candid ones, taken when the subject does not know they are being photographed. If you hold your camera phone up and point it at someone, however, they are likely to catch on to what you are doing. To be discrete, you should practice taking photos without looking at the camera's viewscreen. With a little practice, you can aim accurately with the camera phone without giving away that you are taking a photo. It can also help to face away from the subject, aiming the camera to the right or left to get the photo. When photographing strangers, however, you should be aware of privacy concerns (covered in Chapter 9).

You should also be careful about taking your camera phone into places where they are not allowed. Some establishments really dislike having phones and camera phones on their premises. They might even do something nasty to retaliate if you violate their policies. I was on a boat trip once and as the boat was leaving the harbor, the captain came out to the main part of the deck to give a talk about the safety features of the boat. This is something required by the Coast Guard. Before he started his talk he asked everyone to put away their phones and their camera phones. He really wanted us to pay attention. There was a lady on the boat who kept talking away on her phone and then she tried to snap a photo and send it to her friends. The captain kept asking her to put the phone away and pay attention. But she ignored him and finally he walked over to her, grabbed the phone, and threw it into the ocean. I think every passenger on the boat wanted to cheer the captain on at that point! Sneaking in your camera to take a picture you are not supposed to can be fun but it's not worth it if you lose your camera.

Watch the Lighting

Camera phones are not well suited for taking photos in dim light. If you have experimented with your camera phone, you will know what I mean. The best

photos are usually taken outdoors during the day. Bright indoor lighting usually works pretty well too. Of course, you often have no control over the lighting. You might be able to ask your subject to move, or move it yourself if it is an object. Indoors you may be able to open a window shade or move a lamp to a better position.

Sometimes you want to take a photo indoors but cannot adjust the lighting, such as when you are photographing a product in a store. To make the best of this situation, avoid throwing your own shadow on the subject. When photographing through glass, watch for reflections. It is usually better to take the photo at an angle to the glass rather than straight on.

Use Your Zoom—Not!

At present, no camera phone offers a true optical zoom. The "zoom" feature that is found on some handsets is actually a digital zoom that works by taking the regular size photograph and then enlarging the central part. The result is unavoidable loss of detail. If you do need to zoom in, you are much better off moving closer to your subject. If that's not possible, take the photo normally and then transfer the photo to your computer and use a graphics program to zoom. You'll learn how to do this in Chapter 4.

There is talk of incorporating true optical zoom with some upcoming handsets, and these may be available by now. An optical zoom would let you zoom in without loss of quality.

Movement and Blurry Photos

With their relatively low pixel resolution, camera phone photos are hardly champions of high detail. To make the most of what you've got, you surely don't want to add any additional blur to a photo. As I have mentioned earlier, the chief culprit when it comes to blur is camera movement, so you need to hold the handset steady when taking a photo. Also, don't mash the shutter button suddenly; this can jiggle the camera just as the photo is being taken. Rather, *squeeze* the button with a smooth pressure that does not shake the handset.

If you are trying to take a photo of a moving subject, there is probably nothing you can do about it, but a little bit of blur in this case can add a sense of movement to the photo, so it's not always a bad thing.

This restaurant window displays a pictorial menu.

Pay Attention to Composition

Composition refers to the way the elements in a photo are arranged. It refers not only to the main subject but to all elements, including the background. Perhaps the most notorious example of bad composition is a photo in which a tree or telephone pole is in the background and seems to be growing out of a person's head. This sort of mistake is pretty easy to spot and avoid, unless you are looking for a humorous effect, of course!

Most elements of composition are in the eye of the photographer. The only "rule" I can think of is that it is usually better not to have the subject perfectly centered in the photo, but as with all rules, there are many exceptions to this one. In other words, a good composition is one that results in an effective photograph, and you, the photographer, must be the ultimate judge of that.

How can you control composition? Sometimes you can literally rearrange the elements of the scene you are photographing. When taking a posed portrait, for

example, you can ask the subject to move. At other times you are pretty much limited to the following techniques:

- Move closer or farther away to make the subject larger or smaller and to exclude or include elements at the edges of the frame (see Figure 3.5).

Figure 3.5
Move in to make the subject larger and exclude unneeded background.

- Move left or right to change the angle of view. This kind of movement also changes the relationship between foreground and background objects and can help you to remove distracting and unnecessary background elements from the photo.

- Turn the camera from vertical to horizontal or *vice versa* to suit the subject (see Figure 3.6).

Figure 3.6
Rotate the camera phone to a vertical or horizontal position to best suit the subject.

You are not limited to moving left or right to change the angle of a photograph; you can also move up by holding the camera over your head or down by holding the camera at knee level or lower. Such unconventional viewpoints can result in very effective photographs. For example, look at Figure 3.7. The first photo was taken from the standard eye-level point of view, while the second was taken from ground level. I think you'll agree that the second photo is more unusual and eye-catching.

Figure 3.7
Shooting from a high or, as in this example, low point of view can make an ordinary subject more interesting.

By being aware of composition and how it affects your photographs, you can make a marked difference in the quality of your images.

Play Tic-Tac-Toe with Your Camera

This kid's game can provide a useful compositional tool. When you are framing your photograph in the camera phone's viewscreen, imagine a tic-tac-toe grid superimposed over the image. Then, place the main subject at one of the four line crossings. This simple guideline often results in very pleasing compositions, much better than if the subject was centered. Figure 3.8 shows an example. The main subject, the person's face, was placed at the upper-left line crossing.

Figure 3.8
Using a grid to decide on subject placement.

Use the Highest Resolution and Quality

Camera phones often offer different settings for resolution and quality. What do these mean?

Resolution is, of course, the number of pixels in the final photograph. The maximum possible resolution is set by the camera's hardware, but sometimes you'll have the option to use a lower resolution. For example, my handset has a maximum resolution of 288x352 pixels and offers a low-resolution setting of 120x160 pixels. The general rule is to always use the highest resolution available. The higher resolution is relatively low anyway when compared with stand-alone digital cameras, and using a lower resolution will result in too much lost detail.

The only advantage of the lower resolution setting is that the photos take up less memory space, which means that you can store more of them on your handset. When you are unable to send photos—perhaps you are in a location with no wireless coverage and you need to take a bunch of photos—you may want to use the low-resolution option. I cannot think of any other reason to use it, however.

Some handsets also offer a quality setting—for example, low, medium, and high. This refers to the way the photographic image is stored in the file. All camera phones use a file format known as JPEG. JPEG is a lossy compressed format. The software in your handset processes the raw image data so that the resulting file is smaller than if the raw image data were stored in its native form. The term *lossy* means that some of the original information is lost in the compression process. The JPEG standard was developed specifically for photographic images and is

very good at retaining the information that is required for a photographic image to look good.

Here's where the quality settings come into play. JPEG offers different levels of compression. You can use a lower level of compression, which results in a better quality image and a larger file, or a greater level of compression, which gives a lower quality image and a smaller file. Note that JPEG compression does not affect the resolution of the image. It will remain the same regardless of which quality setting you select.

Selecting a file quality level is a trade-off between image quality and file size. If your handset offers this option, I recommend making some tests at the different quality settings to see just how much of a difference it makes. Unless you need to maximize picture storage capacity, however, there's no reason to ever use any but the highest quality setting.

Helpful Photography Resources

If you are interested in learning more about photography, you'll find a wide range of material available in books and on the Web. If you prefer a book, *John Hedgecoe's Photography Basics* by John Hedgecoe is one good place to start; another is *How to Take Good Pictures* by Eastman Kodak. On the Web, a couple of sites that I like are **www.palmettobayinc.com/photo_tutorials.html** and **www.silverlight.co.uk/tutorials/toc.html**.

Avoid Backlight

The term *backlight* refers to any situation in which the main source of light is behind the subject. For example, you might be taking a picture of a group of people outdoors with the sun behind them; this is *backlighting*. You should try to avoid it whenever you can. Let's look at why.

If the main source of light, whether it be the sun, a window, or an electric light, is behind the subject, then unavoidably the part of the subject that is facing the camera is in shadow. The camera sees the bright background as well as the shadowed subject and adjusts exposure accordingly, with the result that the subject comes out too dark with poor detail. With front lighting, however, the subject is well illuminated and will show up much better in the photograph. This is illustrated in Figure 3.9.

Of course there are times when backlighting can give you interesting results. Severe backlighting, for example, gives a silhouette effect. Sometimes you simply

Figure 3.9
With backlighting (left) the basket is underexposed and does not show up well in the photo. Front lighting (right) gives much better results.

can't avoid it. When you come across Elvis Presley at the mall, you are not going to ask him to move because the light is behind him! For most photos, however, and when possible, backlighting is best avoided.

Wrapping It Up

Photography is an interesting combination of technology and aesthetics. As a photographer you should feel free to take any kind of photo that interests you. There's no reason to feel constrained by what the "experts" say. Even so, there are some widely accepted guidelines for picture taking that every camera phone user should know about. You won't always follow them, of course, but in many photographic situations they are the easiest way to get the photograph you want. You can be creative within these guidelines or by breaking them, and that's half the fun of camera phone photography.

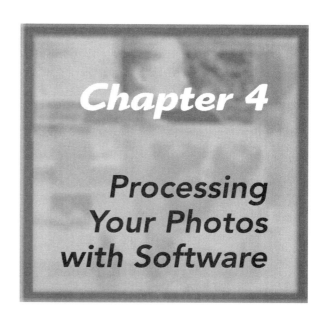

Chapter 4

Processing Your Photos with Software

Many users of stand-alone digital cameras like to perform a lot of manipulation on their images after they are taken. In contrast, most camera phone photos are used just as they are. This follows a sort of a *what you see is what you get* approach and is in keeping with the general camera phone culture of spontaneity and freedom. Of course, sometimes you simply can't manipulate a photo, say if you are sending it directly from your handset to an email recipient or a moblog. Once you transfer a photo to your computer, however, a world of possibilities opens up to you. This chapter explains some of the cool things you can do with the digital photos you take with your camera phone.

Manipulating Your Photos

The most important software tool for manipulating digital photographs, whether from a camera phone or any other source, is a general purpose image editing and manipulation program. There are quite a few of these on the market, ranging from the free (or almost free) to the rather expensive. Some programs are available for both the PC and the Macintosh, others for only one or the other. I'll give a brief rundown here, although I certainly cannot mention all of the available programs.

At the high end of the spectrum is Adobe Photoshop, generally considered to be the industry standard (whatever *that* means) for image editing. It has way more power and features than anyone but the most advanced graphic artist will need, so don't run out and buy a copy just because you think you should. But if you plan on

Oom-pa-pa.

doing a lot of sophisticated photo manipulation work, and your budget allows, you might look into getting a copy of this software.

Corel Painter is another high-end product having much more power than you'll likely ever need. Again, you probably don't need to buy it, but it's fine to use if you already have it.

Paint Shop Pro and Photoshop Elements are two popular programs in the middle of the spectrum. They are reasonably priced and have all the power and features that 99.5 percent of digital photographers will ever need.

The low-end programs are often free. Typically, they are included as a bonus when you buy a scanner or color printer. I have even seen them offered as part of a camera phone purchase. These programs vary widely in their capabilities, but they usually have the dozen or so tools you will need most often to manipulate your camera phone photos.

Tip: Using Microsoft Photo Editor
If you have a recent version of Microsoft Office, you probably have the Microsoft Photo Editor installed. It's a very basic program, but using it can be a good way to get started with image manipulation. By default, you'll find this program on the Windows Start menu under Microsoft Office Tools.

Table 4.1 provides some summary information about the programs that I have mentioned as well as some others. You should be aware that most of these programs provide capabilities beyond image editing, such as creation of online albums, photo organization and filing, and special effects. In addition, these programs are sometimes available at a lower price through discount retailers.

Table 4.1 Image manipulation programs for PCs and Macs.

Program	Web site	PC/Mac	List price	Comments
Photoshop	www.adobe.com/products/photoshop/main.html	Both	$649.00	High end, industry standard. More features than 99% of photographers need.
Paint Shop Pro	www.jasc.com/products/paintshoppro/	PC	$99.00	Full feature set at a reasonable price.
Photoshop Elements	www.adobe.com/products/photoshopel/main.html	Both	$99.00	Most of the tools offered by Photoshop but at a much lower price.
Corel Painter	www.corel.com	Both	$299.00	Full-featured, powerful. More tools than most photographers will ever use.
Microsoft Digital Image Suite	www.microsoft.com	PC	$129.00	Includes tools for sharing and organizing photos.
Roxio Photosuite	www.roxio.com	PC	$29.95	Inexpensive but somewhat limited. Fine for most camera phone users.

More Resources:

You'll find a comprehensive list of graphics software packages for PCs and Macs at **http://graphicssoft.about.com**.

Here's looking at you, kid.

Unfortunately, this plethora of software choices puts me in a bit of a pickle. I want to show you how to use image editing software to manipulate your photos, but which software package? I can't cover them all, so I have had to make a compromise as follows:

- I'll show you how to use Paint Shop Pro version 8, and the screen shots I'll include will show you how things look in this program. I made this choice because Paint Shop Pro is probably the most widely used mid-level image editing software.
- I'll include sidebars to provide brief instructions for carrying out the same actions with Photoshop version 7. Instructions for other versions of the program will be similar if not identical

If you don't use one of these programs, you'll have to figure out your program's commands for carrying out the actions I will be describing. Don't worry; it shouldn't be too difficult because most graphics programs use the same terminology.

Resource for Paint Shop Pro Trial Version:

You can download a trial version of Paint Shop Pro from **www.jasc.com**. The trial version has all the features of the regular version but will function on your system for only 60 days. After this period, you are required to purchase the product.

This is what I call a great view! Without my camera phone I would have missed this shot.

File Formats

When a digital photograph or other image is stored on your hard disk, it is saved in one of several different formats. It is a good idea to understand the differences between these formats and when you should use each one.

All camera phone photographs are created in JPEG format, as indicated by the files having the .jpg extension. This file format was developed specifically for digital photographs. It is a *compressed* format, meaning that the raw data in the photograph is processed and redundant or unneeded information is removed, resulting in a smaller file size. It is also a *lossy* format because, during the compression process, some of the information in the photo is lost. Because it was designed specifically for photos, however, the compression process is very good at keeping information necessary to preserve the visual appearance of the photo and discarding information that is not important.

Another feature of the JPEG format is that the compression is variable. When you use a program to save an image in JPEG format, you can specify the amount of compression. More compression gives smaller files and poorer image quality. Unless you have a specific reason to create smaller files, I recommend always using the least compression to preserve the image quality as much as possible.

Unfortunately, JPEG's compression can cause a problem in some situations. When you open a JPEG file in a graphics program, it is decompressed in order to be

displayed on the screen. When you save it, it is compressed again with the attendant loss, however minor, of information. If you are working on a file a lot and open and save it several times, the effects of repeated recompression will add up and the image will be degraded. Fortunately this problem can easily be avoided by saving the image in a different file format, one that does not degrade the image. Then you can open and save it as many times as needed without any changes.

But which file format should you use? The best choice is your graphics software's own native file format. Paint Shop Pro's native format is called Paint Shop Pro Image and the files are saved with the .pspimage or .psp extension. Photoshop has the Photoshop Document format, which uses the .psd extension. Here are the steps required to save a JPEG image in a graphics program's native file format:

1. Use the File|Open command to open the JPEG file of interest.
2. Select the File|Save As command.
3. Click the Save as Type box and select the desired format from the list, in this case Paint Shop Pro Image.
4. If desired, change the file name. If you do not do this, the file will be saved with the old name and new extension.
5. Click the Save button.

What is he laughing at?

Now the image will exist as a PSP file, which you should use for any further manipulations. The original JPEG file will remain on your disk as well. After you have manipulated the image, you may want to convert it back to JPEG format for submission to a moblog or other Web uses. All this requires is to use the File|Save As command again, this time selecting JPEG as the format.

Tip: Saving an Image in Photoshop's Native Format
The steps for saving a JPEG image in Photoshop format are essentially the same as were given for Paint Shop Pro. The only difference is that in step 3 you will select Photoshop (.PSD, *.PDD) from the Format list.*

What about other file formats? You may want to use these when JPEG or a program's native format are not appropriate. For example, you may want to send an uncompressed image to someone who does not have your graphics program. Or, if you are using a low-end graphics program, it may not have its own native format and you'll have to use one of the standard file formats. Table 4.2 describes some other common image file formats.

Table 4.2 Common standard image file formats.

Name	Extension	Description
Windows bitmap	.bmp	A standard Windows format that is suitable for photos.
Tagged image file format	.tiff or .tif	A widely used format with many variants, some of which offer compression. Suitable for photos.
Graphics Interchange Format	.gif	Sometimes called the CompuServe format. It is limited to 256 colors and is not suitable for photographs.
Portable Network Graphics	.png	Designed as a replacement for JPEG, this format offers loss-free compression. It has not yet gained widespread acceptance.

Understanding Resolution and Image Size

A digital photo has a pixel size; it is X pixels wide and Y pixels tall. It does not have a physical size in inches or centimeters—after all, it is just a series of bytes stored on your computer so how can it have a physical size? However, software

Caught from behind!

that works with digital images usually assigns a physical size to each digital photograph. If you are going to use software to work with your images, it is important that you understand what this means.

Suppose that you load a photo from your camera phone onto your computer and display it on the screen. Each pixel in the image will be mapped to one pixel on your monitor's screen. Most monitors are constructed so that each inch, vertical or horizontal, contains about 96 pixels. The monitor's resolution, in other words, is 96 pixels per inch. Let's see how this relates to displaying the photo. Suppose the photo is 352 pixels wide. Perform the following division:

352 / 96 = 3.66

In other words, on screen the photo will be displayed 3.66 inches wide. The display height, assuming the photo has 288 pixels in the Y direction, will be 288 / 96, or 3.0 inches.

It's important for you to understand that this display size of 3.66 x 3 inches is not a property of the photo but of the monitor. If, for example, you had an older monitor with a resolution of 72 pixels per inch, the same photo would display at a size of 4.88 x 4 inches.

When you open a digital photo in a graphics program, the program will assign a resolution—a pixels per inch value—to the photo. Now, the photo has three related measurements:

- The actual number of pixels in the X (horizontal) and Y (vertical) directions
- The assigned resolution in pixels/inch
- The physical size as calculated from the first two values

The point of all this is to realize that these three values are interrelated; you cannot change one of them without changing one or both of the others. You'll see why this is important in the next section.

Changing Image Size

Once you have loaded your photo into a graphics program, you may want to change its size. The usual reason for doing this is to print it at a larger or smaller size. By default, most graphics programs print photos at their actual size (as explained in the previous section). You might also want to change the size of an image (make it smaller, typically) so that the image can still have a good resolution but be quicker to send to someone by email. This could be useful especially if you have to use a dial-up connection to transfer one or more of your photos. This is usually not a concern with camera phone photos because they are relatively small to begin with.

Gee, George, that's the tenth photo of your ear this month!

Tip: Changing the Viewing Size
You can change the size in which a photo is displayed on screen with Paint Shop Pro by pressing + or – on the numeric keypad. For Photoshop, you hold down the Ctrl and Alt keys while pressing + or –. Both programs display, in the image's title bar, the display size as a percent of the actual image size. This information is helpful so that you can keep track of how the size of your image has been changed.

As we have discussed, image size, pixel size, and resolution are linked. This means that to change a photo's size you must do one of the following:

- Change its pixel size, leaving the resolution unchanged.
- Change its resolution, leaving the pixel size unchanged.
- Change both its pixels size and resolution.

There's rarely any reason to use the third alternative, so I will limit discussion to the first two. Since camera phone photos are small to begin with, I'll deal only with enlarging them.

Tip: Resize while Printing
If you want a larger print, you do not have to resize the photo to print it at a different size. You can specify an enlargement factor while printing. I'll show you how to do this in Chapter 5.

Resizing by Resampling

Changing the pixel size of a photo is called *resampling*. Suppose you want to change a photo that is 200x100 pixels so it has 300x150 pixels. Where do those extra pixels come from? The answer is that the software makes them up, calculating them based on existing pixels. For example, if the original photo contains a dark blue pixel next to a light blue pixel, the software would insert a medium blue pixel between them during resampling. The process is really a bit more complex, but this gives you the general idea.

Why resample at all? You rarely need to make a camera phone photo smaller because they are small to begin with. Even so, you may want to shrink a camera phone photo to make a thumbnail image or to use in a collage. A photo is usually made larger to improve printing. Because a camera phone photo has relatively few pixels compared to photos from stand-alone digital cameras, it may not print well

at any but the smaller sizes. By resampling to give the image more pixels you can usually improve the result. This will be covered in more detail in Chapter 5.

To resample a photo, open the photo in Paint Shop Pro and then select the Image|Resize menu option to display the Resize dialog box, shown in Figure 4.1. Note how the photo's original dimensions are listed at the top of the dialog box. Make sure the Resample option is selected. Then you have two choices:

Figure 4.1
The Resize dialog box.

- To specify the new size as a percent of the original, enter the desired value in either the Width or Height box in the Pixel Dimensions part of the dialog box. If you change the width, the height automatically changes, and vice versa, to maintain the same proportions.

- To specify the new size in inches, enter the desired value in either the Width or Height box in the Print Size part of the dialog box.

These two choices produce exactly the same results; they differ only in how you specify the new image size. When the desired value has been entered, click the OK button to complete the operation.

Tip: Undoing a Mistake
Essentially anything you do in Paint Shop Pro or Photoshop can be reversed using the Undo command. It's the same in both programs: select the Edit|Undo menu command or press Ctrl+Z. It's best to

use Undo as soon as possible after making the mistake because there is a limit to the number of actions that can be undone. If you undo an action but then decide you really want to keep your change, you can use the Redo command. In other words, Undo reverses the last image editing action you did, while Redo redoes the last Undo.

Resizing without Resampling

You can also resize a photo without resampling it. In this case, the number of pixels in the image remains unchanged but you can change the resolution (pixels per inch), which has the effect of changing the size in inches.

The procedure is similar to the one I just presented for resampling. After selecting the Image|Resize menu option to display the Resize dialog box, click the Resample option to turn it off. The dialog box will now look as it does in Figure 4.2. Note that the Pixel Dimensions part of the box is now grayed out; you cannot make any changes here. You will change the width, height, or resolution. These three values are linked to one another; changing any one of them changes the other two.

Once the image size is set as desired, click OK to finish.

Figure 4.2
The Resize dialog box when the Resample option is turned off.

Tip: Resampling an Image in Photoshop
To resample an image in Photoshop, select the Image|Image Size menu option to display the Image Size dialog box. Select the Resample option and then enter the new width or height in the specified boxes. You must select inches or percent from the drop-down lists. To resize without resampling, follow the same steps but turn the Resample option off.

To Resample or Not—That Is the Question

Now that I have explained two different ways to enlarge a photo, the obvious question is how you decide which one to use. I'm afraid that I'm going to duck this one, simply because there is no easy way to decide without actually trying both and seeing which one works best for you in a specific situation. In my experience, the differences are usually fairly small—usually but not always.

The most important thing to realize is that there are limits to enlarging a small camera phone picture, or any small digital photograph for that matter. The amount of image information is limited by the number of pixels stored in the image, and nothing you do later can increase this information. The best you can do with an enlargement is to fake it, creating a larger photo from the same information and hoping that it looks good. In my experience, you can enlarge an image by perhaps 20 to 25 percent with decent results in most cases, and up to 100% in some cases, but beyond that things start to go south, as they say, with an unavoidable loss of detail and sharpness.

Automatic Picture Enhancement

With millions of camera phone photos whizzing through the wireless networks each day, someone had the bright idea of intercepting those photos and improving them before sending them on to their final destination. LightSurf Technologies (**www.lightsurf.com**) has put this idea into practice with their Power Media Processor (PMP) service.

PMP consists of software that runs on your service provider's server computers. As a camera phone image moves through the system on its way from your handset to another phone user (as an MMS message), a printing service, or a moblog, the software examines the photos and corrects flaws such as blurriness and distortion. This all happens in real time so there is essentially no delay.

PMP is able to identify the device where the photo originated. In some cases it will be able to identify the destination as well. Based on this information, the software can customize the process. For example, if the photo is part of an MMS message it will be optimized for display on a camera phone screen, however if it is bound for a printing service it will be optimized for printing. PMNP works on video clips as well as still photographs.

At present the PMP system has not been adopted by any cell phone service providers, but if the service seems interesting you should ask about it when shopping for a service plan

But wait, is that necessarily a bad thing? Traditional photography usually holds that sharpness and detail are always good, but then again this is *not* traditional photography! Camera phone users are often rule-breakers, rebels, and do not care about or, in most cases, even know about what their photos are "supposed" to look like. Low detail? So what. Blurry? Cool! Who cares as long as *you* like the image. While a traditional photographer might turn up their nose, remember that you are creating photos for your own use and enjoyment. My thought is that the limitations of how digital photos are taken, stored, and manipulated will bring about changes in how we view the art of photography.

Keep the Original!

When making any changes to an image, it is a good idea to work on a copy and keep the original. This way, if you make a mistake, you can always go back to the original photo and start over. To make a copy of an image in either Paint Shop Pro or Photoshop, follow these steps:

1. Open the original image.
2. Select File|Save As.
3. Enter a new name for the copy.
4. Click Save.

Cropping

Cropping means to remove some sections of a photo near the edges. Basically, you select a rectangular region of the photo to keep and everything outside that region is discarded. You can use cropping to alter the composition of a photo and change

its visual focus. To be honest, cropping is not used too often with camera phone photos because they are small enough to begin with and cropping just makes them smaller! But it's a useful tool to know about just in case. To crop an image, here are the steps to follow:

1. Select the Crop tool from the Paint Shop Pro toolbox, as shown in Figure 4.3.

2. Position the mouse pointer at one corner of the desired crop area. Don't worry about being exact because you can make adjustments later.

3. Push and hold the mouse button and drag to the opposite corner of the crop area; then release the mouse button. You'll see a rectangle expand to outline the selected area.

4. To complete the crop, double-click anywhere in the image. To cancel, right-click anywhere in the image.

Figure 4.3
The Crop tool.

If you draw the cropping rectangle and it isn't exactly where you want it, you can adjust it as needed. You can see that the rectangle has small boxes at its corners and along its edges; these are called *handles* and are shown in Figure 4.4. Point at any of the handles, press and hold the mouse button, and drag the rectangle to a new size/shape. Then, double-click to complete the crop.

Tip: Cropping in Photoshop
Cropping a photo in Photoshop is essentially the same as in Paint Shop Pro. In fact, the Crop tool even has the same icon. The only difference is that, after getting the crop box to where you want it, you right-click in the image and then select Crop to complete the operation or Cancel to abort.

Figure 4.4
The cropping box displays handles that let you adjust its size and shape.

Color Balance

Any image editing program will let you adjust the color balance of a photograph. You can use color adjustment to fix a photo where the balance is off, such as a situation where fluorescent light made your boyfriend's face a pale green. You can also use color adjustments for creative purposes, changing "normal" colors to something quite different. Before I explain the how-to, a little background is in order.

All colors are made up of some mixture of three *primary colors*. Many people remember the primary colors from high school art class as red, blue, and yellow. That's true, but these are the so-called *subtractive* primaries that are relevant when you are mixing pigments such as paint or ink. A computer monitor works differently. It creates colors not by mixing pigments but by mixing the light of different colors. In this case it is the *additive* primary colors that are relevant: red, green, and blue. What seems strange to many people is the way these additive primary colors mix to form other colors. The one really counterintuitive combination is mixing red and green to get yellow. You get used to it pretty quickly, though.

In a digital photograph, each pixel has a color that is defined by a specific amount of red, green, and blue. Each color is assigned a numerical value in the range 0 to 255. By tradition, colors are listed in the order red, green, blue, abbreviated as RGB. Here are some example RGB values:

- 0, 0, 255: bright blue
- 255, 255, 0: bright yellow
- 190, 5, 90: dark purple
- 112, 248, 220: sky blue
- 255, 255, 255: white
- 0, 0, 0: black
- 127, 127, 127: medium gray
- 50, 50, 50: dark gray

A good way to get a feel for RGB values is to open a photo and select the Eyedropper tool, shown in Figure 4.5. Then move the mouse cursor over the photo (no need to click). You'll see a small pop-up box with the current pixel's RGB value displayed, as shown in Figure 4.6. The O value shown in the figure is opacity, which you need not be concerned about.

Figure 4.5
The Eyedropper tool.

Figure 4.6
Reading RGB values with the Eyedropper tool.

Now that you have a grasp of how digital photo colors work, here's how to adjust them. This affects the entire image, changing the RGB value of each pixel by a specified amount:

1. Select Adjust|Color Balance|Red/Green/Blue, or press Shift+U, to display the Red/Green/Blue dialog box, shown in Figure 4.7.

2. Use the three boxes labeled Red, Green, and Blue to enter the desired percentage change in each color, from -100% to +100%.

3. View the two preview images in the dialog box to compare the effect of the changes (right) with the original image (left).

4. Click OK to accept the changes or Cancel to discard the changes.

Figure 4.7
You use the Red/Green/Blue dialog box to make color adjustments.

Tip: Color Adjustments in Photoshop
These are the steps to follow to make color adjustments in Photoshop.

1. Select the Image|Adjustments|Color Balance menu option, or press Ctrl+B, to display the Color Balance dialog box.

2. Enter percent values from -100 to +100 in the boxes, or use the sliders, to adjust the color levels for red, green, and blue.

3. Ensure that the Preview option is checked to have the changes reflected immediately in the image.

4. Click OK to accept the changes or Cancel to discard them.

Brightness and Contrast

I don't think I need to explain brightness to anyone! Contrast refers to the degree of separation between the dark and the light parts of an image. A photo taken outdoors in direct sun is likely to be high contrast, while one taken on a foggy day will be low contrast. Figure 4.8 shows the same photo with low contrast on the left and high contrast on the right. Getting the right level of contrast in a photo can make a big difference in its appearance and how interesting and appealing it is. You can also use contrast adjustments, particularly high contrast, to get some interesting visual effects in your photos. Increased contrast, for example, tends to decrease the small details while emphasizing the larger shapes in the photo.

Figure 4.8
Adjusting the contrast of a photo can make a big difference.

To adjust the brightness and/or contrast of an image, follow these steps:

1. Select Adjust|Brightness and Contrast|Brightness/Contrast, or press Shift+B, to display the Brightness/Contrast dialog box (Figure 4.9).

Figure 4.9
Adjusting the brightness and contrast of an image.

2. Use the Brightness and the Contrast boxes to enter percent changes from -100 to +100.

3. View the effects of the changes in the preview panes in the dialog box.

4. Click OK to accept the changes or Cancel to discard them.

In the Field: Camera Phones and Barcodes

The idea of using camera phones to read barcodes has been around for a while. While nothing has really caught on widely, there are numerous ideas in the works. You never know when someone will come up with that "killer app" that will make barcode-reading camera phones a must-have.

One of the most popular ideas is to use barcode scanning as a shopping aid. You'd use your camera phone to scan a barcode in a store or perhaps in an advertisement. Software on your handset would decode the barcode and send it to a Web site which would then return information about the product specs and purchasing information which you could then view on your phone's screen. Neomedia technologies (**www.neom.com**) is one of several companies working in this area.

Barcode scanning is catching on faster in Japan than anywhere else. The latest system is called QR Codes (QR is for Quick Response). The idea is to place these codes on, for instance, a concert advertising a musical group. By scanning the QR code your camera phone would take you to a site that lists the group's concert venues and lets you buy tickets or order a CD. The barcode could also on a bus stop sign to let people scan the code and download a bus schedule.

In Finland, barcode scanning is being tested as a help for grocery shoppers who have special dietary needs, such as diabetics or people with severe allergies. Called TIVIK, the project is partly underwritten by Nokia, the giant Finnish cell phone manufacturer. Customers will be able to set up a personal profile either on the handset or on a central computer. Scanning a grocery item's code will display information about that item as it relates to the individual's dietary needs and restrictions.

Finally, in what seems like a strange twist, Fujitsu Labs is developing technologies to embed "invisible" codes in photos and other images. The code could contain a phone number, say, or a URL, which would be decoded by special software in a camera phone. There's one fly in the ointment as far as I can tell—if the code is invisible to the human eye, how will a camera phone user know to photograph the image?

Other Adjustments and Manipulations

As you may well have guessed, I have only scratched the surface here. Paint Shop Pro, Photoshop, and other image editing programs offer a wide array of tools that go way beyond the adjustments covered in this chapter. You may be perfectly happy with these basics, or you may want to explore more on your own. This section describes some of the other image manipulations you can play with.

Using Automatic Adjustments

Many graphics programs, including both Paint Shop Pro and Photoshop, have some automatic image adjustment commands that can greatly simplify the manipulation of certain photographs. These commands work by examining the color or contrast of the photo and adjusting it to match the values for a "typical" photograph. These automatic adjustments do not work well for all photos, but it's worth trying them because they are so fast and easy. If you don't like the results, you can also undo the adjustment with the Edit|Undo command. In Paint Shop Pro the commands are as follows:

- Adjust|Color Balance|Automatic Color Balance—This command adjusts the overall color balance.
- Adjust|Brightness and Contrast|Automatic Contrast Enhancement—This command adjusts the image contrast.
- Adjust|Hue and Saturation|Automatic Saturation Enhancement—This command adjusts the saturation or intensity of colors.

Each of these three commands brings up a dialog box in which you can adjust the settings for the automatic adjustment. I have found that the default settings work perfectly well in most cases, but you can experiment with different settings if you like to fine-tune the process.

Photoshop also has automatic adjustment commands, as follows:

- Image|Adjustments|Auto Color—This command adjusts the overall color balance.
- Image|Adjustments|Auto Contrast—This command adjusts the image contrast.
- Image|Adjustments|Auto Levels—This command adjusts the image highlights and shadows (the brightest and darkest parts of the image).

Photoshop's automatic correction commands always use the default settings; there are no dialog boxes for you to make changes.

Converting an Image to Monochrome

Camera phone images are full color, and that's what you want for most subjects. Sometimes, however, a monochrome image can be more appealing. Monochrome means one color, and the most common example is black-and-white photography (okay, I know that's really two color, but the white isn't counted). You are not limited to black, however (or, more accurately, shades of gray); you can create a monochrome image using any color you like.

Why convert an image to monochrome? Many people feel that monochrome photographs, particularly black-and-white photographs, provide a different way of looking at your subject. With the colors removed, the subject's shape and lines, as well as the photograph's composition, are emphasized. More abstract and artistic effects are possible, quite different from the realistic rendition that a full color photo provides.

Converting a color image to black and white, or *grayscale* as it is sometimes called, requires only a single menu command. With the image active, select the Image|Greyscale menu option—that's all there is to it.

Creating a monochrome image using a different color is called colorizing. Here are the steps required:

1. Open the image you want to colorize.

2. Select Adjust|Hue and Saturation|Colorize to display the Colorize dialog box (see Figure 4.10).

3. Use the Hue box to specify the color. You can enter a value of from 0 to 255 or use the slider under the box to adjust the color with the mouse.

4. Use the Saturation box to specify a saturation value of from 0 to 255. Higher values give intense color while lower values give softer, more pastel-like color.

5. Use the preview panes in the dialog box to preview the appearance of the image before and after.

6. When the settings are as desired, click OK.

Tip: Monochrome Images in Photoshop
To create a monochrome black-and-white image in Photoshop, select Image|Mode|Grayscale. To colorize an image, select Image|Adjustments|Hue/Saturation to display the Hue/Saturation

dialog box. Be sure that the Colorize and Preview options and checked; then use the Hue and Saturation sliders to get the desired effect. When finished, click OK.

Figure 4.10
You use the Colorize dialog box to convert a full color image to a monochrome image in a color other than black.

Rotating Images

When you transfer images from your camera phone to your computer, they all come across with horizontal orientation. Any photos that you took with the handset rotated to the vertical position will have to be rotated so they are upright. You can do this by opening the photo in Paint Shop Pro and using the Image|Rotate command, but there's a better way that does not require opening the image. If your have Windows XP as your operating system, use Windows Explorer as follows:

1. Start Windows Explorer.
2. Navigate to the folder that contains your images.
3. If necessary, select View|Thumbnails to display small thumbnails of the images in the folder.
4. Right-click an image and select Rotate Clockwise or Rotate Counter Clockwise from the pop-up menu.

Earlier versions of Windows do not have this image rotation feature, but you can still do it without having to open the images by using the Paint Shop Pro browser:

1. Start Paint Shop Pro.
2. Select File|Browse to open the browser.
3. Navigate to the folder that contains your images.
4. Right-click the image and select JPEG Lossless Rotation from the pop-up menu.
5. Select the desired rotation from the submenu.

Tip: Rotating Images in the Photoshop Browser
Photoshop also has a browser that lets you rotate images without opening them. Select File|Browse to open the browser and then navigate to the folder that contains your images. Right-click an image and select the desired rotation from the pop-up menu.

You are not limited to rotating images in 90-degree increments; you can rotate them by any amount desired. This requires opening the image in Paint Shop Pro. Then follow these steps:

1. Select Image|Rotate|Free Rotate to display the Free Rotate dialog box.
2. Select the direction of rotation: right (clockwise) or left (counterclockwise).
3. Select the Free Rotate option and enter the rotation amount, in degrees, in the box.
4. Click OK.

When you free-rotate an image, Paint Shop Pro automatically increases the image size to adjust. This is shown in Figure 4.11. The background of the rotated image, indicated by a gray checkerboard on screen, is empty and will not print.

Framing a Photograph

Photos often look better in a frame. You don't have to use a wood and glass frame, but you can add a digital frame using Paint Shop Pro. Figure 4.12 shows a camera phone photo with one of the many available frame styles applied to it. The frames you can apply do not all look like conventional frames, but include a variety of edge effects such as those in the figure.

Here's how apply a frame to an image:

Figure 4.11
Use the free rotate command to rotate an image by any amount, 45 degrees in this example.

Figure 4.12
You can apply a digital frame to your photos in Paint Shop Pro.

1. Open the image in Paint Shop Pro.
2. Select Image|Picture Frame to display the Frame dialog box (see Figure 4.13).
3. In the Picture Frame section of the dialog box, select the desired frame style from the drop-down list.

4. If necessary, set other frame options. The options that are available will depend on the frame style that you selected.

 5. Click OK.

Figure 4.13
You select a frame style and options in the Picture Frame dialog box.

You can apply two or more frames to the same photo and get some interesting effects.

Tip: Frames in Photoshop
Sorry, but Photoshop does not support automatic frames.

Special Effects

No, I'm not talking about the kinds of special effects you see in movies, such as explosions and car crashes. Rather, I am referring to a wide variety of image manipulations that change or distort the image in some way. Some effects work on the image's colors, others on its geometry. Paint Shop Pro has a large assortment of built-in effects, and most graphics programs have at least a few. There's no way I can explore all or even most of these effects here, but I'll describe a few of the ones I think are more interesting. You can experiment with the others on your own.

Exploring the effects that are available is made easy by Paint Shop Pro's Effect Browser, shown in Figure 4.14. To open the Browser, select Effects|Effect Browser.

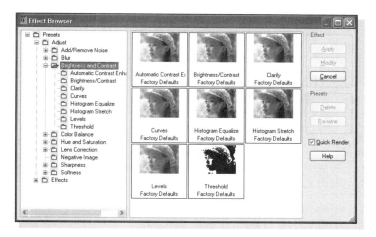

Figure 4.14
You can use the Effect Browser to explore the various special effects available in Paint Shop Pro.

The panel on the left displays a hierarchical tree of the available effects, organized by category. When you select an effect or category, the panel on the right shows thumbnail images of the selected effect(s) as applied to the currently active image. To apply an effect, click it. Then click the Modify button to change the effect settings and the Apply button to apply the effect to the image. You do not have to use the Effect Browser. If you know the effect you want, you can select it from the Effects menu.

Now let's look at a few of my favorite effects.

Posterize

The posterize effect works by reducing the number of colors in the photograph. The name comes from the style of old posters, such as those used to advertise movies. Because the printing process used in those days could not easily reproduce the full color range of a photograph, the number of colors was reduced, giving the "poster" appearance. This can be an effective way to change an ordinary photograph into something more interesting. Figure 4.15 shows a photo before and after posterizing.

To posterize a photograph, follow these steps:

1. Open the image in Paint Shop Pro.
2. Select Effects|Artistic Effects|Posterize to display the Posterize dialog box.

Figure 4.15
Posterizing reduces the number of colors in an image, giving an "old time poster" appearance.

3. Enter the desired value in the Levels box (this is explained more in the text following these steps).

4. Click OK.

The Levels setting for posterizing controls how many colors are in the final image. However, there is not a direct relationship. For example, the image in Figure 4.15 was posterized with the default setting of 7 levels, and the resulting image has 100 different colors. More levels means more colors, but there is no direct correspondence between number of levels and number of colors.

Silhouetting

Silhouetting is the name I have given to a technique for converting an image into a pure black-and-white image—no grays, just the two colors black and white. It can result in some strong graphic images. Most of the details are lost, and only the outline of major image elements will remain. This technique does not work well with all photographs and is best suited to those with strong areas of light and dark. Figure 4.16 shows an example.

Follow these steps to create a silhouette from a photograph:

1. Open the image in Paint Shop Pro.

 Select Image|Decrease Color Depth|2 Colors (1 bit) to display the Decrease Color Depth dialog box.

2. Set the options as desired (more on this later), although I find that the default settings work fine in most cases.

3. Click OK.

Figure 4.16
Reducing an image to two colors can give a strong silhouette effect.

The various options in the Decrease Colors dialog box have fairly subtle effects on the final result. You can experiment with them, using the preview panel in the dialog box to fine-tune the results, before clicking OK.

Sunburst

The Sunburst effect changes the photo to look as if the sun or some other bright source of light is behind the subject. It adds the light, "rays" radiating out from it, and some optical reflection effects that often occur when you actually take a photo containing a bright light source. Figure 4.17 shows an example of applying this effect to a photograph.

Figure 4.17
The Sunburst effect makes a photo look as if the sun were included in the field of view.

To create the Sunburst effect, follow these steps:

1. Open the photograph in Paint Shop Pro.

Figure 4.18
The Sunburst dialog box.

2. Select Effects|Illumination Effects|Sunburst to display the Sunburst dialog box (see Figure 4.18).

3. Make settings in the dialog box as explained in the paragraph that follows, or use the default settings.

4. Click OK.

The Sunburst dialog box offers several parameters that control the final appearance of the effect. They work as explained here:

- If you want the sunburst to be a color other than white, click the Color box and select the desired color from the Color dialog box that is displayed.

- Light Spot Brightness: Change to a value between 0 and 100 to change the brightness of the main light spot.

- Light Spot Horizontal: Change the horizontal position of the main spot, expressed as a percentage of the image width.

- Light Spot Vertical: Change the vertical position of the main spot, expressed as a percentage of the image height.

- Rays Density and Brightness: Change the appearance of the rays that emanate from the main light spot.

- Circle Brightness: Change the brightness of the reflected circle from 0 to 100.

You can get a dual-sunburst effect by applying the effect twice with the main light spot located in two different locations.

Tip: Effects in Photoshop
Photoshop does not provide exactly the same built-in effects as Paint Shop Pro, although there is a lot of overlap. In Photoshop, effects are called *filters* (although not all of Photoshop's filters are effects). Unfortunately, Photoshop does not have an equivalent of Paint Shop Pro's Effect Browser, so you'll need to experiment with the individual effects to see what they do. Almost all of Photoshop's filters are accessed via the Filters menu. For posterization, the command is Image|Adjustments|Posterize.

Specialized Graphics Programs

I recommend that you look into various specialized programs for performing specific image manipulations. These special purpose programs are quite different from general image editing software such as Paint Shop Pro because they are designed to do one thing, or perhaps a few things, and nothing else. As a result they are usually very easy to use. You can usually get the same result with a general purpose graphics program, but it will be more effort.

One of my favorite types of specialized graphics software is for creating panoramas, in which several overlapping photos are "stitched" together to create a single wide photo. For example, you could stand on a street corner and take one photo facing north, one facing northeast, one facing east, and so on. With a panorama program, you can combine these into a single impressive photo. I'll walk you though a panorama project in Chapter 10.

Resource for Creating Panoramas with PanoGuide.com:

This is a very useful guide, with reviews, of many different software products for creating panoramas: www.panoguide.com/software/.

Other software is designed for creating collages, in which multiple photographs are combined in a single image. Still others provide masking and composition tools, photo enhancement, special effects, batch processing (where the same action is applied to multiple photos at the same time), and just about anything else you can imagine. There are way too many to list here, and new ones are coming

out regularly. It's much better to use the Web, where you can find not only product descriptions but reviews, prices, and free downloads. Some good websites to learn about specialized digital photography software are **graphicssoft.about.com/od/digitalphotosoftware/** and **www.onlinereviewguide.com/software.shtml**.

Wrapping It Up

A camera phone is just one kind of digital camera, and while the photographs it takes may be on the small side, they can be manipulated just like any other digital photograph. You may not want to do this because some people feel that photos are best straight out of the camera. But if you decide that some digital manipulation is a good idea, the possibilities are almost endless. Let your creativity run wild!

Chapter 5

Printing Your Photos

The final destination for a lot of photos taken with camera phones is a web page, a multimedia message, or a moblog. But guess what? You can also make prints of your camera phone photos, just as you can with photos taken with any other kind of camera. There are lots of great things you can do with prints, such as send them to friends and relatives, hang them in your home or office, or make a scrapbook. Some camera phone users never get into making prints and it's a shame because they are missing a lot of fun.

There are two basic approaches to making prints. You can do it yourself or you can have someone else make them for you. This chapter shows you how to make the most of both these techniques.

The Do It Yourself Approach

Making your own prints has several advantages. You have more control over the final product, for one thing. In addition, it is cheaper on a per-print basis (although you need to consider the cost of buying a printer). If you want to make your own prints, you'll need to choose a printer and learn something about using it to its full potential.

Selecting a Printer

Recent years have seen major advances in printer technology, and many manufacturers are offering inexpensive printers that will allow you to make high-quality

prints. With such an abundance of riches, however, it can be difficult for the uninitiated to make a choice when shopping for a printer. In this section, I'll help to sort things out for you in terms of printer features and capabilities.

First, let's look at the types of printers available. For the consumer, they fall into three categories:

- Laser printers are great for text and diagrams but are not suited for photographs. Even the new color laser printers don't do all that good a job with photos, and they're quite expensive to boot.
- Ink jet printers are very flexible and have the potential to print high-quality text as well as terrific photographs.
- Photo printers are specialized for printing photographs and are not usable for more typical printing such as letters and other documents. Most photo printers use the same technology ink jets use.

 Note: Canon refers to its ink jet printers as bubble jet printers. Same thing, different name.

Your choice basically boils down to an ink jet printer or a specialized photo printer. It should be easy to make a choice. Photo printers are for photos only, and most are limited as to the print size. For example, some models produce 4x6-inch borderless prints and nothing else. They are easy to use and the results are usually great, but if you will be using your printer for other things, this is not a good choice.

 Note: Some manufacturers are releasing special mobile printers designed specifically for use with camera phones. These printers are small, lightweight, and battery operated. They communicate with the camera phone by infrared or Bluetooth and let you make small prints right in the field. One such offering is the Fuji Photo Film NP-1 Camera Phone Printer. The print quality is not as good as other printing methods, but the portability sure opens up some interesting possibilities. For example, you can take photos at a party and hand out prints right away.

For most people, an ink jet printer is the better choice. In addition to printing photos, you can use it for other printing tasks, such as letters and envelopes, and the output quality on most models is really terrific. Unless you have a really good reason to get a specialized photo printer, I believe that an ink jet is definitely the way to go.

Camera phones are great for those spontaneous photos you might miss otherwise.

Now the question becomes, which ink jet? I cannot give specific recommendations because there are dozens of models and new ones come out regularly. I can give you some guidelines.

Finding Good Printer Resources

Computer magazines such as *PC Magazine* and *PC World* often publish reviews of ink jet printers. The reviews typically include information and the printers' specifications as well as tests of printing speed, output quality, and predicted cost of supplies (ink and paper) on a per-print basis. The reviews are usually made available on their websites as well as in the printed magazines: the websites are at **www.pcmag.com** and **www.pcworld.com**. Other sources of printer information include printer reviews at **www.itreviews.co.uk/hardware/hard4.htm**, the Review Centre at **www.reviewcentre.com/products14.html**, and ZDNet at **http://reviews-zdnet.com.com/**.

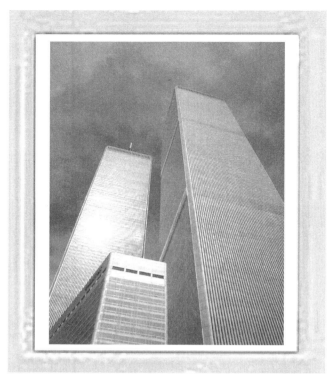

Going up?

The size of the paper that the printer can handle is the first thing to consider. Most ink jet printers have a maximum size of 8.5x11 inches, the standard "letter" size. This is a good choice for many people because it lets you print letters and other documents as well as photos, so the printer can do double duty. You can print smaller photos too; you are just limited to this maximum size. For camera phone photos, 8.5x11 or the more standard photo size 8x10 is usually more than enough because the low-resolution photos taken by camera phones are not usually printed this large.

Using Dye Inks versus Pigment Inks

If you do some reading about ink jet printers, you may learn that there are two types of inks: dye and pigment. Dye inks consist of a colorant that is dissolved in a liquid, whereas pigment inks consist of a colorant that is suspended in a liquid. Think of putting a spoon of salt in a glass of water and stirring—it will dissolve. In contrast, a spoonful of flour will be suspended.

How do dye and pigment ink differ on the practical level? Dye inks can produce brighter colors and also have a wider color range, whereas prints made with pigment inks are reported to last longer without fading. Recent advances in dye inks have improved their longevity, so this factor is less of a concern now.

Do you need to be concerned about which type of ink you are using? Generally no, simply because only dye inks are available for almost all of the consumer-level printers that a camera phone user is likely to consider.

Some printers can output pages up to 11x17 inches, but they tend to be more expensive. Even so it might be worth considering such a printer, particularly if you use a stand-alone digital camera as well as a camera phone. Camera phone photos do not have enough resolution to look really good at this size, but you can certainly get some interesting effects with large blow-ups.

Tip: Using a Preview Screen
Some new printers offer a small preview screen that's part of the printer itself. When you "print" a photo, it appears first on this screen to let you verify that the size and placement are what you expected. Once you are satisfied, you press a button to start the printing process. These screens are not very good for evaluating details and color in the print, however.

Your second consideration is the ink cartridge configuration. At a minimum you want a four-color printer: black, cyan, magenta, and yellow. Even better is a printer that uses black and six or eight colors of ink. With more colors of ink, the printer is able to reproduce more accurate colors in your photographic prints. Also, you want the black ink cartridge to be separate from the color ink cartridge so that you don't have to throw away a lot of color ink if you have run down the black ink printing a lot of text. Some higher-end printers even have separate cartridges for each of the colors, but I do not consider this to be a necessary feature.

The Cost of Consumables

One reason that ink jet printers are relatively inexpensive is that the manufacturers make most of their profit from so-called consumables, namely ink cartridges and paper. A low-priced printer may end up being relatively expensive if you do a lot of printing and the ink cartridges are pricey. It's difficult for the average consumer to figure this out because you have to know not only the cost of the cartridges but also

the number of prints you can get from each one. Here's where a magazine or web review can come in handy because they will actually test a printer to see just how many prints you can expect to make from one set of cartridges. I'll discuss some ways you can save on the cost of cartridges in the sidebar Tips for Saving Money later in the chapter.

Paper size and cartridge configuration are the most important choices to make. Printers also differ in their printing speed, which may be important to you if you plan to make a lot of prints. Printing speed is usually listed in the manufacturer's specifications, but they are sometimes unduly optimistic. (I would trust information from independent reviews a lot more.) Some printers come with bundled software that may save you from spending a lot of money buying separate programs. Again, the manufacturer's specs and published reviews are your best source of information.

The Printer Buyer's Checklist

With some careful shopping, I am sure you can find a printer that suits your needs just fine. To help, I have provided a checklist that you can use when deciding on a printer.

Keep your eyes open for interesting details, and don't be afraid to move in close.

Step 1: Decide on the maximum print size you want. 8.5x11 inches is widely supported and is fine for most camera phone users. Printers that can handle 11x17 inches are more expensive but offer more creative output options.

Step 2: Evaluate the ink cartridge configuration. The minimum you should accept is black plus three colors, preferably with separate black and color cartridges. Printers with six or eight colors produce the highest-quality prints, but the printers as well as replacement cartridges are more expensive.

Step 3: Check the reviews. These will provide invaluable information on printing speed, per-print cost, output quality, and other important decision factors.

Installing a Printer

After buying a printer, you have to install it, connect it to your computer, and load any required software. I cannot walk you though the specific steps needed for this process because the steps differ from one printer to another. Be sure to read the instructions that come with the printer. When unpacking your printer, check the instructions carefully because you sometimes need to remove tape or Styrofoam from within the printer, used to prevent damage during shipping.

Every printer requires a *driver*, specialized software that lets your computer communicate with the printer. For some printers, the driver is part of the operating system and will be installed automatically when the computer detects the printer. For other printers, the driver is provided on a CD-ROM that comes with your printer and you will have to install it using the instructions that came with the printer.

Paper

Nothing affects the quality of an ink jet print more than the type of paper you use. If you go to an office supply store and look at the ink jet papers, you are likely to come away confused because there are many different types.

You cannot use ordinary paper and get decent results when printing photographs. By "ordinary" I mean the plain white paper that is used for laser printers and copiers. You can find paper that is labeled "for ink jets," but that's not good for photos either (although it will give better results than copier paper for text documents on an ink jet printer). You must use photo paper if you want decent results. There are two ways to identify this:

Low-light situations can be difficult for a camera phone, but the results can be lovely.

- It is labeled "photo paper" or "for photos" or "ink jet photo paper" or something similar.
- It is expensive.

Sorry, there's no getting around the second point, and I'm talking up to almost $1.00 per sheet for top-of-the-line paper. Photo paper has a special surface that prevents the ink from blurring. This is necessary for good photographic reproduction. Try making a print on regular paper and you'll see what I mean!

There's more than one kind of photo paper. The differences lie mostly in the surface of the paper.

- Glossy paper, with a surface that is smooth and shiny, gives the best detail in printed photographs but is also the most expensive.
- Matte paper, with a soft and nonreflective surface, gives less detail but is significantly less expensive.
- Semi-gloss or pearl surface falls somewhere between these two in both detail and price.

Photo printing papers also differ in other respects. The weight, or thickness, does not affect the appearance of the print but does affect the durability of the paper and how it feels to the touch. Thin paper will be fine for a print that is going to be framed or mounted in an album, but when the print will be handled a lot, such as greeting cards and flyers, you may want to choose a thicker paper. Papers differ in whiteness as well, with some being a bright, pure white and others a more subdued tone. There's no sure way to determine a paper's weight and whiteness from the package. The best you can do is to rely on manufacturer's terms such as *bright white* and *heavyweight*.

When choosing a paper surface, your own taste must be the guide. I suggest trying some of each and seeing how they differ. Most manufacturers offer sample packs containing a few sheets of each type of photo paper that they make.

You can also experiment with what are called *fine art* and *specialty* papers. While there are no strict definitions of these terms, fine art papers generally have unusual surface textures that are designed to make a print look like something other than a photograph, such as an etching or painting. Specialty papers run a wide gamut from paper with magnetic backing, translucent paper, T-shirt transfer paper, metallic finishes, fabric, and so on. These papers offer lots of opportunities for creativity.

Tip: Use Caution with Specialty Papers
Some specialty and fine art papers are thicker than regular printer paper. Before using such paper, check its thickness against the maximum thickness your printer can handle (which will be listed under "Specification" in the printer manual). Using a too-thick paper can damage a printer's ink nozzles.

Resources:

The Web is a great place to learn about and buy ink jet papers of all kinds. Here are some sites to check out:

www.redrivercatalog.com/browse/spec.htm

www.inkjetmall.com/

www.acecam.com/inkjet-paper.html

www.kelvin.com/ac_inkjetpaper.html

You will not go wrong buying paper made by the manufacturer of your printer. Each manufacturer carefully matches the characteristics of its papers and inks to give the best result. You don't have to, however. Other brands of papers will probably give great results too, and may be less expensive. For example, if you own an Epson printer and see Kodak, Hewlett-Packard, or Canon photo ink jet paper on sale, go ahead and try it.

Be aware, however, that you run more of a risk if you stray away from the major brand of papers. Off-brand photo paper can be a lot less expensive than the brand-name stuff, and while most of it is fine for most printers, you can run into problems. I suggest trying out a small package of paper before plunking down your money for a whole case of the stuff. I learned this lesson the hard way. I bought a 150-sheet box of high gloss photo paper from a company I had never heard of. The price was really great but it turned out to be a bad deal. The prints looked fine but they took forever to dry and curled up terribly.

Settings for Printing

When you are ready to print a photograph, there are several settings that you can make to control the details of the print job. Some of these settings are part of your graphics programs, while others are related to a specific printer.

Bald as...

Resampling for Printing

It's a general rule of thumb that the higher the resolution (number of pixels) in a digital photograph, the better quality print you can make. Camera phone photos, however, are a bit challenged in terms of pixels, and this will limit the size of print you can make without loss of quality.

You can compensate for this, at least to some extent, by resampling. This is a software technique that increases the number of pixels in a digital image (resampling can also decrease the pixel count, but that is not of interest here). The image's existing pixels are examined and new pixels created in a manner that maintains the appearance of the photo as much as possible. With the increased pixel count, your prints are almost sure to be better.

Resampling is not perfect and always entails some loss of quality, even if rather minor in some cases. You have to balance the loss of image quality caused by resampling with the increase of print quality. How much can you increase a photo's pixels without a serious loss of quality? A lot depends on the specific photograph, its level of detail, contrast, and colors. In my experience, you can almost always double a photo's size. You could increase a photo from 352x288 pixels to 704x576, for example, with good results. In many cases you can resample to an even larger size. You'll have to experiment and see how it works. You'll find detailed instructions for resampling your images in Chapter 4.

Program Settings

Program settings for printing are part of your graphics program and typically control features such as print size, image placement, and number of copies. They are independent from printer settings, which are covered in the next section.

To print an image in Paint Shop Pro, for example, select File|Print or press Ctrl+P. The program will display the Print dialog box as shown in Figure 5.1.

Then, follow these steps. You should do these steps in the order given:

1. The name of the default printer is displayed at the top of the dialog box (Epson Stylus Photo 1280 in the figure). If you have more than one printer and you want to use a different one, click the Printer button and select the printer.

2. Click the Properties button to display a dialog box for changing printer settings. These are explained in the next section. At this point, the most important setting is paper size if you will be printing on a size other than

Figure 5.1
The Print dialog box.

the default. When you are finished with the printer settings dialog, close it to return to the Print dialog box.

3. Select the paper orientation:

 - Portrait—Paper is taller than wide.

 - Landscape—Paper is wider than tall.

4. In the Size and Position section of the dialog, make selections as follows:

 - Fit to Page—Photo is enlarged to fill the entire page.

 - Center on Page—Image is centered. Use the Width, Height, and Scale boxes to specify the image size. Note that these three values are linked to one another – changing one changes the others to maintain the photo's proportions.

 - Upper Left of Page—Photo is printed at the top left of the page. Use the Width, Height, and Scale boxes to specify the image size.

 - Custom Offset—Photo is printed at the position you specify. Use the Left Offset and Top Offset boxes to specify the position and the Width, Height, and Scale boxes to specify the image size.

5. Click the Print button to start printing.

Printing in Photoshop

Printing from Photoshop is a bit more involved because the options are spread out over several dialog boxes. The options are basically the same: paper size and orientation, print size, and position. Here's how:

* Select File|Page Setup to display a dialog box in which you specify paper size and orientation. This dialog box also has a Printer button that lets you select the printer to use.
* Select File|Print with Preview to display a dialog box in which you specify the size and position of the image.
* Select File|Print to display a dialog box you can use to select a printer, specify number of copies, or open the printer settings dialog. Click OK in this dialog box to start printing.

Tip: Changing Print Size
In Chapter 4 I showed you how to change the size of a digital photograph. If all you need is to change the print size, you can skip that and simply specify a different print size without changing the image size, as explained in this chapter.

Printer Settings

Printer settings are the settings that are specific to the selected printer. They are not part of your graphics program but are installed along with the printer driver. This means that the details of printer settings are different for each printer. For example, the Settings dialog box for an Epson printer will be different from the one for an HP printer and will likely be different from the one for a different model of Epson printer.

This means that I cannot give you specific steps for making settings. You may want to read your printer's documentation or you can try to figure it out as you go. I can, however, tell you what the most important settings are and how to deal with them.

In the Field: Camera Phone Photos Used in Racism Charges

The *Portland Tribune* reported a story in which photos taken with a camera phone were used as evidence in a racism complaint against local police. Here's what happened.

A local restaurant hosts a weekly hip-hop show, and the audience is almost exclusively African-American. In the past, the event has received a little too much attention from the police, at least in the opinions of the organizers. One week recently the police went a bit further—a large toy gorilla was mounted on a police car's bumper, and the car was parked so that the gorilla was clearly visible to the patrons through the restaurant's windows. As you might expect, some of the people found this highly racist and offensive. A couple of them went outside and took pictures with their camera phones. The police soon drove off, but hurt feelings remain and the photos are being used in an effort to bring pressure on the police to change their ways.

You may think this is blown way out of proportion, or you may think that it is a legitimate response. In either case, this story brings home the fact that the prevalence of camera phones makes it less and less likely that anyone, particularly a public servant, can do something and later claim it never happened. This also has a bad side, of course—people in general have less privacy. One thing's for sure—camera phones are not going away.

Media type or paper type is the most important setting. The printer needs to know what kind of paper you are using because different types of paper require different amounts of ink. If you use the "plain paper" setting for glossy photo paper, for instance, the results will be poor. If you are not sure which setting to use, check the package the paper came in because sometimes it is specified.

Some printers offer an Ink setting of black and white or color. You would select color, of course, for photos. Black and white is used primarily for printing text documents.

Another very important setting is quality. Most printers have an Automatic option that makes settings based on the type of paper and type of ink that you selected. There may also be a specific Photo option for photographs. You will also be able to make settings manually. In this case, the dpi (dots per inch) is crucial, with higher values giving more detailed prints.

All in all, the best advice I can give you is to experiment with the settings until you get the print quality you want. I know that reading the documentation is a last resort for some people, but in this case it really can be helpful.

Tip: Printing Tips
Here are two sites that offer some tips for getting the most out of your ink jet printer:

www.maxpatchink.com/printer-tips.shtml

www.rippedsheets.com/faq/faq_23.htm.

Thoughts for Saving Money

The cost of paper and ink can really start to add up if you make more than a few prints. Here are some time-tested tips for printing your photographs while minding the budget:

- Shop smart. Paper and ink cartridges are usually less expensive on the Web than at a local shop. Buy larger quantities if you can to save on the shipping costs.
- Use your software's Print Preview command to check the size and placement of a photo *before* printing it.
- Experiment with off-brand paper and ink cartridges. The savings can be considerable.
- Make sure your software is set for the right kind of paper.
- Save on paper costs by putting a sheet through the printer more than once. For example, after making a 5x7 print on the top half of an 8.5x11-inch sheet of paper, you can rotate the paper and print another photo on the other half.

Another way to save money is to refill your ink cartridges. You'll find refill kits for sale at most places where printer supplies are sold. You won't be able to get your printer manufacturer's inks, but you can look for inks that claim to match their characteristics. The process is time-consuming and messy, however, and I don't find it worth the bother.

Using an Online Print Service

Maybe you don't want to make your own prints. Heck, maybe you don't even have a computer! Not to worry because you can still get high-quality prints of your photos at very reasonable prices from online print services. In a nutshell, here's how it works: you go to the service's website, upload your photos, and specify the size and number of prints. A few days later your prints arrive in the mail.

But there's a lot more to these services. Some offer photo sharing—friends and family can go to their website and view photos that you have uploaded. (Photo sharing is covered in detail in Chapter 6.) Most offer photo enhancement and editing tools such as red-eye removal, rotation, and cropping. Some let you choose several special print formats, such as cards, calendars, and T-shirts. In this section we will take a look at a couple of the better known print services and I'll show you how to use them. Then I'll list a number of other print services with a brief comment.

Please note that just because I cover the Ofoto and Shutterfly print services in detail does not mean I endorse them over the other services. I've used them both with excellent results, but I am sure you can do just as well elsewhere.

Tip: Using a Local Print Services
You don't have to go online to get prints made from your digital photos. Many local businesses have similar services. This includes camera stores, of course, but you'll also find them at other kinds of stores, such as discount department stores, drug stores, and copy shops. Typically you will put your images in a disk or CD-ROM and take it in. Prints may be made by an employee or in a do-it-yourself kiosk. You'll have to look around in your area to see where printing services are available and how exactly they work.

Using Ofoto

Ofoto at www.ofoto.com is Kodak's entry in the online print services field. Print sizes range from wallet size through 4x6 all the way up to 20x30. In addition to prints, Ofoto offers a variety of other services, including online sharing. Check out their website for full details.

Using Ofoto is simple and the interface is well thought out. Once you have created your account, you can get started. Photos are organized in albums, and you can have essentially as many albums as you like. Uploading photos and ordering prints can be done two different ways. One is to use their free program, which you can download from the website and run on any version of Windows (Ofoto offers software for Mac users as well). This program is shown in Figure 5.2. Once you have selected photos from your hard drive, you can perform basic editing on them (crop, rotate, and a few other basic manipulations) and then upload them to Ofoto with or without ordering prints. Uploaded prints remain in your albums until you delete them.

Figure 5.2
Ofoto's photo manipulation and upload program.

The second way to upload photos and order prints is to do everything on the website. You can use drag-and-drop to select photos from your hard drive to upload and then select prints to order, all in your web browser.

Another nice feature of the Ofoto website is that you can manipulate photos even after they have been uploaded to your albums. There are tools available for cropping, red-eye removal, rotation, adding borders, and creating special effects.

Using Shutterfly

Shutterfly (www.shutterfly.com) is similar to Ofoto in terms of the services offered:

- Prints from wallet size to 20x30
- Unlimited photo storage
- Basic image manipulation and editing
- Photo sharing
- Photos organized by albums

Shutterfly does everything on the Web – there is no program to download (other than a small browser plug-in). When you are ready to upload photos, sign in to

your Shutterfly account and click the Add Pictures button. After selecting an album (or creating a new one), you are shown a dialog box that lets you browse your computer and select photos to upload, as shown in Figure 5.3.

Figure 5.3
Uploading photos to Shutterfly.

Once you have uploaded your photos, you can do a variety of things with them, including sharing them and ordering prints. Shutterfly's image manipulations include rotation, special effects, red-eye removal, cropping, and adding borders.

Other Print Services

Table 5.1 lists some of the other online photo printing services that are available. For each one I give the URL and a brief description of what the service does and does not offer. Remember, however, that things change quickly in this business. By the time you read this, any of these companies may have changed their offerings.

Tip: Getting Free Prints
Many of the photo print services regularly offer a number of free prints to new customers. This would be a good way to try out several services to see which you like.

Table 5.1 Other online print services.

Name	Web address	Comments
PhotoWorks	www.photoworks.com	Offers a wide range of tools and services, but at present is limited to photos with resolution 640x480 or better, so is not usable for most camera phone photos.
Club Photo	www.clubphoto.com	Not as many photo viewing/editing/manipulating options as some other services.
ez Prints	www.ezprints.com	Not as many photo viewing/editing/manipulating options as some other services.
dot Photo	www.dotphoto.com	Good set of image editing/manipulation tools.
ImageStation	www.imagestation.com	Offers only glossy prints at present.
SnapFish	www.snapfish.com	Low prices but fewer features than most others.
Wal-Mart	www.walmart.com	Free photo storage limited to 10MB.

What, No Computer?

While the online photo printing services are great, they do have one limitation: You must transfer your images to a computer to upload them. There is no way to send photos directly from a camera phone to the service. This capability may come along in the future, but for now there is one alternative. Snap-n-Print (www.snapnprint.com) is a new service that lets you create and send a postcard from your camera phone. Here's how it works:

1. You download the Snap-n-Print software onto your camera phone. The software is compatible with most but not all camera phones. Check the company's website for more information.

2. Use the software to guide you through the process of taking a photo, adding a message and address, and uploading it to the server.

3. The company prints the postcard, picture on one side, message and address on the other, and drops it in the U.S. mail.

4. The charge shows up on the bill from your cell phone carrier.

The Snap-n-Print service is designed to let you send picture postcards to friends and family while on vacation, but you can also use it to send postcards to yourself

if you do not have another way of making prints. The postage charge makes it more expensive than other ways of getting prints, but even so it can be a great tool in some situations.

New Service Coming from Kodak

Eastman Kodak Inc., perhaps the best known name in the world of film photography, has announced a new service for camera phone users who want prints but don't want to do it themselves. Kodak already has thousands of Picture Maker kiosks installed at various retail locations, and the new service will consist of upgrades to these kiosks to meet the needs of camera phone users.

The most important change is that the new kiosks will be able to accept photos sent wirelessly from a camera phone. Less important but also nice is that the prints will be produced very quickly—in about 5 seconds. Any camera phone with Bluetooth or infrared capability should be able to use this new feature. Kodak is in the process of rolling out the new kiosks as this is written, and they should be available at over 24,000 retail location in the U.S. by the end of 2004.

View Kodak's press release at **www.kodak.com/US/en/corp/pressReleases/pr20040108-04.shtml**.

Wrapping It Up

I love making prints of my camera phone photos. There are so many things you can do with a print that you could not do otherwise. Camera phone users have plenty of options when it comes to printing. I like to do it myself because this gives me the most control over the final result. But even if you don't have or don't want to use a computer and printer to make your own prints, you still have plenty of options. Between local and online print services, you'll be able to get just the results you want.

Chapter 6

Sharing Your Photos

Taking a great photo is not much fun if all you do is look at it by yourself. Sharing is where it's at because it's great fun to show your photos to friends and family. Or maybe you want to share your photos with the whole world—that's possible too. This chapter covers many of the ways you can share the photos you take with your camera phone. Two of the most popular ways to share photos, prints and moblogs, each gets its own chapter (Chapters 5 and 7, respectively).

Sharing Photos from Your Phone

Sure, you can display a photo on your camera phone's screen and show it to someone, but that's a pretty limited way to share your photos. There are better ways, including email and multimedia messages.

Email is probably the most popular way to share camera phone photos. This is because almost anyone who is at all connected (electronically, that is) can receive emails and view your photos. When you send a photo via email, it is sent as an *attachment*. In other words, the recipient receives a normal email with a subject and body text and the image file comes along as a separate file. They can then view it, print it, and so on, just as they can any other image file. Be aware that most camera phones let you attach more than one photo to a message.

> **Tip: Sending Multiple Photos**
> If you send multiple photos with some PC-based systems, such as AOL, your photos will be compressed together into a zip file. When the recipient receives your email message, they will need to download the attachment and uncompress it so that they can view your photos. This might sound complicated, but it is actually quite easy.

The exact steps for sending a photo via email will depend on your handset. In most cases, there are two approaches that give exactly the same result but require slightly different steps:

- Select your phone's Create Email command, and then add a picture as an attachment to the message.
- Use your phone's View Pictures command to view your photos, select one, then select the Send as Email command.

The exact steps required will depend on your handset, so please refer to the documentation. Here, as an example, are the steps required to email a photo with my Sony Ericsson T616 camera phone:

1. Select Pictures and Sounds from the main menu.
2. Select My Pictures from the next menu.
3. Use the joystick to select the desired photo from the displayed thumbnail images.
4. Press the More button.
5. Select Send from the menu.
6. Select As Email from the next menu.

At this point the handset displays a blank email message with the photo already attached. All I have to do is fill in the To, Subject, and Text boxes and then select Send from the menu.

Saving Bandwidth

If you want to send one or more photos to several people, you might be tempted to create a separate message for each recipient. This is best avoided, however, because each individual message, with attached image file, must be uploaded separately over your wireless connection. It is preferable to create one message and address it to all

your recipients. This results in the message and attached photos being uploaded only once, saving time and possibly also usage charges.

There's another way to save bandwidth when you need to send photos to multiple recipients, but it works only if you have a computer with a regular email account. Email the photos to yourself. Then, when you get home, use your computer email account to email the photos to all your recipients.

Most camera phones support multimedia messaging. This is a special kind of email in which pictures and sounds can be incorporated as part of the message and sent to someone else's phone. For example, you could take a photo of your baby, record 10 seconds of its delightful cooing and gurgling, type some text describing your baby's latest accomplishments, and send the entire message off to Grandma.

Sounds like great fun and it is! The only fly in the ointment is that the recipient must have an MMS-capable phone (that's Multimedia Messaging Service) and their service plan must include MMS, which is usually an extra-cost option. If you send an MMS message to someone without this capability, the message is likely to vanish without a trace, and with no indication to you that it did not reach the intended recipient.

You are not limited to sending multimedia messages to other phones; you can also specify an email address as the recipient. Much of the effect is lost, however, because instead of arriving as an integrated whole, the message arrives as a bunch of attachments: one for the text message, one for each photo, and one for the sound recording. To make matters worse, the sound recording is often encoded in an unusual file format that your PC won't recognize, making it impossible to play. We can hope that standards will evolve to surmount these difficulties, but for now

Six heads are better than one.

your options for sending MMS messages are pretty much limited to people with MMS-capable phones.

Tip: Sending Postcards
One other way to send a photo directly from your camera phone without a computer is as a postcard. This service was covered in Chapter 5.

In the Field: Calling all Paranoids

This almost seems surreal, but it is true. A company called the Spy Supply Store has taken the concepts of a camera phone to the next level. They take an actual Nokia cell phone and remove the guts, leaving only the outside shell. Then they install a color CMOS camera, a battery, and a transmitter. The package includes a remote receiver that can pick up the signal from the camera up to 300 feet away.

The phone doesn't work, of course, but that's not the point. You can leave the "phone" in some innocuous location where no one would think twice about seeing a cell phone. Then, the receiver will pick up photos of what's going on wherever the unit is pointed. Think your babysitter may be nipping at your bourbon? Maybe your secretary is snooping in your office when you're out. Here's a sure way to catch them.

A tribal mask makes a good subject for the intrepid camera phone user.

Moving Photos to Your PC

Some of the techniques for sharing your camera phone photos require that the photos first be copied from the handset to the PC. One method of doing this, email, was covered in the previous section. Here I cover the other options that are available for transferring photos to your PC. All camera phones should offer at least one of these technologies, and many offer two of them.

Tip: Removing Photos from Your Handset
Once you have transferred your photos from your handset to a PC, you should always delete the photos from the camera phone in order to make room for new ones.

The earliest transfer method for moving photos from a camera phone to a PC was via a cable. You would attach the cable between the handset and your computer, usually using a USB port. You might also have to install software on your PC that was provided by the handset manufacturer. Cable transfer works fine, but really—cables are so *yesterday!*

Tip: Getting More USB Ports
With USB devices proliferating at a rapid rate, you may find yourself without an empty port to plug your handset into. Heck, my new computer came with six USB ports and they are already all used! Don't worry; you can get a USB hub that plugs into one port on your computer and gives you four or six extra ports to use.

Infrared (IR) transfer is a popular wireless technology. It uses basically the same technology as remote controls for TVs. Information is encoded as pulses of invisible infrared light. Pulses emitted by the handset are picked up by a PC and *vice versa*. Of course, your PC must be equipped for IR for this to work. The only disadvantage of using IR to transfer your photos is that there must be a clear line of sight between the handset and your PC, but that is rarely much of a problem.

My favorite transfer method, the one that seems to be gaining the most popularity, is Bluetooth. No, I'm not talking about what happens when you eat too many blueberries! Bluetooth is a short range data transfer standard that uses radio waves. Bluetooth is used for many different tasks, such as wireless keyboards, mice, and printers. It has the advantage that no line of sight is required. Bluetooth adapters for your PC are readily available. For example, when I got my camera phone I picked up a Bluetooth adapter that is about the size of a key fob and plugs into a

Tire tracks in the sand.

USB port on my PC. The best part is that it costs less than $50. In my opinion, Bluetooth is definitely the way to go.

The step-by-step details of photo transfer, whatever method you use, will be slightly different depending on your specific handset and computer. This means that I cannot walk you though step-by-step procedures for performing a transfer. Fortunately, phone and software manufacturers have realized that not all of us have a Ph.D. in computer science and generally make the instructions fairly easy to follow.

Watch Those File Names

I recommend that you check out how your handset names your photo files. Most use a sequential naming scheme such as Picture(1).jpg, Picture(2).jpg, and so on. Once you have transferred the photos to your PC and deleted them from your camera phone, the sequence is started over for new photos. And here's where a problem can arise: when you are transferring a later batch of photos from the camera phone to your PC, the new file names may conflict with the names of photos previously transferred, and it's possible that the older files will be overwritten without warning. You could have a new Picture(1).jpg on your handset and an older Picture(1).jpg on your computer. What to do?

One solution is to rename photo files after they have been transferred to your computer. You can use the names to help identify the photos. For example, if you took a bunch of photos at Jack's birthday party you could name them JacksBirthday(1).jpg, JacksBirthday(2).jpg, and so on. Another solution is to create separate folders for each group of photos. If you use this approach the folder name can identify the subject. You can still rename the individual photo files too, of course.

A Lake Huron view almost looks more like a painting.

Sharing Photos from Your PC

Your photo sharing options are greatly expanded once you have your photos on your PC. Let's take a look at what you can do.

There's something about a nice ponytail.

Email

While you can email photos from you phone, you may prefer to do it from your PC. It's usually easier, and you save on connection charges. Any email program will let you attach a photo to an email message, and the result for the recipient is exactly the same as if you had sent an email message with an attached photo from your handset.

Recent versions of Windows have a nice feature that makes it a snap to email photos to people. Here are the steps to follow:

1. Start Windows Explorer.

2. Navigate to the folder that contains the picture files.

3. Click the names or icons of the file(s) to send. Hint: hold down the Ctrl key while clicking to select more than one.

4. Select File|Send To from the menu, and then select Mail Recipient from the next menu. Windows displays the dialog box shown in Figure 6.1

5. To keep your photo size unchanged, select the Keep the Original Sizes option. This is usually fine for camera phone photos because they are fairly small to begin with. Or, select one of the other sizing options.

6. Click OK.

7. Windows creates an email message with the images attached and displays it. You then fill in the recipients, add text and a subject if desired, and click the Send button.

Figure 6.1
Windows can automatically resize your pictures before sending them to email recipients.

Tip: Not Just Ordinary Email
It's easy enough to attach a photo to an email but perhaps you would like to fancy things up a bit. SendPhotos is a program that does just that. Working with Microsoft Outlook or Outlook Express, SendPhotos lets you choose image size, stationery, layout, captions, and more. It also permits simple photo corrections, such as removing red eye and adjusting contrast. You'll find the details at **www.novatix.com/Products/SendPhotos/**.

What about multimedia messages? PCs are not really set up for this, at least not yet. You can get a bit fancier than a plain text message, however, if your email program supports HTML messages. With HTML you can include pictures as part of the message, not just as an attachment. You can also format the text. For example, Figure 6.2 shows an HTML email message with a picture and some text formatting. The recipient will see the message just the same. In the unlikely event that their email program does not support HTML messages, all is not lost. They'll just see a plain text message with the photo(s) as attachments.

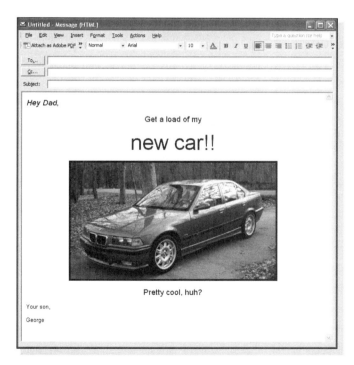

Figure 6.2
An HTML email message with a picture and text formatting.

Tip: Understanding HTML
HTML stands for *Hypertext Markup Language*. It is the language of the Web and was created to allow the creation of documents that contain formatted text, pictures, and other elements. HTML is used for web page you will ever see. Because of its flexibility, HTML has been adapted for other uses, such as creating formatted email messages. When you send or receive an HTML mail message, you do not see the HTML itself. It remains hidden behind the scenes and you see only the text and images as formatted by the HTML.

Websites and Online Albums

More and more people these days have a personal website. If so, it's an ideal way to share photos. Anyone with Web access will be able to access and view your photos. There are basically two ways to go about this.

If you have any experience with web authoring, you can "roll you own" photo presentation. This means you can create your own web page using an authoring tool such as Microsoft FrontPage. This approach gives you complete control over the text and photos, their arrangement and formatting. That's the approach I have taken for my web page with photos from my fishing trips. Figure 6.3 shows part of this page. This is a pretty simple layout. You can get a lot fancier if you like.

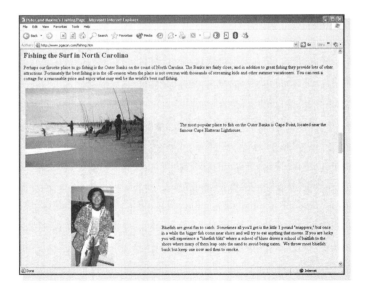

Figure 6.3
Personal photos displayed on a custom web page.

The advantage of authoring your own web page to share your photos is that you are in complete control of the formatting and layout and can let your creative urges run wild. On the downside, it does require some software skills and time, and maybe you would rather be out taking more photos than sitting in front of the computer creating web pages. If that's your situation, you can turn to one of the automated online album generating programs (an online album is sometimes called a web gallery). This is software that runs on your computer and lets you combine a series of images into a web page complete with captions and formatting. These programs are easy to use and can create very attractive, professional looking results. Once you have created your album, you must upload it to your website. You can then give the URL to friends and others who you want to share the photos with.

Figure 6.4 shows an example. This album, which I created with Photoshop, displays photos I took while on vacation recently. Like most online albums, it displays a "filmstrip" of all images and then a larger version of whichever image the user clicks.

An automated album generator does most of the work required to create an attractive web album of your photographs. While the details differ from one product to another, the basics are pretty much the same. You'll need to perform the following tasks:

Figure 6.4
An online photo album created with Photoshop.

- Selecting the photos to include in the album.

- Choosing a theme or template. This determines the background, colors, border, image size, and other aspects of the album's appearance. All album software products that I have used include a nice selection of predefined templates.

- Adding captions to the individual photos.

Paint Shop Pro does not include album tools, but a sister program from the same publisher, Paint Shop Photo Album, does (along with a number of other features). Let's take a look at creating an online album with this program.

Tip: Getting Paint Shop Photo Album
You can download a trial version of this program at www.jasc.com/products/photoalbum/?. The trial version is fully functional and will run for 60 days. After that period you'll have to pay the registration fee to continue using the program.

Here are the steps to follow:

1. Start the Paint Shop Photo Album program and make sure the Browse tab is selected along the left edge of the program window.

2. In the left panel, navigate to the folder on your hard drive where the photos are located. Thumbnails of the photos will be displayed in the program's right panel (see Figure 6.5).

Figure 6.5
Selecting photos to include in the web album.

3. Right-click any image and select Add Image Title and Description from the popup menu to open a panel where you can add a title and description for the image. Adding at least a title is important; otherwise the image file name will be used for the image's caption in the web gallery.

4. If any images need rotating, right-click the image and select Rotate from the pop-up menu.

5. Select the photos to be included in the web album by holding down the Ctrl key and clicking each image. Or, select all images by pressing Ctrl+A.

6. Select Share|Create Web Gallery. If you selected a lot of photos, it will take the program a while to process them.

7. At this point, the program will display the gallery templates, as shown in Figure 6.6.

8. Select a template in the left panel and view it in the right panel.

9. Click the Adjustments tab to change the gallery background and text color.

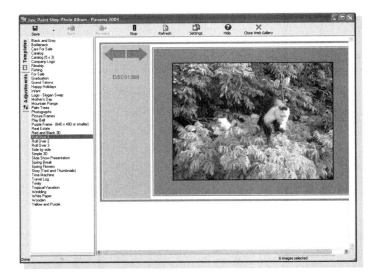

Figure 6.6
Selecting a template for the web gallery.

10. When the gallery is the way you want it, click the Save button and select one of the following:

- Save to Drive. The album will be published to a folder you select on your hard drive. This is useful when you want to create a distribution CD, as discussed in the next section.

- Publish to Web Site. The album will be published to your website. To use this option, you must know the URL (address) of your website as well as the username and password required for publishing.

Whether you publish to a local folder or to a website, the album is the same. It consists of a series of web pages, each linked to the previous and next ones, plus some subfolders containing support files. The URL will be as follows:
http://*YourWebSite*/**JascPaintShopPhotoAlbum**/*AlbumName*/**image001.htm**

- *YourWebSite* is the URL of your website

- *AlbumName* is the name you assigned to the album

You can give this URL to your friends and family to let them view your photos using their web browser.

Do You Yahoo!?

Yahoo! is an extremely popular web site, offering just about everything from auctions to travel information and movie reviews. As you might expect, it also offers some photo-related services, specifically online photo albums and print ordering. As with other photo sharing services, you must use a computer to upload photos to Yahoo!—it does not accept photos sent by email.

To try out Yahoo! photo sharing, you must have a member account (which is free). You'll be asked to log on before you can create or use a photo album. Here are the steps required:

1. Go to **www.yahoo.com**.
2. Click the Photos link. (It is hard to find—look for it in the Organize section.) Yahoo! will display the Yahoo! Photos page (see Figure 6.7).
3. Use the commands on this page to view any existing albums, create new albums, and upload photos.

Yahoo! photo sharing is pretty basic but as a result it is easy to use. If you use Yahoo! for other things that may be a good reason to share your photos there as well.

Figure 6.7
Yahoo! offers a basic but free and easy to use online sharing service.

Tip: Attention Mac Users!
Apple Computer offers a great application called iPhoto that offers many things a dedicated digital photographer might want. It can organize your photos, enhance their appearance, and share them via print and web. Check it out at www.apple.com/ilife/iphoto/.

Tip: Creating Web Albums Using Photoshop
Web album capability is built into the Photoshop program. To create an album, select File|Automate|Web Photo Gallery and then follow the prompts to select photos, choose a template, and create the album. It does not offer a publish option—you must save the album to disk and then manually publish it to your website.

Distribute Your Photos on a CD

Another way to share your camera phone photos is to create a CD that you can send to friends and family. To do so you need a so-called *CD burner* installed in your computer. These have become quite reasonable recently and are a common component in new systems. The blank CDs are quite cheap too. If you decide to create a CD of your photos, there are several ways to go about it.

The first is simply to burn the photo files onto the CD. The recipient will be able to open the CD and view each photo using their graphics program. This method works but does not provide for photo captions, creative backgrounds, or an automated way to move from photo to photo.

One better approach is to create a web album as described in the previous section. Save it to your hard disk and then burn the entire album to the CD. The user can insert the CD and use their browser to open the album's first page. The result will be the same as if they were viewing the album on the Web.

Another way to put photos on a CD is to use slideshow software. A slideshow is like a web album with added features such as narration and background music. Most slide show software offers to ways to burn the show to a CD. One is for computers—in other words, the recipient puts the CD in their computer's CD-ROM drive and the slideshow plays on the monitor and speakers. The other is for television—the CD can be played in your DVD or VCD drive and viewed on the TV.

Tip: Making a Slideshow
Ulead Photo Explorer and DVD Photo Slideshow are two popular programs for creating slideshows. You can find details and download a trial version of these programs at www.ulead.com/pex/runme.htm and www.dvd-photo-slideshow.com/.

Using Replay TV and TiVo to View Your Photos

Replay TV and TiVo are the two best-known names in digital video recorders (DVR), devices that connect between your cable box and your TV and provide for digital recording of TV shows. If you have a computer network in your home, you can connect your DVR to the network, permitting you to copy your digital photos to the DVR and view them on your TV. It's a lot more fun to view photos this way than to have everyone crowd around your computer screen! See **www.replaytv.com** and **www.tivo.com** for more information.

Online Photo Sharing Services

A photo sharing service lets you upload photos and store them in online albums. You can then direct your lucky friends to the proper Web address for viewing your creations. This differs from the online albums that were covered earlier in the chapter in that, instead of creating the entire album on your computer and uploading it to your own website, you need only upload your photos to the service's website and use one of their predefined albums. This is a great way to go for those who don't to have their own website.

Tip: Sharing Photos vs. Using Moblogs
Is photo sharing the same as a moblog? No. A moblog is one way to share photos, but moblogs are specialized to receive photos directly as email sent from your handset. You'll learn all about moblogs in Chapters 7 and 8.

The various online photo sharing services differ in their photo manipulation tools, the degree to which you can customize the design of an album, security features, and ease of administration. They also differ in price. Two that I know of (Sacko and Yahoo!) are currently free while the others charge modest fees.

There's a lot of overlap between these photo sharing services and the online print services that were covered earlier. Some of the print services also offer online

sharing, and the sharing services all offer prints through a partnered printing service. Generally, however, the sharing services offer more sharing options than the print services, such as more control of the appearance of your albums. Table 6.1 lists several popular photo sharing services.

Table 6.1 Photo sharing services.

Name	URL
SmugMug	www.smugmug.com
Sacko	www.sacko.com
Funtigo Deluxe	www.funtigo.com
PhotoSite	www.photosite.com

Tip: Finding Online Photo Sharing Services
You can find online photo sharing services in a variety of places where you might not expect them. See the sidebar about Yahoo!, for example. Some of the larger low or no cost web hosting services such as Tripod and Geocities are just as good. If you already subscribe to some web hosting or service, it may be worth your while to check out if they offer photo sharing first.

An Online Sharing Tutorial

To give you a feel for the process of using an online sharing service, let's walk through the steps required to create and online album. I will use Sacko (www.sacko.com) because it is both easy to use and free. I think it is a great place to get started with online albums.

Creating an Album and Uploading Photos

The first step is to go to www.sacko.com and create your account. The only information you need to give is your email address, which they promise not to use for spam. You'll receive your password by email shortly and then you can log on to your account. You'll see that Sacko will have created a sample album for you to experiment with. But let's get started creating a new album and adding some photos to it. Sacko offers three ways to upload photos:

- Multiple photo upload using an ActiveX control that is supported by Internet Explorer browsers and Netscape browsers version 6 and higher on the Windows operating system. You may be prompted to download an ActiveX control and should select Yes.

- Multiple photo upload using Java, a technology that works on many browsers that do not support ActiveX and on non-Windows operating systems.

- One photo at a time upload using an HTML tool that works with all browsers and operating systems, including OSX for the Macs.

Sacko is very good at selecting the proper method for your computer and software. Here are the steps required to create an album and upload photos using the ActiveX control method in Internet Explorer:

1. Click the Add Photos tab on the Sacko web page. Sacko displays the web page shown in Figure 6.8.

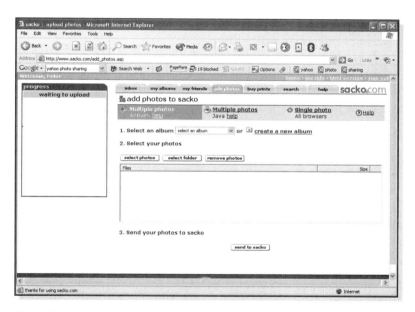

Figure 6.8
Uploading photos to a Sacko album.

2. If you want to use an existing album, select it from the Select an Album list and continue with Step 5.

3. If you want to create a new album, click the Create a New Album link. Follow the prompts to create a new album, assigning it a name, description, and privacy level (more on this soon).

4. After the album has been created, it will be listed in the Select an Album list. Select it and continue.

5. To select individual photos, click the Select Photos button. Use the dialog box to navigate to and select photos; hold down the Ctrl key while clicking to select more than one file. When you are finished, click Open to close the dialog box and add the files to the main list. Repeat as needed to select photos from other folders.

6. To select all the photos in a particular folder, click the Select Folder button. Use the dialog box to navigate to the desired folder; then click the Scan button to add all photos in that folder to the list.

7. Click the Remove Photos button to remove all photos from the list and start over.

8. Click the Send to Sacko button to begin the upload process. The window on the left side of the web page will display a thumbnail of the photo currently being uploaded as well as a progress bar showing progress for the current photo and overall progress.

When the upload is complete, you'll see a message reminding you that you have to share your album for anyone to be able to see it. Then you can click the link to view the photos you just uploaded.

> **Note**: *When you create an album in Sacko, you can make it either public or private. A public album can be viewed by your friends and they can share it with other people who are not your friends. A private album can be viewed by your friends only—they cannot share it with others.*

Sharing Your Albums

The sharing of photos in Sacko is based on a Friends list. You must enter a person's name and their email address in this list in order to share your photos with them. Entering a person's name and email address in your Friends list also creates a personalized Sacko account for them and will automatically notify them when they are identified in a photo (another Sacko feature I'll explain soon). You can also enter a person's name with no email address but you'll be limited to identifying this person in photos and will not be able share photos with them.

To work with your Friends list, click the My Friends tab of the Sacko screen. You can use the links on the My Friends page to add new friends and to view or delete existing ones. Note that you, as the account owner, are automatically listed in your own Friends list.

When all the people you want to share photos with are in your Friends list, here are the steps required to share photos with them:

1. Click the My Albums tab to display a page with icons for each of your albums.

2. Click the Share link under the album you want to share. Sacko displays a dialog box, shown in Figure 6.9, with a list of all your friends and a place to enter a message.

3. Select those friends you want to share with. If you have already send an invitation for this album to a friend, the Resend Invitation option will be available below the person's name (as shown in Figure 6.9).

4. Click Save to send the invitations.

Figure 6.9
Sharing a Sacko album with friends.

Each person that you have shared the album with will receive an email containing your message, a thumbnail view of the album, and a link they can use to go to Sacko and view the album.

Identifying People in Photos
One really nice feature of Sacko is the ability to identify people in photos. When people view the photos, they will be able to tell who is whom. To do so, open an album and click the desired photo to display it in the Sacko Editor. (This editor has other features, but I will not be covering them here.) This is shown in Figure 6.10. You can see, directly above the photo, that it says "In this picture>> No one identified."

Figure 6.10
A photo displayed in the Sacko Editor.

Follow these steps to identify a person in the photo (the person must be in your Friends list for this to work):

1. Click the words "In This Picture" directly above the photo. Sacko displays a smaller version of the photo along with your Friends list.

2. Click the name of the person you want to identify to put a check mark next to it.

3. Click the Highlight in Photo option under the person's name.

4. The list of Friends is hidden and a small circle is displayed at the mouse cursor. Move the mouse (without clicking) until the circle is centered over the person's face in the photo; then click.

5. The Friends list is displayed again. If you want a bubble caption to be part of the photo, click the Bubble Caption option under the person's name.

6. Enter the caption text in the box and click Update.

7. Repeat steps 2 through 6, if desired, to identify other people in the photo.

8. Click Next to move to the next photo in the album, or click Show All Pictures to close the editor and return to album view.

When a person views a photo that has one or more people identified in it, they can move the mouse over the person's name or the person in the photo. The caption will be displayed and the person will be displayed in an enlarged circle, as shown in Figure 6.11.

Figure 6.11
Viewing a photo on Sacko that contains an *identified* person.

Other Sacko Features

Sacko has quite a few features and tools beyond those I have described:

- The ability to share individual photos as well as entire albums
- A search tool that lets you locate all photos containing a specific identified person
- Online print ordering

You can explore other Sacko features on your own. I hope that this brief introduction has convinced you that online print sharing is easy and fun.

Specialty Sharing Software

Leave it to the computer geeks to come up with ever more creative ways for you to share your photos. Here are a few of them.

Hello (**www.hello.com**) builds on the popular Instant Messenger model to provide you with an easy and instant way of sharing your photos. With Hello, your messages can include not only text but photos as well. You and your chat partner (both must have the software) can look at the same photos and exchange oohs and ahs by message.

PiXPO (**www.pixpo.com**) takes a different approach to sharing. You create a photo album on your computer and provide direct access to the album using a technique called peer-to-peer networking. A simple text chat tool is included as well. Both you and the viewer must have the software and an Internet connection.

Finally, the popular Microsoft Network (MSN at **www.msn.com**) has a new product called Photo Swap. Available only to premium subscribers, it lets you share photos with other MSN members.

Wrapping It Up

You can get much more enjoyment out of your camera phone photos by sharing them. In today's connected and computer-savvy world, there are many ways to share without having to make prints. You can email photos directly from your camera phone, which is perhaps the fastest and most immediate way to let others see what you are photographing. You can also transfer the photos to your computer and put them together into an album, which can then be made available on your website or burned to a CD-ROM for distribution. Last but not least, you can use one of the many online photo sharing services to upload your photos and make them available for viewing by friends and family. Don't be shy; get your photos out there so we can see them!

Chapter 7

Moblog Madness

Moblogs are the latest and greatest way to share your camera phone photos. But they are about more than just sharing. The are essentially a new generation of blogs that were ushered in by the mobile age, hence the name "moblogs." Because of the widespread use of camera phones, moblogs are becoming really popular. Many people are now using their moblogs to make personal statements of some kind. Moblogs tend to be a bit edgy, weird, creative—you name it! Of course, some moblogs are also boring, but what's boring to you or me may not be boring to someone else. It's all about personal expression. And with a moblog, the whole world is your audience.

In this chapter I'll be introducing you to moblogs, and in the next chapter I'll show you how to create your own moblog. Once you get the hang of it, you'll be surprised at how easy they are to create. But before you start creating one of your own, I suggest that you look at as many moblogs as you can so that you can gather up ideas. This will also help you develop a full understanding of the possibilities for moblogs.

Why a Moblog?

To make a short story even shorter, first there were web logs, text journals or diaries about anything and everything: personal life, politics, art, sex, you name it. The term *web log* soon was shortened to *blog* (the noun) and pretty soon *blogging* (the verb) came along too. A blog may include pictures as well as text. There's

really no strict definition, but in general they are all or mostly text. Today there are thousands of active blogs on the Internet. Some of them have become so popular that they actually generate a revenue stream.

Some Popular Blogs

If you are interested in blogs and want to do some exploring, here are few that I find interesting.

BoingBoing at **www.boingboing.net** touts itself as "a directory of wonderful things." The posts on this blog are pretty wide ranging, but if there's any theme to it I would have to say it's about how technology and culture influence and fertilize each other. It's run by five coeditors (or perhaps coconspirators would be a more apt description!) and is loaded with fascinating tidbits about science fiction, films, robotic technology, and just about anything else you can imagine.

The Blogs of War (**www.blogsofwar.com/**) is not exactly a fun site, being devoted to news and comment on the war in Iraq. It's not one sided; you'll find both pro- and anti-war comments here, but the postings are often very thought provoking.

The Agatha Experience at **www.theagathaexperience.com/** is an edgy counter-culture blog that includes somewhat random posts on everything from religion to sexuality and politics.

At Cliff's Notes (**www.cliffsnotes.info/**), some guy named Cliff regales you with odd news stories, commentary, and apparently anything and everything else that pops into his fertile mind.

As mobile wireless devices became more widespread, the concept of mobile blogging became popular. The big advantage is that users can add to their blog while on the go. Needless to say, *mobile blog* soon was shortened to *moblog*. Initially, the term *moblog* did not refer specifically to photos, but the ability to include photos along with text was very popular right off the bat. At present, a moblog is generally understood to contain photos. It is not necessarily limited to photos taken with a camera phone, but that's the general trend. Some moblogs limit the size of pictures, so you will not be able to upload multi-megabyte images from a digital camera.

Camera Phone Obsession

I make sure to always have my camera phone with me when I am traveling.

You may be thinking that a moblog is not much different from the photo sharing services that I discussed in Chapter 6. In some ways they are, in fact, quite similar. After all, they provide a way to post photos on the Web for others to see. There are, however, some things that set moblogs apart:

- You can add photos by email. You don't need to upload your photos from a computer (although you can in most cases).
- Your photos can be made publicly visible to anyone who visits the moblog site.
- Viewers can comment on your photos.

As time goes by, I think we will see more and more overlap between photo sharing and moblog services. For example, a moblog will start to offer the ability to order prints and a sharing service might start accepting email uploads.

Resource for the Mikan Moblog:

This is a wonderful moblog documenting everyday life in Japan: www.kamoda.com/moblog/. The site is updated almost every day and is a terrific example of how the seemingly ordinary aspects of life can, when photographed and combined in a moblog, make an interesting and compelling story. Of course, the fact that the subject is Japan makes it a bit more exotic to westerners! Recent subjects include local shrines, fishing trips, unusual food finds, and children's school performances.

The Culture of Moblogging

Some people think of moblogs as just another way to share photos on the web, not really all that different from an online album or sharing service. Wrong! Technically there are certain similarities, but moblogging has developed its own culture that sets it apart. What is this culture? Well, you can't even say that all mobloggers are on the same wavelength, so there's no defined "culture." But perhaps this is exactly what the moblog culture is—a lack of a defined culture! No rules, no famous mobloggers from the past to imitate, no books to read. It's really, more than any other photographic medium, a "do it your way" kind of thing. As a result moblogs tend to be weird, edgy, and outrageous. Of course you'll find a lot of dull stuff out there too, there's no avoiding that. But with a little searching I bet you'll find some material that really grabs you!

How Do Moblogs Work?

The first step in creating your own moblog is to find a service provider and create your account. Many offer the service for free, others charge a small fee. Some offer a public moblog with ads for free and require a fee for a private or ad-free moblog. You'll find a list of moblog providers later in the chapter.

Once you have set up your account, you will be given an email address. The email address is for sending photos to your moblog. You can send a message to this address with a photo attached and, presto, it appears in your moblog. Some services let you attach more than one photo to an email message. Others automatically use the subject and/or text of the message for the photo's caption and description in your moblog. Otherwise, you will have to log on to your moblog to edit/add photo captions and descriptions.

You'll also be given a URL that links to your moblog. You can send this URL to people you want to see your photos. There are some more details that differ from one service to another, but these are the basics.

Adult Content

Some moblog services permit adult content, and you may want to take this into account when selecting a service provider. Those that do permit it require photos with adult content to be so marked and allow viewers to filter out these photos if desired. Even so, such a site may not be the best choice for letting Aunt Emily view

your vacation photos! You should be aware that it is essentially impossible for a moblog service provider to monitor all the images that are submitted, so you can never tell what will be posted even if not officially permitted. In my experience, inappropriate content is not common at all, but it does occur. Table 7.1 later in the chapter provides information about which moblogs permit adult comment.

Public versus Private

A public moblog is open to one and all for viewing. In fact, some moblog providers display an ever-changing album of recently uploaded photos on their main page. Yafro is one example, as shown in Figure 7.1.

Figure 7.1
Newly submitted public photos are displayed on Yafro's main page.

I think that public access is the heart and soul of moblogging. It creates a community of camera phone users who can view and comment on each other's images. I love looking through other people's moblogs, getting a feel for how they see the world and what they find interesting. Seeing other people's photos is a great way to get new and creative ideas for your own endeavors.

Still, there will be times when you do not want every Tom, Dick, and Harriet looking at your photos. For these situations, most moblog providers offer private moblogs that can be viewed only by people you specify. Access may be controlled by a password or by a private URL that only you and your friends know. You submit photos to a private moblog by using a different email address than you use for your public moblog.

In the Field: Moblogs and Activism

Blogs have become a popular tool for political, environmental, and other kinds of activism. Howard Dean's 2003 campaign for the Democratic presidential nomination was perhaps the first widely known use of blogs and other internet tools for a political candidate. Dean's blog is still active at **blog.deanforamerica.com/**. When you combine pictures and text, the message can be even more powerful—enter the activist moblog.

One example of this is the group CASPIAN, an acronym for Consumers Against Supermarket Privacy Invasion and Numbering. This group, whose web site is at **www.nocards.org/**, works against retail marketing schemes that imfringe on individual's privacy, such as the well-known supermarket "loyalty" discount cards. One of this group's new target is Radio Frequency Identification, or RFID. Miniature chips are embedded in a product or its packaging to allow the item to be tracked remotely. As part of their protest activities, CASPIAN has started the Stop RFID moblog on TextAmerica where protesters can share photos and stories. You can view this moblog at **stoprfid.textamerica.com**.

The war in Iraq has stirred a lot of passions, and regardless of your position it's always a good idea to be well informed. One way to do this is visit the moblogs of soldiers who are stationed in Iraq. These moblogs usually do not express a particular "pro" or "con" opinion—they just show how things are over there. Given how interesting some of these photos are, you may wonder about the military's supposed ban on camera phones at military installations in Iraq (see Camera Phones in the Field in Chapter 2).

Finally, with the U.S. presidential campaign in full swing, supporters of both candidates are making good use of moblogs to help organize and motivate the campaign workers. For example, there's a John Kerry moblog at

kerrysocal.buzznet.com/cat/. Surprisingly I could not find a moblog supporting George Bush. Does this mean his supporters are not as "with it" technologically?

Camera Phone Obsession

Moblogs and Community Spirit

Some moblog service providers have demonstrated their public spirit by creating community moblogs for important local, national, and even international events. Some recent examples are the Northeast blackout (**http://blackout.textamerica.com/**), the California wildfires (at **http://fire.textamerica.com/**, see Figure 7.2), and anti-war demonstrations. The sponsor publishes an email address for submitting photos and the public is welcome to contribute. If you are interested in finding community moblogs your best bet is to Google for "community moblog." If you want to start one, check out your moblog service provider's terms for community moblogs.

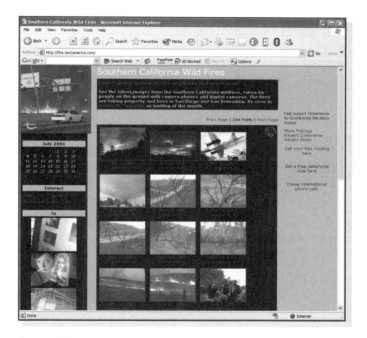

Figure 7.2
Textamerica's community moblog of the California wildfires has some amazing photos.

Choosing a Moblog Service

To be honest, choosing a moblog service is not that big a deal. Most are free, or offer free trials, so it's easy to try a few out and see which one you like. This is particularly true if your main motivation for setting up a moblog is to share your pictures with friends and family.

> **Resource for the Bento Moblog:**
>
> This unique moblog is a Japanese mother's documentation of the bento lunches she makes for her two children every weekday: http://mito.typepad.com/photos/bento/.

If, however, you are more interested in the public community aspect of a moblog, it will be worth your while to do some investigating. Most mobloggers really enjoy having their images out there where lots of other like-minded people can see them. They also like seeing other people's images, making comments, and engaging in discussions. For this, you will be best served by a moblog service that is popular and has lots of members and visitors. The only reliable way to check this out is to spend some time at each of the services, looking at other people's blogs, reading comments, and getting a feel for the amount of activity and interaction that is going on. I have listed about a dozen moblog service providers in Table 7.1 along with a brief description of what each offers.

Table 7.1 Moblog service providers.

Moblog	URL	Comments	Adult Content
20six	www.20six.co.uk/	Based in the United Kingdom, 20six offers free basic private and public moblogs to anyone who registers.	No
Albino gorilla	www.albinogorilla.dk/	Albino Gorilla is located in Denmark. Because Danish is used on the website, it is not that useful for people who do not speak this language, but you can still enjoy the photos.	No
Blogger	www.blogger.com	Blogger started out as a text blog service and remains more text than photo oriented, but it does permit photos to be included in posts. The service is free.	No

(continued)

Table 7.1 Moblog service providers (*continued*).

Moblog	URL	Comments	Adult Content
Buzznet	www.buzznet.com/	Buzznet offers free personal and community moblogs and is planning to introduce premium subscription services in the near future.	No
CamBlog	www.camblog.com/	CamBlog offers basic moblogs at no cost.	No
Eachday	www.eachday.net/	Each day is a hybrid between a moblog and a more traditional photo sharing service. The cost is about $7.00 per month, with a free three-month trial available.	No
Fotolog	www.fotolog.net	A large and popular site that offers free basic moblogs and premium services for a fee.	No
Mlogs	www.mlogs.com/	An active and well-designed service. The basic plan is free; a premium plan is free for a trial period.	No
Photokyo	www.photokyo.com/	Almost completely Japan oriented.	No
Ploggle	www.ploggle.com/	Smaller service based in England that is trying to compete with the big boys. A free basic account lets you upload a limited number of photos. Paid accounts with fewer restrictions are available as well.	No
Rare Window	www.rarewindow.com/	One of the less-active sites, but offers good basic services for free.	No
TextAmerica	www.textamerica.com	Probably the largest and most popular service. Offers free public moblogs with ads. For a fee you can have a private and/or ad-free moblog.	No

(*continued*)

Table 7.1 Moblog service providers (*continued*).

Moblog	URL	Comments	Adult Content
TypePad	**www.typepad.com/**	A popular and well-designed moblog host with more user options than most. Offers a basic account at a modest fee and a premium account at a higher cost.	No
Yafro	**www.yafro.com/**	A very edgy and popular moblog.	No

Roll Your Own?

Do you really need a moblog service? Can't you create a moblog on your own website? Well, yes you can, but it's not for the faint of heart. The hackers, web heads, and hardcore camera-phoners among us may want to explore the world of self-run moblogging, but it's not easy. Let's take a look at the details.

The one basic feature of a moblog is that it will automatically display photos, and in some cases text, that is sent via email. Seems simple enough, but these things do not happen by magic. Someone has written a program that runs on the web server, receives the email, and processes the photos and text to appear in the moblog. This is all custom software—it is not something you can get at the local computer store. So the bottom line is that if you want to create your own moblog on your own website, you will have to write the software yourself or find some user-supplied scripts on the Web. Before doing so, you should consider the advantages and disadvantages.

One advantage is that everything is completely under your control. How photos are displayed, which photos are displayed, formatting—everything can be exactly as you want it. You do not have to settle for the formatting and options offered by a moblog hosting service.

Another advantage is that the moblog is, in fact, on your website and not somewhere else. This is important if you are an individual or small business with an established website with lots of regular visitors. If you are going to start a moblog, you want to tell visitors they can find it on your site rather than directing them to some third-party service.

Don't ask!

Hosting Your Own Moblog

The technical details of how to set up your own moblog are beyond the scope of this book, but here is some background information, as well as some pointers. There are several different technical approaches that can be used, and the one you select will depend on your knowledge and on the type of web hosting you are using (for example, Linux or Windows). Most people will use Perl scripts, Active Server Pages (ASP), or PHP, although there are certainly other ways to do it. As far as I know, there are no commercial products designed specifically for moblogs, although the Radio Userland software (**http://radio.userland.com/**), while designed primarily for web publishing and weblogging, can be adapted for photos as well.

You may want to start from scratch and write your own code, but you can also contact other do-it-yourself mobloggers and ask for advice. Here are some resources:

- Joi Ito has a very popular moblog that he runs himself. He offers information about how he did it at **http://joi.ito.com/archives/2002/12/26/mail2entry_script_for_mt_moblog.html**.
- At **www.danger-island.com/~dav/blogpost.pl**, you'll find a Perl script that you can use as a starting point for your efforts.
- Brandt Kurowski has made his script public at **http://brandt.kurowski.net/blog/blog/moblog/**.

- Another script can be found at **http://ben.milleare.com/archives/000133.html**.

For most camera phone users, however, a moblog hosting service is definitely the way to go. Remember, the main point of a moblog is that it's part of a community that is sharing their day-to-day photo experiences with one another. With a hosting service, you have a ready-made community—something that can be difficult or impossible to attract to a do-it-yourself moblog. It's not much fun putting your photos in a moblog if no one else sees and comments on them!

Eric gets an unpleasant surprise when viewing his roommate's moblog.

Publicizing Your Moblog

It is not realistic to expect a lot of people to visit your moblog, particularly if you host it yourself rather than have it hosted by an established moblog service provider. In either case, you may want to spread the word to attract visitors. Hopefully your moblog will be interesting enough to draw people back after their first visit. Here are some publicity ideas:

- If you have friends and family who might be interested, let them know about your moblog.
- Visit other people's moblogs, and when you leave comments, include an invitation to view yours.
- Include a link to your moblog in the signature you use for email messages and Usenet postings.
- If your moblog has a specific theme or subject, post an invitation on any relevant newsgroups or chat boards.

Make sure your moblog has a decent amount of content before publicizing it.

Wrapping It Up

Moblogs are a fascinating new phenomenon that is linked directly to the spread of camera phones. They are a perfect example of how technological advances can fertilize changes in our culture. Moblogs are used for everything from important social commentary to personal diaries—and that's exactly how it should be. A moblog should be thought of as a medium, just as painting and sculpture are media—a means of personal expression with as few constraints as possible.

Chapter 8
Moblogs Step-by-Step

I hope that the previous chapter sparked your interest in moblogs. They are really a lot of fun, and because you can try your own moblog for free, you have nothing to lose. Moblog services are designed to be easy to use, but the first steps of setting up a moblog are not always as clearly explained as they should be. In this chapter, I will walk you though the steps of creating and using a moblog on three of the available services and one hybrid service. I am not necessarily endorsing these four services over the others (you'll find a list of moblog service providers in Chapter 7). I chose the three for this chapter because they offer a good cross section of what's available.

Please remember that because these are Web applications things change, and by the time you read this some of the details of the moblog services discussed here may have changed. Even so, by following these guides you should be able to figure out what to do.

Using Textamerica

Textamerica provides an active and feature-rich moblog experience. Its home page, shown in Figure 8.1, is busy with photos and links, including these:

- Randomly selected recent photos
- Last commented, most commented, most viewed, and highest voted images

Figure 8.1
The Textamerica home page displays lots of images and links.

- Editor's Pick images
- A link to Textamerica Times, the moblog's community "newspaper"
- Links to frequently asked questions (FAQs), a user guide, camera phone tips and tricks, and other information

Textamerica offers many options and features and, to be honest, its website is a bit confusing. If you want a moblog service that is easy to use, look elsewhere. If you're willing to put in the time, however, Textamerica provides a lot of bang for the buck. In this section, I'll walk you through the basics, and then you can explore all the extras on your own.

Here are some of the basic features that Textamerica provides (and ones that you might not realize from a quick look at its home page):

- Images you provide will be displayed publicly by default, but you can pay a little extra to set up a private moblog.

Dang, I *still* can't figure out how to take a picture.

- You can upload multiple photos at once or send photos from your PC via email. You can also post as many photos as you want.
- You can set up nice visual displays such as slide shows.
- The service tries to enforce a PG rating, and thus they do not allow nudity.
- You can customize your moblog by using scripts and other features

Creating Your Basic Moblog with Textamerica

Creating your Textamerica account requires a simple registration. You can set up your account in just a few minutes. The steps involved are as follows:

1. Go to the Textamerica main site at **www.textamerica.com**.
2. Look for the Register Now button or a link to register and click the button or link. This will take you to the registration screen, which should look like the one shown in Figure 8.2.

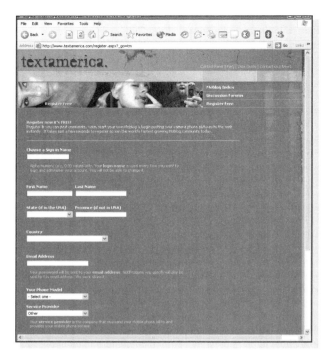

Figure 8.2
Using the Textamerica registration page to enter your account setup information.

3. Using the registration page, you need to specify your screen name and also enter your real name, email address, and some information about your camera phone model and service provider. Make sure that you enter all of the information required and then click the Submit button.

4. After you submit the registration information, Textamerica sends you an email message that contains your temporary password. Make sure that you put the temporary password in a safe place. You'll need this information so that you can log onto your account. Once you log in, you can change your assigned temporary password to a password of your own choosing.

Once you have set up the basics for your account, you can sign on to your account and set it up the way that you want it. Here are the steps to follow to set up your account:

1. Log into your account (if you are not currently logged in) by entering your sign-in name and password. You can log in from the Textamerica home page.

2. Once you log in, go to the Control Panel that Textamerica provides. This is where you create and manage your moblogs.

 In this section you will find a menu with a number of options including:

 My account: This is where you can change your password and update your profile.

 My images: This is where you can view your uploaded imagery and initiate transfer from a PC (real camera phone users).

 Notifications: Lets you know when new photos or other entries have arrived.

 Favorites: Lists your favorite Textamerica Moblogs.

 Links: Lets you create other useful bookmarks.

 Slideshows: Lets you organize photos into slideshows or view previous efforts.

 You will also find buttons for help functions and of course a big Create Moblog button.

3. The first thing I suggest you do is change your temporary password to one that you want to use and can remember. This is under the My Account function.

4. Next, you'll be ready to create a moblog on the web page shown in Figure 8.3. To do this, click the create Moblog button which will bring you to the opening form where you can set it up by filling out key information.

5. The Moblog Admin screen (see Figure 8.3) lets you assign your moblog a title of your choosing and also a domain name. This name will be how you and others view your moblog. For example, if you use the name stevezmblog, then you and others will be able to access your moblog by pointing a web browser to **http://stevezmblog.textamerica.com**. If you choose a name that is already in use, you'll be prompted to enter a different one.

 You also have to enter a secret word for the moblog. This word acts like a password because you need it to email photos to the moblog. The email address for submitting photos will be *domainname.secretword***@tawm.com**. By keeping this word private, you prevent others from adding photos to your moblog. For example if your domain name is smith.textamerica.com and your secret word is black then the email you'd use to send photos to **smith.black@tawn.com**.

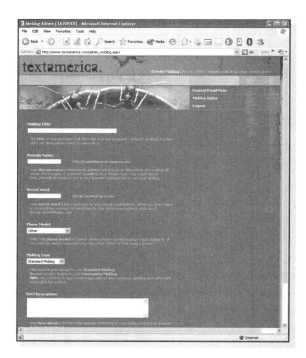

Figure 8.3
Creating a moblog on Textamerica.

Tip: Receiving Posting Notification
You can also check a box to have Textamerica automatically send you an email message when anyone posts a comment to one of your moblogs. This is a nice feature because you do not have to regularly log on and check your moblog for new comments./

Next you must specify the type of moblog you want to set up:

- Standard: Only you can post photos.

- Community: Anyone can post photos; however, you must approve submitted photos before they will be displayed.

The final action you must deal with is registering the type of service you want. There are three options:

- Free personal blog gives you more then enough for most casual users.

- Premium Personal gives you some great extra features which are good if you are posting as many as 4 to 5 images a day or you want to be part of a small group posting imagery.

- Commercial: Lets you go totally wild and is great if you're doing something for your store, business, or just a large personal project that's going to post hundreds of photos in a short span.

Textamerica lets you create as many moblogs as you want, within reason, at any rate! Basic moblogs are free, but they come with some potential drawbacks:

- Ads are displayed when someone views the moblog.
- They are not private; anyone visiting the Textamerica site can view your photos.
- You can't upload imagery directly from your PC—you can only email it.

If you want an ad-free and/or private moblog, you need to sign up for Textamerica's commercial services, available for a modest monthly or annual fee. You'll see Upgrade links scattered all over the Textamerica site. You can't miss them!

6. Once you are done entering all of your information and selecting the options you want, click the Create button to finish the process.

Using Community Moblogs

Textamerica's intention is for its community moblogs to be used for actual community events such as political rallies, natural disasters, graduation ceremonies, and the like. The terms of use say that a community moblog should receive submissions from multiple people and also be linked to from various sites. They reserve the right to revoke community status from a moblog that doesn't meet these criteria, although I do not know how strict they really are.

Of course, you can let anyone you want post to your private moblog. What makes a community moblog special is that Textamerica features it in the Community Moblog section. Textamerica has certain criteria for community status. To create a community moblog, you must first have a regular moblog that is in use. You then submit it for review by following these steps:

1. On the Textamerica home page, click the Community Moblogs link.
2. On the Community Moblog page, click the Suggest a Community Mob link (Textamerica refers to their moblogs as "mobs" in some places).
3. On the next page, review the community moblog requirements and enter the URL of the Textamerica moblog you want to submit.

4. Click the Submit Mob button.

The people at Textamerica will review your moblog and inform you if it was accepted as a community moblog. If you have a community moblog, then when you log on to your Textamerica account and go to the Control Panel, you will be informed if any images are waiting to be approved. You can then view the new images and approve or disapprove each one. Approved images will immediately become available in the moblog. Note that you are responsible for all images in a community moblog that you moderate and Textamerica's rules against nudity and racist content do apply.

Customizing Your Moblog with the Control Panel

Textamerica gives you a great deal of control over your moblog's appearance. In your Control Panel, there is an entry for each moblog, as shown in Figure 8.4. This figure shows a single moblog; if you had more than one, each would display in the Control Panel the same way.

Figure 8.4
The Textamerica Control Panel has an entry for each of your moblogs.

You can see that for each moblog there are four tabs across the top. You use these tabs as follows:

- Entries: Click this tab to view the moblog entries and add or edit titles, descriptions, and comments. You can also delete individual photos.

- Template Design: Click this tab to design the appearance of your moblog, setting features like background colors, design themes, photo layout, and image links. See "Using Templates" later in this chapter for more details.

- Categories: Click this tab to assign categories to your moblog. By assigning descriptive categories such as "antique cars" or "Chinese food," you make it easier for other Textamerica users to find your photos.

Friends visiting from Japan knew more about camera phones than I did!

- Web Traffic: Click this tab to display statistics about how many people have visited your moblog.

The Control Panel also displays several other links for each moblog. They have the following functions. These are displayed in two areas:

On the left hand side:

- The moblog title or Edit: Click either of these links to view and change the moblog title, domain name, secret word, or description.

- Address: Click this link to create an email message addressed to the moblog. You can then attach images and send them.

- Change: Click to change the number of images displayed per page, maximum image size in pixels, and whether visitors are allowed to comment on your images.

In the middle are a set of links in a menu:

- Change Site Settings: Same as change.

- Who Links to Me: Click this link to see if any other users have linked to your moblog.

- Hi-Light Reels: This lets you assemble a number of images from your moblog into a vertical bar that displays constantly on the side of your moblog making it easy to highlight the best stuff amongst all your photos.

- Add to TA Directory: This lets you add your site to a directory of all the sites on TextAmerica.

Even something as ordinary as a garden hose can make an interesting pattern.

On the right hand side:

- The thumbnail image: Click the image to view your moblog as visitors will see it.

- Delete: Click this link to delete the moblog and all images in it.

Tip: Getting Help Using Instant Messaging
TextAmerica has customer service reps active via IM some parts of the day. They use AOL instant messenger. If you don't have this program visit **www.aim.com** to get your own free copy. Clicking on the IM help links and you will automatically launch AIM. This lets you interact via chat with customer service representatives.

Interacting with Other Users

When you have logged into Textamerica, you can browse other people's moblogs, leave comments, and generally participate in the community. The site is designed so you can navigate it in many ways, there's no one right way to do anything. Clicking any small photo will take you to another page where that photo is displayed at a larger size. Figure 8.5 shows an example. The details of how the photo displays and what options are available will depend on how the person has set up their moblog. Here are some of the things you may be able to do:

- Rate the photo on a scale of 1–10.

- Read comments that others have written.

Figure 8.5
Viewing an individual photo in a Textamerica moblog.

- Add your own comment.
- View the person's links (for example, to their personal website).

Tip: Keep Your Moblog Civil
One of the beauties of a moblog is that you are exposed to a lot of different opinions. Unfortunately, this can cause some people to get a bit hot under the collar. While it's not too common, in my experience, sometimes you'll find some rather nasty exchanges that include profanity, insults, and personal attacks. My advice is to take the high road and remain civil at all times. If you disagree with someone, you can express your opinion in a way that is not insulting or threatening. If you are attacked, ignore it. Remember, resorting to insults and foul language is usually a sure sign of being wrong!

Working with Favorites

Textamerica has a system called *favorites* that lets people link to other Textamerica moblogs that they find interesting. You can add other moblogs to your favorites,

and other people can add your moblog to theirs. To add a moblog to your favorites, first display the moblog in your browser and note its domain name. In the browser's address bar you'll see this: ***xxxxxx*.textamerica.com**. The *xxxxx* part is the domain name. Make a note of this. Then follow these steps:

1. Go to your Control Panel.
2. Click the Favorites link to open your Favorites page (see Figure 8.6). This will display any favorites you may already have.

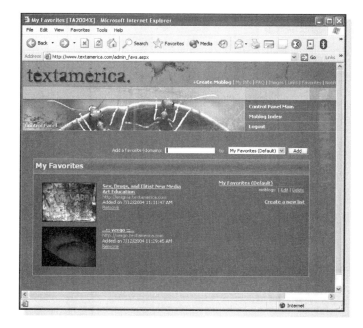

Figure 8.6
Your Favorites page lists your current favorite moblogs and lets you add new ones.

3. Enter the moblog's domain in the Add a Favorite box.
4. Click the Add button.

You can also see who has made your moblog one of their favorites by clicking the Who Links to Me button in your Control Panel.

Here's how favorites work. When anyone views your moblog, they will also see thumbnail images from your favorites along the left edge of the screen. Likewise, when someone views the moblog of someone who has made you a favorite, they

will see a thumbnail of your moblog in the same way. By clicking these thumbnails, a Textamerica user can quickly and easily move among moblogs as defined by people's favorites links—a good way to find related photos and topics.

Using Templates

Textamerica lets you customize the appearance of a moblog by the use of templates:

1. Display your Control Panel. It will have an entry for each of your moblogs and each of these entries will have a series of tabs along the top.

2. Click the Template Design tab for the moblog you want to customize.

3. On the next page, click the Design Your Moblog Step-by-Step link.

4. The next page displays an assortment of predefined moblog designs, as shown in Figure 8.7. You will need to scroll to see all of them. Select the desired design by clicking the option button above it; then click the Next button at the bottom of the page.

5. The next page displays a selection of moblog elements that you can choose to display or not, along with your photos. These include an interactive

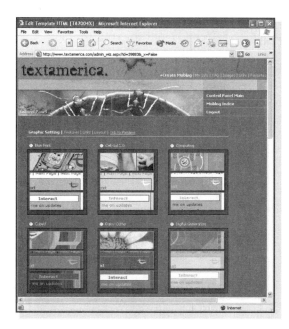

Figure 8.7
Selecting the base template design on Textamerica.

A fog bank suddenly appeared to create this lovely photograph.

calendar and a Notify Me link for subscribers. You can also enter a screen name and email address to be included, if desired. Make your selections and then click the Next button.

6. On the next page, you can set an option to display your favorites in your moblog (see the section on using favorites earlier in this chapter). You can turn this on or off. Then click Next.

7. The final step is to select a layout for your moblog. You can choose one of four, as shown in Figure 8.8. After you make a selection, click Finish.

Figure 8.8
The final step is selecting the moblog layout.

There's nothing permanent about a moblog design, of course. You can always modify it later.

Textamerica is a popular, active moblog site. I particularly recommend exploring its community moblogs—some of them are a blast!

In the Field: Receiving Webcam Pictures on Your Handset

This story isn't about using a camera phone to take photos, but rather about using your handset to receive photos taken elsewhere. I'm sure you have heard about webcams. Here a camera is set up and hooked to a computer. The camera is programmed to take a photo every so often—every 30 seconds, perhaps—and the photo is posted to a web site where it can be viewed. Many webcams are public, but they can also be used privately, as a surveillance or security tool, for example.

Viewing a webcam requires web access, and despite significant advances in mobile technology, few people will always have a wireless-enabled laptop computer or PDA with them at all times. What if you want to view your webcam images at any time—you may want to check your company's security webcam while out to dinner? Thanks to a new service offered by EarthCam (**www.earthcam.com**), you can.

Called EarthCam Mobile, the service lets you receive webcam pictures on your handset. You can set up a profile with the identities of the webcams you want to see, selecting from any of the webcams that are hosted by EarthCam. (If you want to view your own webcam, you must sign up for a premium account.) Then, all the selected webcams will be available to view on your handset. You can sign up for a limited free service or a more flexible paid subscription for a modest monthly charge. The service includes moblog hosting and a few other things. It's a really new twist on cell phones and photos!

Using Yafro

Yafro is one of the simplest and easiest to use moblogs and, seeing as it is free, would be a good choice for anyone wanting to try their own hand at a moblog. The home page, shown in Figure 8.9 displays a random selection of recently submitted photos. Many, but not all, of the photos on Yafro are from camera phones.

A quiet moment at home.

One consideration when deciding whether to give Yafro a try is that it is one of the moblog services that permits adult-themed images; in other words, nudity. You can choose to show or block these images, but even so it is probably not a good choice for some camera phone users.

Signing up for a Yafro moblog requires only that you fill out the registration form shown on the home page (see Figure 8.9). You need to enter your email address, a user or screen name, password, and some other information. The email has to be valid because Yafro will use it to send a message to you. This message will contain a link that you must click to verify your account. Your email will also be used by your friends to communicate with you (more on Yafro friends soon).

Once you are registered, you are provided with two important bits of information:

- An email address for uploading photos to your moblog. This takes the form *YourUserName.xyz*@yafro.com where *xyz* is a secret three-letter code that ensures that no one but you can upload to your moblog. This code is assigned to you.

- A URL in the form *YourUserName*.yafro.com that you can give to people to let them view your moblog.

A Yafro moblog is limited to pictures that are 200kBytes (200,000 bytes) or smaller in size in the GIF, JPG, or PNG formats. In addition to sending photos to your Yafro email address, you can upload them from a computer using a web browser.

Figure 8.9
To create a Yafro account, fill out the information on their home page and click Sign Up.

You can have only a single, public moblog at Yafro. In order to have more than one moblog you will need to register more than once.

Once you have uploaded photos to your moblog, you can log in at the Yafro website using your username and password. You'll be taken to your moblog where your photos will be displayed, as shown in Figure 8.10.

Clicking the photo itself or the commands listed next to each photo let you perform the following tasks:

- Click the photo to go to a page where the photo is displayed along with any comments that you or others added (more on comments later).

- Click Add a Description to add a short text description that will be displayed next to the photo. If the photo already has a description, this command will not be available. You can then use the Edit command to change the description.

- Click Add a Comment to add a comment to the photo.

- Click Edit to edit the photo's description, specify who can view it (anyone, your friends, or just you), and specify whether comments are allowed. You can also select the photo to be your profile photo (details later).

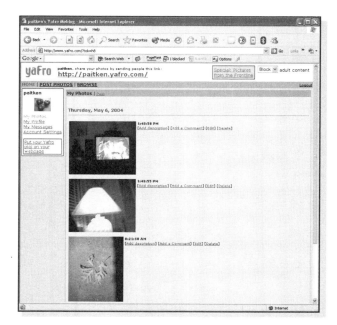

Figure 8.10
Viewing the photos in your Yafro moblog.

- Click Delete to remove the photo from your moblog.

The Yafro moblog is organized around the concept of *friends*. While you are browsing another person's moblogs (using the Browse command that is available on almost every Yafro page), you'll see an Add as Friend link displayed. Click this link to add the person to your friends list. This is similar to the Favorites list in Textamerica. By adding someone as a friend, you are in effect telling them that you find them and their photos to be interesting. A person you add as a friend can, but is not obligated to, reciprocate by making you one of their friends.

When a friend relationship exists, two things happen:

- Recent photos submitted by your friends are randomly displayed, as thumbnails, in your moblog.

- When you view the moblog of someone who has designated you as a friend, you can see the photos that they specified as viewable only by friends.

The end result of the friends system is that Yafro contains a complex network of people who share common interests. If you find someone who posts photos of,

say, antique motorcycles, their circle of friends is likely to include other motorcycle buffs. But then again, friends may share certain interests while being wildly divergent in others. It can be surprising to learn that an avid Harley-Davidson motorcycle collector also raises orchids. Exploring friends links can be a lot of fun.

When you sign up for Yafro, you'll be assigned a profile. Initially this is blank, and you can add as little or as much information as you like. This can include your real name, address, phone numbers, instant messaging accounts, keywords describing your interests, and a brief biography. In other words, you can remain completely anonymous or make yourself known—it's totally up to you. Your profile can also contain a photo—you select this photo using the Edit command that was described earlier.

The moblogs on Yafro stand out as weird and edgy—not all of them, of course—but if you are looking for the unusual, this is a good place to start!

Using Mlogs

Mlogs is an interesting sort of hybrid, straddling the line between a traditional text blog and a picture-oriented moblog. One unusual feature that I have not seen elsewhere is the ability to upload audio clips to your moblog. It's one of the better designed services, with a clean user interface.

Now that's a nice bubble!

To start your moblog, go to **www.mlogs.com** and click the Register Now link. The registration screen, shown in Figure 8.11, asks you to enter a user name, personal identification number (PIN), your name, and email address. Note that you also have to enter your camera phone number—this is required for some of Mlog's features to work properly.

The next screen lets you select a free basic account or a premium account. If you want to post pictures, you must choose the premium account—the basic account is for a text-only blog. At the current time the premium account is free for a limited period.

On the next page you specify some details about your moblog (see Figure 8.12):

- The title.

- The domain name. Your moblog will be available at *xxxx*.**mlogs.com**, where *xxxx* is the name you select. This will also be the email address you use to submit material (*xxxx*@**mlogs.com**).

- Whether the public can post to your moblog (select Yes to create a group or community moblog).

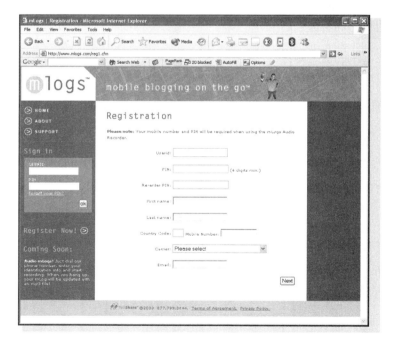

Figure 8.11
Registering for an Mlog account.

Figure 8.12
Selecting a name and look for your moblog.

- Whether an archive or calendar is displayed in your moblog. The effect of this setting depends on the layout you select (next step).

- The layout and color scheme of the moblog. Some of the layouts are predefined, others start out essentially blank and must be designed by you. Note that archives (previous step) are relevant only for user-designed layouts; the predefined layouts always display a calendar. I recommend using a predefined layout, at least to start. You can explore designing your own layout on your own.

When you are finished making your selections, click Next. Your moblog will be displayed—empty of course. While logged into your account, you'll see the following links displayed near the top of the page:

- My Account: Use this link to view and edit account information, such as your email address and mobile phone number.

- Add Entry: This link lets you add a text entry and/or upload a photo to your moblog.

- Edit Entries: Use this link to edit existing moblog entries.

- Settings: Lets you change moblog settings such as its title, whether it is public, and the archive display.

- Layout: Lets you change the moblog's layout and color scheme. On the second layout screen you can change the About and Links information that is displayed in your moblog by clicking the Edit buttons on the right of the screen. After making changes, be sure to click the Publish button to save them.

- Preview: Use this link to preview how others will see your moblog.

- Log Out: Exit your account.

One thing to note about Mlog is that while you are logged in and working on your moblog, it will not appear as viewers will see it. In order to preview its final appearance, you must use the Preview command as described in the preceding list.

Submitting material from your camera phone is a snap. Use the email address that you set up, which is *YourBlogName*@mlogs.com. Send a message with an attached photo to add it to your moblog. The message subject becomes the entry's title and the message text becomes the text.

Figure 8.13 shows what a final Mlogs moblog looks like with the layout and color scheme I selected. Your entries are listed with the most recent one at the top. A user can click a photo to go to that entry, where they will see a larger version of the photo and can view any comments that have been left and enter their own comment. You'll receive an email notification whenever a comment is added.

Mlogs' audio clip feature is easy to use. You will be provided with a toll-free number to call. Enter your PIN and record the message—it's that simple! You can also send an MMS message that contains a voice clip. The recording will appear in your moblog and users can click to listen.

If you want to explore other moblogs on Mlogs, go to the site without logging in. The home page, shown in Figure 8.14, has thumbnails from recent and features moblogs as well as a search feature. You can also select from the scrolling list of moblog titles near the top of the page.

One thing that Mlogs lacks is a "friends" or "favorites" feature. I hope that this is added soon because it is, I believe, the best way to help find moblogs that are of interest to you. The best thing you can do is use the Links feature, explained earlier, to list the links of a few moblogs you like on your moblog.

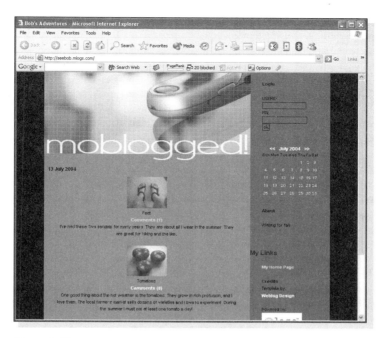

Figure 8.13
A visitor sees your moblog entries with the most recent one listed first.

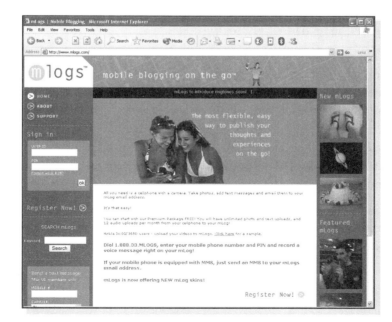

Figure 8.14
Start at the Mlogs home page to explore other people's moblogs.

Mlogs is one of the easiest moblog services to use and boasts an impressive array of users. The lack of a "friends" feature is the only major shortcoming—let's hope it's added soon.

Using Flickr

Flickr (**www.flickr.com**) is a cool service that lets you turn any existing blogging tool or service like Blogger.com, Typepad.com, or LiveJournal.com into a moblog. This is a great tool because not all of these services and others offer moblogging capability. So if you have an existing blog (as millions of you do) on any service that doesn't yet offer email based moblogging, you can follow these steps to turn your blog into a moblog:

1. Set up an account with Flickr.

This is pretty easy to do. Provide a username, password, and email. You can then provide some optional information such as first name, last name, timezone, gender, and more. You will need to confirm the account via an email link as well.

2. Once you've logged in you will have an active Flickr account. Flickr is another gallery and blogging tool but one great option is you can not only submit photos by email but you can ask Flickr to cross-post them to your other blogs. To set this process up, go to **www.Flickr.com/account/** and choose the **uploading photos via email** link.

3. Flickr will display an email address you can send photos too. The email address will be a weird combination of words and numbers like hunting89lazy@photos.Flickr.com. Fortunately you can reset it any time in case it starts getting some spam or someone you don't want to discovers it. Don't rush to use this email address though! That only sends photos to Flickr itself. Once you set Flickr up for moblog cross-posting it will modify this address slightly so you can send a photo directly to the blog you want to send it to.

4. Underneath the email address they give you is a line that reads, "Do you want to automatically post photos to your blog? Click here." Click that link and you'll be taken to a page where you can start to provide the info Flickr needs to properly cross post photos to your blog.

5. If you haven't told Flickr about any of your blogs you'll need to do that first. The Set Up A New Blog page starts by asking you the blog service or type of blog technology you use. Choose one from this list and proceed to the next step.

6. The next step will involve providing a username and password to your blog, and if you run your own blogging software, an actual Web address to the key login site for your blog. If you have multiple Web logs Flickr is even smart enough to let you choose the precise one you will post to.

7. Once Flickr has determined and stored exactly how to log in to the backend of your blog you're nearly done. The next step is to choose a custom blogging template that denotes where an image will be placed and how the text will display around or near it. You can choose some basic templates or even customize them further. Once you're done here it gets added to your cross posting list and you can test it out easily.

8. With a blog set up you can now send photos by email to them. Go back to the page listed in step 4. This will now show you a list of blogs you've registered with Flickr and three image sizes Flickr can resize photos to when it receives them. Choose small, medium, or large and click next.

9. Once you finish configuring the moblog option, Flickr will list the specific modified email address to use to send moblog entries through Flickr to your personal blog. This entry is usually the address listed in step 3 with 2blog appended to it (e.g., hunting89lazy2blog@photos.Flickr.com).

10. At this time you can only tune Flickr to post to one blog via moblogging. I'd bet though that if Flickr proves popular they may offer an option to have multiple blogs. Keep in mind also that Flickr offers lots of other photo hosting features so be sure to check it out from time to time.

Tip: Another Flickr-Like Service
Another similar service to this one offered by Flickr is provided by MFOP2 (which stands for Moblogging For Other People Too) and can be found at http://new.bastish.net/cgi-bin/mfop2/index.cgi.

Setting Up Your Own Moblog System

I included a sidebar in Chapter 7 to introduce the idea of creating your own Moblog but let me provide some more information and resources here. For most camera phone users, using a good moblog service like the ones described in this chapter is the best way to go. Some people who run their own blogs and servers, may want to set up their own custom moblog. Unless you use Flickr (which I just described) this requires a lot more work. At this point, let me outline some resources for those of you who are familiar with servers, and scripting languages like PHP or Perl:

- Ben Millare has written a great tutorial at **http://ben.milleare.com/archives/000133.html** that details how to modify a Moveable Type blog (**www.moveabletype.org**) to work as a moblog.

- pMoblog is an add-on script for popular blogging software pMachine (**www.pmachine.com**) and can be found at **www.sacredsmile.com/moblog/**.

- Mark Tremblay has created a Perl script for moblogging which you can read more about at **http://pansapien.com/geekstuff/moblog/**.

- For those of you using Radio Userland (**www.userland.com**) a great blogging tool there is a tutorial on adding moblogging capability to it at **http://nipernaadi.kolhoos.ee/nipernaadi.root**.

- Moblogger extrodinarre Joi Ito (**joi.ito.com**) has a lot of resources for moblogging script extensions to popular sites. Check out this one for Moveable Type users **http://joi.ito.com/archives/2003/03/12/mail2entry_moblog_code_update.html**.

- **Kablog.org** has a ton of personal moblogging tools for popular camera phones.

- For those of you running Perl-based sites an extensive *Unix/Linux knowledge base can be found at Joi ito's Mail2Entry script site- ***http://joi.ito.com/archives/2002/12/26/mail2entry_script_for_mt_moblog.html***.

- If you are looking for home-grown scripts for hosting your own moblog you can find them at Moblog scripts— **www.danger-island.com/~dav/blogpost.pl**.

- Here is a good source for finding home-grown software for the .Net platform for creating your own moblog host— **www.fperkins.com/MoblogSoftwarewritteninVB.Net.html**.

- Finally, here is a good source for finding script resources for hosting your own moblog created by Brandt Kurowski—**brandt.kurowski.net/blog/blog/moblog/**.

As moblogging matures, we can expect more do-it-yourself scripts coming. My best suggestion is that major blogging tools like Moveable Type, pMachine, B2, and Radio will gain increasingly sophisticated moblogging features. While the hosted sites will be the easiest systems to use, those of us intent on having total control of our sites and moblogs scripts will want to use some of the resources that I have provided.

Promoting Your Moblog

By now you should have a moblog or more than one. That's not the same thing though as having lots of people looking at it and enjoying it. If you put your moblog on a service like TextAmerica you're bound to get some traffic just from the thousands of people who go there everyday. To do more then just attract the casual surfer, you'll need to promote your moblog. So what are some things you can do? Here some obvious ideas and some not so obvious ones:

- Start by emailing everyone you think would be interested in following your moblog. Send them a simple email invite to your moblog. As you make major updates you might re-mail them as well. Make sure the link to your moblog is in the first few lines of your email.

- It's critical to write great and relevant captions to all your photos. This makes it easier for people to find you with search engines. Keep in mind that the search engines won't know one picture from the next if you don't also have some accompanying text.

- Crosslink: Find moblogs that cover your topic and ask them to link to you if you link to them. This means visiting the other major moblogging sites I mentioned in Chapter 7 and using the search features for them to find other mobloggers with similar interest.

- Get your site noticed on blog directories like **www.Blogwise.com**. You can submit your blog at **www.blogwise.com/submit**. Other blog directories include **www.blogdex.com** and **www.rootblog.com**.

Wrapping It Up

There are at least a dozen moblog hosting sites that offer free or low-cost moblogs to anyone who is interested. The sites vary a lot in their complexity and also in the services and features they offer. In this chapter, I have provided step-by-step instructions for getting started with three of the most popular moblog services and one hybrid service. It's not that difficult once you get used to it—and it sure is a lot of fun. I love visiting other people's moblogs to see all the weird, creative, and wonderful photos they are taking. I also love having other people comment on my photos. I may not agree with every comment, but hey, that's what moblogging is all about!

Chapter 9

Camera Phone Legal Concerns and Etiquette

The camera phone culture embraces freedom and creativity. The last thing that most camera phone users want to worry about is stuffy matters of legality and etiquette. The unpleasant fact is that you do need at least some awareness of these matters. Some concerns have been around since the first camera was invented. Others are new, having cropped up with the development of camera phones. This chapter will explain how privacy and legal matters may affect you and will also provide some guidelines for your own photo-taking activities. I wrote this chapter from the perspective of laws and customs in the United States. Remember that things may be different in other countries and when you travel you should try to gain at least a basic awareness of the local customs regarding photography. Remember also that I am not a lawyer, and while I have done my best to provide accurate information, I can make no guarantee that it will apply to a situation that you may find yourself in.

What Are the Legal Concerns?

When you are out and about taking photographs, you need to be mindful of some important legal issues. There are three major areas to consider from a legal point of view:

- Where you can and cannot take photos
- What subjects you can and cannot photograph
- What you can do with photos you have taken

As you'll see, there are more restrictions on what you can do with a photograph than there are on the act of taking it. You need to pay more attention to the use of a photograph than to where and when you took it. But still, all are important.

Where Can You Take Photos?

The general rules as to where you can take photographs are as follows:

- In a public place you are free to take photos.
- In a private place it is up to the property owner.

As with any rules, there are exceptions. For one thing, there is often some confusion as to what exactly constitutes a public place, with some places that seem public actually being private (see the sidebar "What Is a Public Place?" for details). Other places are clearly public but have restrictions on photography. Courtrooms and police stations are two examples of public places where photography restrictions are likely to be in place. Finally, in response to the recent terrorist attacks, photography of certain public facilities such as bridges and water supplies has been restricted. The fear is that terrorists could use photographs to help in planning an attack.

What Is a Public Place?

Some places, such as a city park or a public street, are undeniably public and there are few restrictions on what you can do photography-wise. Other places are obviously private—a person's home or a company's office space, for example. In such a case, the owner has the final say as to what you can and cannot do there. But a lot of places fall in between. Is a shopping mall or a restaurant public? Private? It's a bit of both, actually. Such places are public in that the general public is welcomed and the owners cannot deny you access on a whim or based on discrimination. They are, however, private property, and as such the owners or managers have a lot of control over what behaviors and activities are permitted, including taking photos. If you are snapping away in a mall, don't be surprised if a security guard asks you to cease and desist, and possibly to leave as well.

So, what's a photographer to do? I'm afraid there is no easy answer to that question. Some places will have "no photography" signs posted, which makes things perfectly clear. Otherwise, the direct approach is to find someone in authority and ask, but

Taking photos from a car can be fun—as long as you are not driving!

that can be a major inconvenience and is certainly not conducive to taking spontaneous photographs. Plus, even if you do find someone in authority, they will probably not know the answer and will say no just to play it safe.

My approach in most public places is to go ahead and shoot. This applies to many public/private places as well, such as shopping malls, flea markets, sporting events, amusement parks, and the like. I have almost never been given any trouble for this, and the few times I have it was simply a request to stop. The worst I have heard happening to any photographer is a request to erase any photos already taken.

Taking Photos on the Sly

In the early twentieth century, the famous photographer Paul Strand had his camera equipped with a mirror so he could take photos at a 90-degree angle to the way he was facing. His subjects were mostly people on the streets of New York City, and this ruse helped him to get some fascinating candid shots that might not have been possible if the subjects knew he was photographing them.

Needless to say, Strand was not using a camera phone! Sneaking a photo is even easier for us because camera phones are small, have no focus adjustments to worry about, and have a wide field of view. You can often get the photo without even looking at the screen—just point the handset at the subject and snap away. I've

gotten some nice photos while walking around town by holding my handset with my thumb on the shutter button and my arm hanging normally. With a little practice, you can get pretty good at this sort of "blind" aiming.

According to a BBC report, however, sneaking photos in Japan is becoming ever more difficult. Camera phones are more common and have been around longer in Japan than anywhere else. People have gotten pretty good at recognizing the posture of someone who is taking a photo with their camera phone as opposed to making a call or playing a game.

I am not advocating sneaking photos in places you shouldn't, but you may still want to be surreptitious with your camera phone even when photography is okay just to keep your subject from reacting to you.

What (and Who) Can I Photograph?

In terms of photographing things (as opposed to people), the rule is "anything goes." The only exception that I know about is with regard to installations or facilities that are restricted due to military security or worries about terrorist attacks.

Does this apply to private property as well? Yes. A property owner can restrict your activities while on the property only. For example, a mall owner can prevent you from taking photos while in the mall, However, they cannot keep you from

This may look like an abstract painting, but it's really lily pads on a pond.

taking picture of the mall while you are standing outside on a public sidewalk or road. They do have a say in what you can do with such a photos, as will be discussed later in the chapter.

Tip: No Photos on Planes
You should not use your camera phone to take photos on a plane. Even though you are not making a call, the handset will search for the network when it is turned on and could interfere with the plane's instruments. So, courtesy and privacy issues aside, using a camera phone on a plane is a no-no.

Photographing people is a more complex matter. Legally, the rules are pretty much the same as for taking pictures of objects: you are free to photograph people in a public setting (including malls and so on). Again, what you can do with the photo is another matter. But just because something is legal does not mean it is always a good idea. When people are involved, privacy considerations also come into play.

Many people don't mind being photographed when they're out in public. Others do, however, and I think that a photographer needs to keep this in mind from a purely ethical point of view. In other words, even if taking a photos is legal, do you really want to annoy and anger people by doing so? Your subject may not say anything, or they may get really angry and get in your face. The fact that you are within your legal rights to take their photo in a public place is not likely to mollify them. How, then, should you handle taking photographs of strangers in a public place?

Legislating Camera Phones

Camera phones and their potential for taking illicit photos has gotten a lot of press recently—more than deserved in the opinion of some! Roughly 15 bills have been introduced in 10 states dealing with one aspect or another of camera phones. Most of these bills deal with what you can and cannot do with the devices, or where they are or are not allowed. California is taking a different approach. A bill referred to as CA 1833 would mandate that all camera phones be designed to emit a noise or a flash when a photo is taken. The idea here is clearly to make it impossible for people to sneak a photo in places where they should not.

While this might seem to make sense at first, it is a misguided solution to the problem. It assumes that the problem lies in the camera phones themselves and not in the small number of people who use them to take illicit photos. For one thing, there are many situations where it is perfectly valid to take photos without alerting

Camera Phone Obsession

your subjects. More important, it would not address the real problem, which is that many consumers are not aware of appropriate and inappropriate uses of camera phones. Much better to educate consumers, and toward this end the Wireless Communications Division of the Consumer Electronics Association (CEA) has established a working group to promote camera phone etiquette.

For more information on state legislation related to camera phones, see CEA's State Legislative Status Report at **www.ce.org/members_only/public_policy/slsr/slsr_report.asp#WIRELESS_DEVICES/SERVICE**.

One approach is to be discrete. If they do not know they are being photographed, there will be no feelings of having their privacy invaded. And, if you do not make improper use of the photograph (as will be discussed next), there will be no future cause for bad feelings. While some may think that this is a bit sneaky, I do not think there are any ethical problems with it.

You can also just ask. As I have said, many people are flattered to have their photo taken. They may want to know what the photo is for, and you can say it is just for your personal use. If they say no, there is no harm done and no hard feelings.

Finally, use a bit of common sense. A homeless person dressed in rags is more likely to be sensitive about being photographed than a young lady dressed in her Sunday best.

Sunset in North Carolina.

Play It Safe!

Despite a wealth of evidence that using a cell phone while driving is dangerous, many people continue to do so. Will camera phones make things worse? According to TV station KCCI is Des Moines, Iowa, the answer is yes. A new form of "high-tech rubbernecking," as they call it, has been reported by police. Drivers passing an accident scene will open their window and hold their camera phone outside to take a photo—while still driving! Use common sense, people, and keep your cell phone put away while you are driving—even if you see Elvis or Sasquatch!

What Can I Do with My Photos?

Once you have your photograph, the next question involves what you can and cannot do with it. Some of these concerns are more relevant to the professional photographer and not to the camera phone user and moblogger, but it's still a good idea to have some familiarity with which uses are restricted and which are not. Note that this information applies primarily to photographs of people and then only to photographs that were taken legally.

Identifiability

Concerns about use of people photos come into play only when there are identifiable persons in the photograph. No identifiable people, no restrictions. The category of unidentifiable people would include people photographed from behind, in silhouette, or with their face not showing, such as a photo of someone from the waist down. It also includes photos in which a person's face has been digitally hidden. You'll see this technique used in some reality TV shows, as when a person being arrested by the police, their face is pixelated out.

Photos in which one or more people are identifiable may be covered under the doctrine of *fair use*. This applies to situations in which an identifiable person is photographed at a location where they are in full view of the general public. If you photograph a demonstration in front of the local courthouse, for example, the presence of identifiable people in the photo would be covered under fair use.

Private Use

Private use of a photograph is always legal. Private use includes the following:

- Hanging a print on the wall in your house
- Showing the photo to friends

- Including the photo in your portfolio

What about the Web? This question is obviously of interest to mobloggers. Putting a photo in a moblog is public in the sense that anyone can see it, but some Web presentations are considered "private." It all depends on how the photo is presented. A commercial photographer could not, for example, use a photo of a person on their business website without a model release because that is commercial use. Moblogs are not commercial, of course, but because they have not been around for long, the legal details are still fuzzy. The general consensus at present is that a moblog constitutes private use, so you should have no worries.

Tip: Watch Your Messaging
It's fun to send a lot of photos as MMS messages to your friends—but remember that they pay to receive these messages, and too many messages may clog up their handset memory. Don't overdo it, and respect your friends' wishes if they ask you to reduce the volume of messages you send. If you find that you are sending a lot of photos to certain friends, you might want to plan out a system where you send just the photos you need to from your camera to theirs and then email the other photos from your PC to their PC.

First Amendment Use of Images

The First Amendment to the U.S. Constitution provides broad protection for certain uses of images. In a nutshell, this means that photographs of identifiable people can be used for news, editorial, and some educational purposes without restriction. This is a good example of how the *use* of a photograph is more important than questions about taking it.

Suppose you got a photo of the mayor tippling in a local bar with a woman who is not his wife. You would be free to sell the photo to a newspaper or TV news station. You could not, however, sell or even give the photo to an agency for use in a public service campaign about the dangers of drinking. (Strictly speaking, you *could* give it to them but they couldn't use it.)

What about Model Releases?

Most everyone has heard of model releases, but what exactly are they and does the casual camera phone user need to be concerned with them? I'll answer the second question first. No; it would be very unusual for a camera phone user to have to

worry about model releases. Note that I said "unusual" and not "never," and I'll get to this in a moment.

A model release is a form that the subject(s) of a photograph sign giving the photographer permission to use the photo in certain ways. As I explained earlier in this chapter, there are many situations and uses in which the photographer does not need permission to use a photograph of one or more identifiable people. The main area in which model releases do in fact come into play is for commercial use of photos. Some uses are unambiguously commercial, such as using the photo in a magazine ad or billboard. Others are clearly not commercial, such as displaying a photo in a moblog. There are some gray areas, however.

Suppose you print and frame some of your photos and hang them at the local community center. So far there is no problem because the display is considered art (no matter how good or bad your photos really are!) and is not for commercial use. But what if the prints are for sale? Then you have crossed the line into commercial use.

Here's another example: If you have posted some photos on your personal web page simply as a way of displaying your work, it is noncommercial use. But if you are a professional photographer and post them on your business web page, it could be considered advertising for your business and thus commercial use.

The bottom line is that 99.9 percent of camera phone users will never need a model release. But by understanding the distinction between commercial and noncommercial use, you can be aware if you ever cross the line.

Resource for Model Releases:

Dan Heller's page at www.danheller.com/model-release.html provides a good source of information on legal aspects of photography and model releases. As I have mentioned, model releases are rarely a concern for the camera phone photographer, but it's still not a bad idea to be informed.

And the Ban Marches On

Bans on camera phones are becoming more and more common. Here are some examples.

The school district in West Lothian, Scotland, has banned all camera phones in both primary and secondary schools. The local authority said the ban was in the interest of the students' "safety, security, and well-being."

The Flex Fitness Center in Lubbock, Texas, is one of many gyms and health clubs around the country that have banned camera phones. They claim that there have been no problems yet but they are acting proactively to prevent them from occurring in the future.

Film studios are asking reviewers to leave their camera phones at home when attending previews of new films. They do not want unauthorized still photos of the movie to be leaked before the release date.

The legislature in Edmonton, Canada, has banned camera phones from the floor after the speaker chastised some members for "breaches of decorum."

Baltimore area courts are confiscating camera phones from people entering the courthouse and returning them when they leave. Cameras are not permitted in the courts except with special permission, but the ease with which photos can be taken secretly with a camera phone has prompted this action. The federal judiciary is considering a similar ban for federal courts.

The Kingdom of Saudi Arabia has banned all camera phones. The main complaint is one of morals because the devices are being used to photograph women on the street or without their veils, which violates certain interpretations of the Muslim religion. Despite this ban, camera phones are still freely available according to some reports. The ban is currently under review and may be lifted, but no action has been taken yet.

Some strip clubs have banned camera phones—it seems that looking is okay as long as you pay!

Hong Kong considered a ban on camera phones in swimming pools and locker rooms but decided against it. According to the secretary for home affairs, such a ban would have caused too much inconvenience for the vast majority of people who own such devices, who are law abiding and would never consider using them to take illicit photos.

In Kentucky, the Owensburg Board of Education has banned camera phones. Their concern is not only with taking of improper photographs, but with use of the devices for cheating.

Camera Phone Etiquette

Just because something is not illegal does not mean it is automatically okay. This is where the concept of etiquette comes into play. You wouldn't rush ahead of an

old lady to get the last seat on a bus, would you? Nor would you take a cell phone call while you are a dinner guest at a friend's house. And I'm hoping that you wouldn't cut in line at the bank. None of these things are illegal, but they are pretty universally understood to be wrong because they violate social norms of appropriate behavior, or in another word, etiquette.

The existing rules of etiquette have evolved over many years, and here's the rub. Camera phones have been around for a very short time, not long enough for very many rules to have developed. Think about cell phones themselves, which have been around for a bit longer. When they were first introduced, there were no generally accepted rules and a lot of users made themselves obnoxious blabbing away in restaurants, letting their phone ring in a meeting or a theater, and so on. Over the past few years, society has started to develop some rules, and things are slowly getting better.

Of course, cameras have been around for a long time, and many accepted dos and don'ts have been in place for years. Therefore, the first rule of camera phone etiquette is this: If you wouldn't do it with a regular camera, don't do it with a camera phone. The problem of course is that camera phones are smaller and less obvious that regular cameras, so it's a lot easier to take photos secretly. But just because you *can* does not mean you *should*. Table 9.1 presents some examples. These are not meant as rules set in stone, but they can provide you with some common-sense guidelines.

Table 9.1 Some camera phone etiquette guidelines.

Polite	Rude
Ask your subject if you can take a photo.	Stick your camera in someone's face without asking.
Avoid photographing people in embarrassing situations.	Look for embarrassing moments to photograph, such as when someone has spilled soup on themselves or is picking their nose.
Keep your camera phone put away when in a health club, locker room, or similar place.	Take your camera phone out in such situations, even if you are not taking photos.
Avoid sneaking photos in places you know you shouldn't take photos.	Sneak photos whenever and wherever you can.

If the fish aren't biting, you can always trade your fishing rod for your camera phone.

Resource for Phone Etiquette:

Here's an interesting article from the Associated Press on camera phone etiquette and abuses thereof: **www.cbsnews.com/stories/2003/07/09/tech/main562434.shtml**. The author presents some examples of bad camera phone behavior and discusses how society is still in the process of developing standards for what is acceptable and what is not.

Privacy Concerns

When taking photographs of people, you should be aware of the expectation of privacy that they might have. Of course, individuals differ in this, but you can use some common sense. When a person is in a shopping mall or on a city street, they know they are in a public place and will have reduced expectations of privacy. While in a restroom or their own home, they will feel differently, of course. I discussed this earlier in the chapter when talking about photographing people in public places. Most people will not feel that their privacy has been violated if you photograph them in a public place—but you should still use common sense and good judgment

Do We Need New Laws?

In the U.S. Congress, Representative Mike Oxley has introduced legislation dealing with privacy violations by camera phone users. According to Oxley, who is a former FBI agent, "If they use the phone and they take a picture of a person undressing, for example, and put it on the Internet, they could be fined and serve up to a year in jail under the statute." This law, if enacted, would apply only to people on federal property. It is meant to serve also as a model for states and cities who want to develop their own privacy statutes.

While there are no reliable statistics on the prevalence of the kind of "photographic voyeurism" that this bill is aimed at, officials are clearly worried that it could become more of a problem. Small, easily concealable cameras, including camera phones, only make the problem worse. And, of course, cell phones are used almost everywhere, and it can be hard to tell if someone is calling to order a pizza or taking a photo. While simple voyeurism is already against the law in most states, the new technology is prompting concerns about whether these laws need to be rewritten.

Other instances of privacy violation are blatant, and there is really no question that they are wrong. Here are some examples:

- Japanese police have arrested people using camera phones to take photos up the skirts of women in crowded stores and trains (one offender was fined over $4,000).

What is he laughing at?

Camera Phone Obsession

- In Asia, many people are concerned about photos being secretly taken of people in various stages of undressing in public bath houses and locker rooms.
- One woman was sued for surreptitiously taking photos of another woman in a public restroom and transmitting them to mutual acquaintances.

Another concern is perceived violations of privacy. You might never dream of taking a photo in a public restroom, but you might want to make a phone call. If someone sees you fiddling with your phone, they might get the wrong idea!

Remember, when taking photos of people, the one surefire safe approach is to ask.

You were just making a phone call - right?

Etiquette Dos and Don'ts

Aloysius Choong offers some common sense camera phone dos and don'ts and etiquette tips at **http://asia.cnet.com/reviews/handphones/ 0,39001719,39133939,00.htm**. Another source of general cell phone etiquette, including camera phones, can be found at **http://care.three.com.au index.cfm?section=Care&pid=1824&pageid=1861&flash=false**.

Interesting photos can be found almost anywhere.

Digital Stealing

Some store owners, primarily in Japan, have been objecting to people using their camera phones to take photos of pages in magazines or books and then leaving without buying the item. Is there anything wrong with this? Is it really stealing?

Stealing usually applies to physical objects. There's no question that someone who slips a book or magazine under their coat and leaves the store without paying is a thief. But people need to keep in mind that information is valuable as well. When you buy a magazine, you are not paying only for the paper and a few staples; you are also paying for access to the information and images in the magazine. When you realize this, you can only conclude that photographing magazines is in fact a form of stealing. So be cool and don't do it!

Shades of 007?

Samsung, one of the major makers of camera phones, has banned them in its research manufacturing facilities over concerns about industrial espionage. They are not alone—the United Kingdom's Foreign Office, the chip maker Intel, and Lawrence Livermore National Laboratories are among others banning camera phones out of fear that sensitive information will be photographed. Samsung is also one of several handset manufacturers who have initiated a public cell phone etiquette campaign, asking customers to refrain from taking inappropriate photos. They are apparently afraid of a public relations backlash that would cut into sales.

Wrapping It Up

Like any photographer, a camera phone user has to be aware of potential legal issues regarding taking and using photographs. In reality, the casual camera phone user rarely if ever has to be concerned with these matters, but it's a good idea to have at least some idea of what's legal and what's not. Legal issues aside, the ease with which you can sneak photos with a camera phone has opened up a variety of concerns about privacy and etiquette. By using your common sense, you can avoid pretty much all concerns about your subjects' privacy. Put yourself in their place and see how you would feel if someone were photographing you without your knowledge.

Remember also that a camera phone is a cell phone too, and that the basics of cell phone etiquette still apply. Turn it off or to silent ring in movies and lectures; don't make or receive calls in quiet restaurants...you know the drill!

Chapter 10

Cool Projects You Can Do with Your Camera Phone

There's a lot more you can do with your camera phone besides taking photos and emailing or moblogging them. Once you get your creative juices flowing, the possibilities are unlimited. This chapter presents some ideas for projects you can do with your camera phone. Most of these are not camera phone-specific, and you could do them with any kind of digital camera. That doesn't matter, though. What matters is being creative and having fun.

Scavenger Hunts

Have you ever participated in a scavenger hunt? They can be a lot of fun. In a traditional scavenger hunt, each person or team is given a list of items and the first one to find them all and bring them to "home base" is the winner. All sorts of variations on scavenger hunts have been developed over the years, including Polaroid (instant print) camera hunts. The latest variation involves—you guessed it—camera phones.

The basic idea of the hunt remains the same with camera phones. The one difference is that, rather than bringing the item itself, you take a photo and email it to the scorekeeper. You can keep score any way you want; here are some ideas:

- First person/team to submit gets 10 points, second gets 5 points, subsequent submissions get no points.

- First person/team to submit all required photos wins, second person/team gets second place, and so on.
- Anyone can win points based on how soon after getting the list they submit a photo: within 30 minutes for 100 points, within an hour for 60 points, and so on.

One nice feature of camera phone scavenger hunts is that you do not need someone to sit at their computer to receive and tally the emails. Since emails are tagged with receipt time when they arrive, everyone can join in the hunt and the scores can be figured out later.

Students Scavenging

What do Middle Tennessee State University, Clemson University, and the University of Buffalo have in common? They are among the 20 American universities where Verizon has sponsored a combination trivia quiz/scavenger hunt for the students. Called Urban Challenge, the hunt involved 125 teams of 2 students each, all equipped with camera phones (which they had to give back at the end—too bad!) The teams were sent trivia questions on their phones via text messaging; the correct answers to the questions were clues that led them to specific locations on campus, which they then documented with the camera phone. Yes, of course this was a marketing stunt by Verizon, but it provides some good ideas for interesting activities that can be organized using camera phones. You can find more details at **www.urbanchallenge.com/oncampus/register.shtml**.

Other than what???

Camera phone scavenger hunts are not limited to things. Another approach is to create a list of weird, embarrassing, or funny activities for the team members to do and then use the photos to document that they were really done. (This is well suited to camcorders, but that's another book!)

> **Resource for a Public Scavenger Hunt:**
>
> You'll find a public scavenger hunt to join at www.dodgeball.com/biggames/index.php. Participants are sent a hint by email every day and then score points based on how quickly they submit a photo. Unfortunately, this service works with only some cell phone service providers.

A scavenger hunt can be combined with other activities to help boost participation and interest. For example, suppose you are involved in a group that is trying to fight pollution and litter in your town and you want to create a photo show of particularly bad polluted/littered spots to help raise public awareness. Why not turn it into a camera phone scavenger hunt? By announcing a week-long hunt with small prizes, you can get more of the public involved and end up with a more complete set of photos than if only your small volunteer staff had participated.

Personalized T-Shirts

When's the last time you saw someone wearing a plain white T-shirt? I can't remember either—T-shirts always seem to have a logo or other design on them, front and back! Instead of choosing someone else's design, why not create your own? With a little work and creativity, you can create T-shirts that are unique. And with your camera phone, you are all set to capture the perfect image to use. But which one? I am sure you can come up with some ideas, but if not, here are some starting points:

- Put a picture of your significant other on a T-shirt for you and a picture of you on one for them.
- Were you on the team when your school won a baseball or basketball championship? Photograph the scoreboard with the winning score and make T-shirts for your teammates.
- Did you catch a big fish while on vacation—or even a small one? That makes a nice photo for a shirt.
- Your kid sister would probably love a T-shirt with a picture of her meeting Mickey Mouse when the family went to Disney World for vacation.

There are lots of possibilities, that's for sure! But how do you go about getting a photograph on a T-shirt? You have two choices. Your first choice is to use one of the many companies that specialize in this sort of thing. There may be a local company, but if not, there are many of them online (see Table 10.1). Note also that some of the online print services that are mentioned in Chapter 5 also offer T-shirt services.

Table 10.1 Some online companies that offer T-shirt printing.

Company	URL
Custom Ink	www.customink.com
T-Shirt Pros	www.t-shirtpros.com
BF Printing	www.bfprinting.com
Promo Peddler	www.promopeddler.com/Printable/Silk_Screening_Tee_Shirts.htm
Get In Print	users.erols.com/tshirts

Your second choice is to use what's called *transfer paper*. This is a special kind of paper that you use to print your image using an ink jet printer. Then you use an iron to transfer the image from the paper to the T-shirt. You may be able to find this paper at an art or printing supply store, or you can order it online. Table 10.2 lists some suppliers.

Table 10.2 Sources for transfer paper.

Company	URL
BestBlanks	www.bestblanks.com/transferpapers.html
Soft Expressions	softexpressions.com/software/notions/transfer.html
Thread Art	www.threadart.com/TS/trnsfr_paper.asp

Which method should you use? In my experience, a commercial printer always gives better results than transfer paper, but at a higher price. With commercial outfits, there is always a minimum order, so this option is best suited for situations in which you need a number of identical shirts, say for a team or club.

Transfer papers can give very nice results and are obviously better suited for creating one-off shirts. You'll have to buy a box of paper, typically 25 sheets or more, but

the price is reasonable—usually about a dollar per sheet for 8.5-x11-inch paper and two bucks for 11x17 inch.

Using a Commercial Printer

When ordering photo T-shirts from a commercial printer, you should talk to them to find out the details about preparing and submitting the image, or look on their web site for a submission checklist. You'll have to select the blank shirts too. Price depends on the quality of the shirt selected, the number of colors being used for printing, and the print locations (front and/or back of the shirt, and sometimes on the sleeves as well). The per-shirt price will decrease as you order more shirts, of course.

Tip: Not Just T-Shirts
Most commercial printers who do T-shirts also offer other printing services that you may want to explore. For example, you can have a photo put on mugs, mouse pads, hats, duffel bags, and sweatshirts. You may be surprised at the number of different materials and objects that can have a photo transferred to them!

Using Transfer Paper

If you have decided to try the transfer paper approach, you should carefully read the instructions that come with the paper. These instructions will tell you how to prepare the image, what printer settings to use, and other details, such as how long the print should dry before you transfer it to the shirt. Here are the basic steps you'll follow:

1. Measure the shirt to determine the desired image size.

2. Open the image in Paint Shop Pro or whatever graphics program you are using.

3. Flip the image left to right. This is necessary because when you transfer the image to the shirt, it will be flipped again, so by flipping it now you ensure that the final image comes out right. In Paint Shop Pro, select Image|Mirror to do this.

4. Select File|Print to display the Print dialog box (Figure 10.1).

5. Click the Properties button to set the printer options. For most transfer paper, you will set this for plain paper.

Figure 10.1
Setting print options in the Print dialog box.

6. In the Size and Position section of the Print dialog box, enter the desired print size. Be sure to select the Center on Page option.

7. Load the transfer paper into your printer, making sure the correct side is up.

8. Click the Print button to begin printing.

Once the print is complete, you'll need to let it dry for a while. Then you can proceed to transferring the image to your shirt, being careful to follow the paper manufacturer's instructions.

Panorama Shots

Sometimes your camera just will not take in the entire scene. If you are standing on the rim of the Grand Canyon, for example, there's no way that any camera, let alone a camera phone, can take in the full view. Here's where panorama techniques come in handy. You can take several overlapping photographs. For example, you can take one facing northeast, one facing north, and one facing northwest and then use software to stitch them together into a panorama shot.

How good are panoramas? That is, can you make a panorama that looks like a single photograph, or will they always look stitched together? To some extent that depends on the care you use in taking the photos and the time you are willing to put in to make the panorama. But that's okay because even a panorama that does not look perfect can still be very attractive.

This raven was not at all shy.

Once you have taken the photographs, you have two choices for creating the panorama. You can do it manually using a graphics editing program, such as Paint Shop Pro, or you can use a specialized panorama program, such as Panorama Factory. It does a great job, and it's easy to use, and what's better, it is shareware so you can download and try it for free and then if you want to continue using it, you just have to pay a reasonable registration fee. You can find out more and download a trial version at **www.panoramafactory.com/**.

Framing the Photos

It may be obvious, but I will say it anyway: photos to be used in a panorama must overlap. They don't need to overlap by a lot—10 percent of the width is fine—but it's better to overlap by more and be safe than to find out when it's too late that you missed an overlap.

Here's the technique I use to assure good overlap. When I take the first picture I notice some landmark near the edge of the image. Let's say I am taking the leftmost image first—I might notice a tree near the right edge of the image in the viewfinder. For the next image I will pivot to the right until that tree is near the left edge of the image and then take the second photo. Continue this way until all the photos you need are taken.

It's also important to keep the camera vertical for all shots, if possible. This makes it a lot easier to stitch the resulting photos together. If you cannot keep it vertical—perhaps you have to point it up or down to get the images you want—go ahead anyway. You can still make a great panorama.

Using Panorama Factory

Panorama Factory has a wizard that simplifies the task of creating a panorama. Note that all the photos that will be used in the panorama must be the same size, but that shouldn't be a problem if you are taking them with your camera phone. Of course, you must transfer the photos to your computer before getting started.

This demonstration uses the four photos shown in Figure 10.2. These were taken in Monument Valley in Arizona, and there was no way I was going to get the whole scene into one photo. I took the four photos, left to right, as shown here.

Here are the steps involved in using Panorama Factory to create a panorama:

1. Import the photos that will be used. Figure 10.3 shows the Panorama Factory screen after importing the four photos. You can use the tools in the wizard dialog box to rotate or change the order of the images, but that's not necessary here. Then click Next to continue.

2. The next wizard screen asks you what kind of camera you used. This information helps the program to perform the best stitching of the photos. Unfortunately, a camera phone is not one of the options that the program offers! I usually just accept the default settings, but you can experiment to see how the results come out.

Figure 10.2
The four photos to be combined into a panorama.

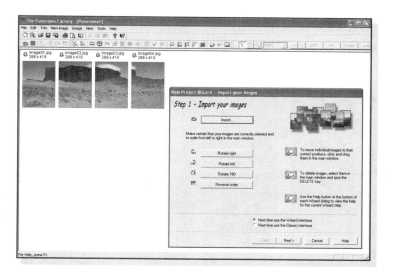

Figure 10.3
After importing images into Panorama Factory.

3. The wizard provides you with some options for the panorama process. Since the program recommends that you leave all these options turned on, that's what I do.

4. Step 4 of the wizard is shown in Figure 10.4. Set these options as follows:

 - Output Format: Select Image File Only. This creates your panorama as a standard image file, such as a JPEG. The other options are for specialized uses.

 - Partial Panorama: Select this option if your panorama is not a full circle (as in this example).

 - 360 Degree Panorama: Select this option if your panorama is a full circle—in other words, if your photos could be stitched together to create a 360-degree view.

 - Spherical or Cylindrical Reprojection. For standard panoramas, you should select Cylindrical. However the Spherical option can give unusual effects and may be worth experimenting with.

5. The next step is to select whether the panorama image should be prepared for Web display or for printing. The other options can be left at their default values.

At this point, Panorama Factory will stitch your photos together to create the panorama. The finished image is shown in Figure 10.5. The program will offer you options for saving or printing the image.

Figure 10.5
The final panoramic image.

There's lots more to the Panorama Factory program, and you can have fun exploring on your own. If you don't want to use a special program to create panoramas, you can do it yourself with an image editing program, as I discuss next.

Creating a Panorama with Paint Shop Pro

You do not need a specialized program to make great panoramas. You can use essentially any image editing program, such as Paint Shop Pro, for example. The process won't be as fast and easy, but the results can be great. In this section, I'll walk you though the process of creating a panorama this way. I'll use the same photos I used in the previous section. This will make it easy for you to compare. Note that when you use an image editing program to make a panorama, the photos do not all have to be the same size.

The first step is to load all of the photographs into Paint Shop Pro. At this point, when the images are still separate, you may want to make some adjustments to the

contrast, brightness, or color balance. Of course, you can do this to the completed panorama as well, and the rules to follow are these:

- If you need to make specific adjustments to one or more individual photos, do it now.
- If you need to make the same adjustments to all the photos, do it after the panorama is complete.

The next step is to create a new, blank image that will eventually hold the panorama. It must be the proper size to hold all the individual photos. Here's how to do this:

1. Activate one of the images you loaded by clicking its title bar. It doesn't matter which one if they are all the same size. If they are not, select the largest one.

2. Press Shift+I to display the Current Image Information dialog box, shown in Figure 10.6.

Figure 10.6
Getting an image's size from the Current Image Information dialog box.

3. In the Image section of the dialog, you'll see a line called Dimensions. The numbers on this line give the width and height of the current image. Remember to write these down.

4. The width of the panorama image will be the number of images times the width of each one. This will actually be more than needed because the images will be overlapped some, but you can always trim the image later.

For the current example, this is 4x288, or 1152 pixels. Let's call it 1200 to be sure you have enough working room. The height will be the height of one image, in this case, 419 pixels. Let's round up to 500. So, the new image should be 1200 pixels wide and 500 high.

5. Select File|New to open the New Image dialog box, shown in Figure 10.7. Make selections as follows:

Figure 10.7
Creating a new image to hold the panorama.

- Units: Pixels.
- Width: the calculated width, 1200 in this case.
- Height: the calculated height, 500 in this case.
- Color Depth: 16 Million Colors.

6. Click OK to create the new image. It may appear out of scale with the other images because Paint Shop Pro will scale it to fit on screen. The title bar of each image displays the percent of actual size that an image is being displayed at.

Tip: Changing the Viewing Size with Paint Shop Pro
You can change the viewing size of the active image by pressing the + and – keys on the keypad.

There's no need to stick your tongue out!

At this point, you are ready to start assembling the panorama. Here are the steps to follow:

1. Activate the leftmost image.
2. Select Edit|Copy or press Ctrl+C.
3. Activate the panorama image.
4. Select Edit|Paste|Paste as New Selection or Press Ctrl+E. The copied image appears in the panorama.
5. Move the mouse (don't click!) until the pasted image is at the desired location at the left edge of the new image. Click to anchor the image at this location. At this point, the panorama image will look like Figure 10.8.
6. Activate the image that is the second from the left.
7. Select Edit|Copy or press Ctrl+C.
8. Activate the panorama image.

Figure 10.8
After pasting the first image into the panorama.

9. Select Edit|Paste|Paste as New Selection or Press Ctrl+E. The copied image appears in the panorama.

10. Move the mouse (don't click!) until the image is at the desired location, overlapping the first pasted image so the elements of the image are in register.

11. Click to place the second image. The panorama will now look like Figure 10.9.

12. Repeat steps 6 though 11 for the remaining images.

13. The panorama at this stage is shown in Figure 10.10.

Figure 10.9
After pasting the second image into the panorama.

Figure 10.10
After pasting the all images into the panorama.

You'll note two things about the panorama at this stage. First, the image itself is quite a bit smaller than the blank image we created as indicated by the white space around the edges in Figure 10.10. Second, the top and bottom edges are uneven. This is due to the camera being pointed at a slightly different vertical angle for each photo. You may want to leave the jagged edges for effect, but you certainly should trim away the extra white space. Here's how:

1. Select the Selection tool by clicking its icon (a dashed rectangle) in the toolbox.

2. Drag in the image to place a rectangle around the area you want to keep. If you make a mistake, press Ctrl+D to cancel the selection and start over.

3. Press Shift+R to crop the image to the selection.

At this point you can make color and contrast adjustments to the image if needed. Don't forget to use File|Save to save the image. The final product is shown in Figure 10.11. You can now print it, post it on the Web, or whatever you like.

Refrigerator Magnets

About 100 years ago, some clever person realized that almost everyone needed a place in the kitchen to hang notes, the kids' drawings, postcards from friends, sale fliers, and other such items. As a result, the refrigerator was invented. And the invention of the refrigerator magnet followed soon after. Someone also realized that by cooling the inside of the box it could be used for food storage as well, but that's another story.

Figure 10.11
The completed panorama after cropping.

Just taking it easy.

The creativity of the people who design refrigerator magnets is amazing. Even so, wouldn't it be nice to make your own custom magnets using the super-cool photos you have taken with your camera phone? No problem!

One approach is to print your own photos and then insert them into blank magnets. You may be able to find the blank magnets at local craft stores, or you can order them online. Two online sources that I know about are Fridgedoor.com (**www.fridgedoor.com**) and Promo Peddler (**www.promopeddler.com/Printable/ Refrigerator_Magnet.htm**).

The other way is to have custom magnets made for you. You can contract with commercial firms to print your image on magnets. Of course, this is more expensive than doing it yourself, and there are almost always minimum order requirements, but if you have lots of friends or relatives, this might be the best option for you.

You can also make magnets from scratch. It's easy and requires only a minimal expenditure for supplies. This technique has the advantage that you can make them any size or shape that you want. Here's what you'll need (in addition to your printed photos, of course). All of these items can be found at craft and office supply stores:

- Thin, flexible magnets
- Medium-weight cardboard that will form the body of the magnet

- Spray adhesive or adhesive sheets
- Glue
- Clear spray coating
- An Exacto or other razor knife
- Masking tape

I prefer using the adhesive sheets over a spray adhesive because there's less smell and mess. If you decide to go with a spray, be sure to get one that's suitable for photos, and be sure to use it outside or in a well-ventilated place.

Adhesive sheets come in two kinds. One kind has adhesive on both sides, protected by peel-off backing. You peel the backing off one side and stick the photo to it and then peel the backing off the other side and stick the photo/sheet sandwich to the mounting board. The other kind of sheet had adhesive on one side only. You peel off the backing and stick the photo to it. Then you peel off the photo—the adhesive remains on the back of the photo—and discard the sheet. Finally you mount the photo. Either kind of sheet can be used for this project.

Family photos are nice—this is my "mummy."

As for the clear spray coating, there are many different kinds, and some are not suitable for photos. Be sure to read the label and/or ask to be sure before you buy. This, too, should be used with good ventilation.

Now that we've discussed the materials and techniques, let's get started. Here are the steps involved:

1. Print your photo a little larger than you want it to be on the final magnet. This larger size will give you extra room so that you can trim your photo later. Cut the cardboard to about the same size.

2. Mount the photo on the cardboard. Follow the directions for the adhesive you are using and be careful to avoid blisters or wrinkles.

3. Use your knife to cut away the edges to get the final magnet size and shape that you want. You can use a metal ruler to get straight edges. Use a sharp blade and cut slowly to get nice, clean edges.

4. Now it's time to glue the magnets to the back of the mounted photo. Use the largest magnets possible to give the best adhesion to the refrigerator. Remember, many people use their magnets to hold up pieces of paper and a weak magnet is likely to fall. You can use almost any household glue. If you use a glue gun, be sure to apply the hot glue to the magnet first to avoid heat damage to the photo.

5. Okay, you're almost done. After the glue has dried, it's time for the final step, applying the protective coating. First, put masking tape over the exposed surfaces of the magnets, otherwise the coating will reduce their holding power. Following the directions on the protective spray that you are using, apply a coat to the front and back of the magnet assembly. It's best to spray the front, let it dry, and then turn it over to spray the back. It's easier to remove the masking tape before the spray has dried. There you have it—your own custom refrigerator magnet.

Fund-Raising

Fund-raising is a never-ending process for most nonprofit groups. And, with so many worthy groups competing for donors' dollars, it can be difficult sometimes to meet goals. If you can give your event that little extra something, it may make all the difference in the world. Can camera phones play a role? I think so.

One popular method of fund-raising is to hold an auction. Group members will donate both items and services, and then at the auction, members or the general

public will bid on them. There's nothing like a photograph to get people interested, so how about creating a community moblog for the auction? Camera phone photos of the items being offered can be posted to the moblog, which is then publicized. The photo captions can give information about the item and perhaps recommend a starting bid. A few photos of last year's auction might liven things up a bit. For services, a photo of the person offering the service can be used. Local news stations might like the idea of a moblog being used for this purpose and give you some free publicity. It sure would be different from other auctions! Maybe you could even let people bid by text message.

Another common fundraising technique is the "run" or the "walk." A bunch of people sign up to walk or run over a specified course. Each participant will have a number of sponsors who make donations to the cause. It can be a lot of fun to have a number of people with camera phones spread out along the route or in the group of walkers/runners. Photos can be sent from the head of the group to people farther back, or to a community moblog to create a record of the event. Sponsors who cannot be present can receive live photos of the event. Camera phones are a great way to share this kind of event and get more people involved.

Create a Photo Diary

Remember when a diary was a small notebook with a clasp and lock? No more. In today's visual, connected world, there are certainly more interesting ways to make a record of your life. A camera phone is particularly well suited to this. You can take photos of what you do and, with most handset models, add in voice narrations.

There's no special technique to keeping a camera phone diary. Just keep your handset with you at all times and be ready to take it out and start snapping when something noteworthy happens. Remember that you are the star of this show, so be sure to photograph yourself. You can do this by holding the handset at arm's length, by using a mirror, or by asking a friend or passerby to take the photo for you. Don't worry about what other people will think of your diary. It's for you, right?

There are many ways to present your diary—and there's no reason you have to limit yourself to just one. The method you'll choose may depend on how you view your diary, whether it's something private just for you or whether it's something you'll be sharing with friends. Here are some ideas:

- Print your photos and paste them in a regular diary or scrapbook along with your handwritten comments and notes. Printing camera phone photos is covered in Chapter 5.

- Put your photos and comments in an online album (Chapter 6) or in a moblog (Chapters 7 and 8).

- Create a custom web page with your photos and comments (Chapter 6).

Greeting Cards

Have you noticed the prices of some commercial greeting cards lately? You can spend four or five dollars or more on a card and envelope. And wouldn't it be better to send your own message rather than something written by an employee at the card company? I think so. It can be great fun to make your own, and it's easy. All you need is a graphics program and an ink jet printer.

One approach is to use a program specially designed for creating greeting cards. These programs include ready-made templates, clip art, and other tools to simplify the process and provide as much design flexibility as possible. Some include the ability to create things other than greeting cards, such as calendars. But the programs are not free. Table 10.3 lists the Web addresses of some companies that offer greeting card software.

Table 10.3 Sources for greeting card software.

Company	URL
PhotoExplosion	www.novadevelopment.com
Hallmark Card Studio	www.hallmark.com
American Greetings CreataCard	www.broderbund.com
The Big Box of Art	www.hemera.com

If you'd rather not spend money for a program and want the maximum creative freedom, you can do your own cards using a graphics program such as Paint Shop Pro. Let's look at how this works.

A standard card consists of a piece of paper that is printed on both sides and folded down the middle, as shown in Figure 10.12. This presents an immediate problem. Most photo-quality ink jet paper is designed for printing on one side only, so how do you get the two-sided printing that is required for a card? You can take two approaches:

- Buy special two-sided inkjet paper, which is available from all major paper manufacturers.

- Print the two sides of the card separately and then cut out the photo or image for the front and attach it to the other piece with glue or double-sided tape.

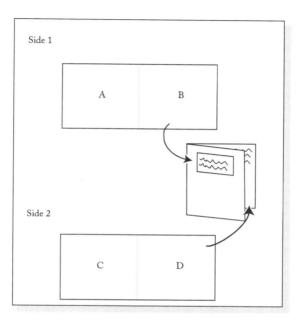

Figure 10.12
The layout of a greeting card.

I think the first option gives a nicer-looking result. Let's see how to create a two-sided card. This will be a simple card, with a photo on the front and a text message on the inside.

Tip: More Than One Way to Make a Card
If you have any experience using a graphics program such as Paint Shop Pro, you'll realize that the instructions I give here are just one way to get essentially the same result. You shouldn't feel constrained to do it exactly the way I say. But if you're a beginner you may be glad to have some specific instructions – you can always experiment later.

Step 1: Create the Blank Images

The first step is to decide on the size of the card and create a blank image for the inside of the card and another for the outside. The maximum size, if you are using 8.5x11-inch paper, is a card that's 5.5 inches wide and 8.5 inches high—the size of a single sheet folded. You can make smaller cards by trimming the paper.

For this project, we'll make a card that is 4.5 inches wide and 6 inches high. The two images you'll create will be twice the width to allow for folding—9 inches wide. Here are the steps to follow:

1. Start Paint Shop Pro.

2. Select File|New or press Ctrl+N to display the New Image dialog box (Figure 10.13).

Figure 10.13
Creating a new image for the greeting card.

3. Change the units for the width and height to inches.

4. Enter 9 in the Width box and 6 in the Height box.

5. Change the units for resolution to pixels/inch.

6. Enter 300 in the Resolution box. You use this relatively high resolution because the image is intended for printing and lower resolutions do not give as good results.

7. Be sure the Raster Background option is selected and the color is set to white.

8. Click OK to create the image.

9. Select File|Save and name the image Outside (to identify it as the outside of the card).

10. Select Edit|Repeat New File to create a second identical image for the inside of the card. Save it as Inside.

Step 2: Create the Message

You can put whatever you want on the inside of the card—photos, text, drawings—but for this example I will limit it to a short text message:

1. Activate the Inside image by clicking its title bar.
2. Click the Text tool on the Paint Shop Pro toolbox.
3. Click in the image where you want the text to appear. This should be in the right half of the image so it will be in the standard message area of the card after it has been folded.
4. Type the desired message into the dialog box that appears. Press Enter to move to a new line.
5. Click Apply.

Paint Shop Pro has a skew of options for adding text. You can change the font, the size, the color, and the position. You should experiment with these options until you get the message just the way you want it. The result for the sample project is shown in Figure 10.14. Don't forget to save the file before continuing.

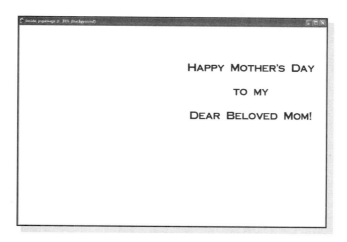

Figure 10.14
The completed image for the inside of the card.

Step 3: Create the Front of the Card

The outside of the card will display only a photo—one of your terrific camera phone photos! There's some adjustment required to make the image the right size and to make its resolution match the resolution of the card image. Why is this necessary?

We created the card image with a resolution of 300 pixels per inch (ppi) to ensure high-quality printer output. Most camera phone photos are assigned a resolution of 72 or 96 ppi. This resolution mismatch means that if you copy the photo directly to the image for the outside of the card, it will be much too small. This is why the adjustments are needed. Here's what to do:

1. Decide on the size that you want for the photo on the front of the card. Since the card will be 4.5 inches wide, let's use a width of 3.5 inches for the photo.

2. Use the File|Open command to open the photograph you want to use.

3. Press Shift+S to display the Resize dialog box (Figure 10.15). Make sure the Print Size section is set to Inches and Resolution is set to Pixels/Inch. Also, make sure that the Lock Aspect Ratio option is turned on (checked).

4. Turn the Resample Image option off.

5. Enter 300 in the Resolution box—this is the same resolution as the outside card image. You'll note that the Width and Height of the image decrease—that's okay; we'll fix it next.

Figure 10.15
The Image Resize dialog box.

6. Click OK. The image's appearance does not change, but its resolution and size have changed.

7. Press Shift+S to display the Resize dialog box again. You'll see the new resolution and size displayed in the dialog box.

8. Turn the Resample Image option on.

9. Enter the desired width, 3.5, in the Width box in the Print Size section of the dialog box.

10. Click OK. The image display size on your screen will increase.

Now that you have adjusted the image size and resolution, you are ready to copy it to the card:

1. Be sure the image that you just resized is active.

2. Press Ctrl+A to select the entire image.

3. Press Ctrl+C to copy the image to the Clipboard.

4. Activate the outside card image by clicking its title bar.

5. Press Ctrl+E to paste the photo into the image.

6. Move your mouse until the photo is at the desired location; then click to place it.

7. Save the image.

Step 4: Print the Card

Okay, you are ready to print. You'll need a sheet of the two-sided inkjet paper. You can print either the inside or the outside image first. Here how to do this:

1. Activate the desired image by clicking its title bar.

2. Press Ctrl+P to display the Print dialog box (Figure 10.16). In this dialog, set options as follows:
 - Orientation: Landscape
 - Scale: 100%
 - Center on Page: on.

3. If necessary, click the Printer button to select your ink jet printer.

4. Click the Properties button to set the printer for the kind of paper you are using.

5. Back in the Print dialog box, click Print to begin printing.

Figure 10.16
Setting print options in the Print dialog box.

Once the first side of the card has printed, you are ready to print the second side. It is simply a matter of flipping the paper over, reinserting it in the printer, and printing the second image. Or is it? When you flip the paper, the image that you already printed gets flipped too. If you just go ahead and print the second image, it will not come out right in relation to the first image on the back of the paper. You must rotate it by half a turn before you print it—then things will come out correctly. Here's how:

1. Activate the second image.

2. Select Image|Rotate|Rotate Clockwise 90 to rotate the image one-quarter turn.

3. Select Image|Rotate|Rotate Clockwise 90 again to rotate the image another one-quarter turn for a total of a one-half turn.

4. Turn the sheet of paper over and place it in the printer's paper tray. Be sure the paper goes in the same way it did for the first print.

5. Follow the preceding set of steps to print the second image.

Once the print has dried, all that's left to do is trim it, if necessary, and fold it. There you have it—a unique, personalized greeting card. Be warned because your friends and relatives can get used to such nice cards!

Wrapping It Up

If the camera phone culture had a key word, it would be *creativity*. There are so many interesting and creative things you can do with your photos, and this chapter has presented a few of them. Let your imagination run free!

Appendix

Camera Phone Resources

This appendix presents a wide range of online resources that will be of interest to camera phone users. The resources are divided by category and a URL is provided for each one along with a brief description. Some of these resources may have been mentioned throughout the book but the goal here is to give you a more detailed set of resources that you can find in one place.

Cell Phone Service Providers

Most of you probably have a cellphone but if you need info on the services of each major North American and some European providers you can check out the Web sites presented here. If a specific page was available that referred to a special camera phone page on a vendor's site, I've listed the specific URL here.

Provider	Link
Alltel	www.alltel.com/axcess/pictures.html
AT&T Wireless	www.attwireless.com/personal/features/fun/photography.jhtml
Cingular	www.cingular.com/beyond_voice/mms
Nextel	www.nextel.com
O2	www.o2.co.uk/mediamessaging
Orange	www.orange.co.uk/services/photomessaging

(continued)

Provider	Link
Rogers	www.shoprogers.com/store/wireless/services/voice/picturemessaging.asp
Sprint	www1.sprintpcs.com/explore/PhonesAccessories/PicturePhones.jsp
Telstra	www.telstra.com.au/mobile/products/messaging/mms_about_picture.htm
Telus	www.telusmobility.com/on/services/pcs/picture_messaging.shtml
T-Mobile	www.t-mobile.com/services/picturemessaging/overview.asp
US Cellular	easyedge.uscc.com/easyedge/GameDetail.do?1011
Verizon	www.vzwpix.com/mlib/index.jsp & getitnow.vzwshop.com/getpix.main.do
Virgin Mobile	www.virginmobile.com/mobile/services/picturemessaging
Vodafone	www.vodafone-i.co.uk

Key Hardware Sites

What's amazing about cellphone hardware in general and camera phones specifically is that most of the companies who make them have created different sites and URLs for their mobile phone offerings. In addition, some companies such as Sharp and Panasonic don't even sell phones in some regions including North America. If you want to see what equipment they are offering you need to check out their Japanese language sites. I've compiled some useful URLs for the major vendors here to make it easier for you.

Hardware Maker	Link
Audiovox	www.audiovox.com
Kyocera	www.kyocera-wireless.com
LG Electronics	www.lge.com/products/mobile/mobile/mobile.jsp
Mitsubishi	www.global.mitsubishielectric.com/bu/mobile/index.html
Motorola	www.hellomoto.com
Nokia	www.nokia.com
Panasonic	www.panasonic.com/consumer_electronics/cellular
Samsung	www.samsung.com/Products/MobilePhones.htm
Sanyo	www.sanyo.com/wireless/

(continued)

Hardware Maker	Link
Sharp	www.sharp.co.jp/k-tai/index.html (Japanese Only)
Siemens	www.siemens-mobile.com
SonyEricsson	www.sonyericsson.com
Toshiba	www.toshiba.co.jp/product/etsg/cmt/index_j3.htm (Japanese Only)

Hardware Information and Reviews

Getting the equipment that best fits your needs isn't always easy because new models appear rapidly. I suggest you check in with the following leading review sites that cover camera phones to keep up-to-date.

Topic	Site	Details
Mobile Phone Reviews	www.mobile-phones-review.co.uk	Review of cell phone handsets.
PC Magazine	www.pcmag.com	Information and reviews for inkjet printers.
PC World Magazine	www.pcworld.com	Information and reviews for inkjet printers.
Printer reviews	www.itreviews.co.uk/hardware/hard4.htm	Information and reviews for inkjet printers.
The Review Centre	www.reviewcentre.com/products14.html	Information and reviews for inkjet printers.
ZDNet	Reviews-zdnet.com.com	Information and reviews for inkjet printers.
Cell Phone Reviews	www.textamerica.com/asp/reviews.asp	Reviews of camera phones.

While on the topic of hardware, just before this book went to press I found out about a Canadian company that is offering a "pen-like camera phone cleaner." The company, Parkside Products, is offering a product called "Cell Klear" (see Figure A.1) that makes it easy to clean the super tiny lenses on most camera phones. To read more about this product, visit www.lenspen.com. You can also visit the parent company site at www.ipd.ca.

Another interesting bit of hardware are devices and technologies that let you view your photos on a TV once you get home. Siemens offers a set-top box (called Gigaset Interactive TV) that can accept MMS message and display them on a TV. Siemens

Figure A.1
The latest and greatest camera phone cleaner.

isn't the only company now offering such a feature—Nokia offers the Image Viewer device that connects to a TV and lets you transfer photos and videos to it via Bluetooth. For more information on Nokia's box visit **www.nokia.com/nokia/0,,5785,00.html**.

Phone Equipment Stores

Here is a list of good places to find handsets and accessories online.

Site	Link
1st in Cell Phones	www.1st-in-cell-phones.com
Amazon	www.amazon.com
Cell Phone Carriers.Com	www.cellphonecarriers.com
LongDistanceWorld.com	www.longdistanceworld.com/cellular-phones
Unbeatable Cell Phones	www.unbeatablecellphones.com
Wirefly	www.wirefly.com

General Information

There are only a few sites that really bring you the world of camera phones in all their glory. The two biggest are **www.Picturephoning.com** and Reiter's Camera Phone Report. These two sites alone can help you get up to speed on news, culture, and technology. I've compiled these two leaders and some other sites which offer additional general information to check out.

Site	Link	Details
PicturePhoning.com	www.textually.org/picturephoning	A blog covering the world of picture and video phones by Emily Turrettini and Cyril Fiévet.
Reiter's Camera Phone Report	www.cameraphonereport.com	Alan Reiter's wide-ranging Web site provides a wealth of opinion and information about camera phones including news, tutorials, equipment reports, and links to other resources.
On-line Photography	www.zonezero.com/magazine/articles/fotomovil/fotomovil.html	An interesting article on the future of camera phones by Julián Gallo who teaches in the journalism program at the Universidad de San Andres in Argentina.
Phone Scoop	www.phonescoop.com	General information on all types of cell phones and service providers.
Joi Ito's Radio Outline	radio.weblogs.com/0114939/outlines/moblog.html	Joi Ito rocks. The unofficial father of moblogging has an interesting exposition on the history of moblogging on his site.
cellular-news	www.cellular-news.com	Latest news about cell phones (not just camera phones).

Articles

Aside from the general information sites I've listed, there are some great links to specific stories that capture the impact of camera phones. I've listed as many interesting ones as I could here.

Article Title	Link	Details
Mobile Phone video clip resources.	www.moremobile.co.uk/mobile-phone-video-clips/	General Video Clips

(continued)

Article Title	Link	Details
Don Heller Photography	www.danheller.com/model-release.html	Good source of information on legal aspects of photography and model releases.
Camera Phones Incite Bad Behavior	www.wired.com/news/culture/0,1284,59582,00.html	An article about how camera phones have tempted some users to take inappropriate photos.
Camers Phones Help Buyers Beware	www.wired.com/news/infostructure/0,1377,61936,00.html	An article on how camera phones can help you be a smart shopper.
Online Journalism Review	www.ojr.org/ojr/technology/1057780670.php	An article on moblogging and how it relates to online journalism.
Mobile Imaging Photography's Next Revolution	www.forbes.com/technology/2004/04/08/cx_pp_ii_0407henning.html	General article on camera phones and mobile imaging from *Forbes* Magazine.
Infoimaging The Next Picture Messaging	www.forbes.com/personaltech/2004/03/16/Boomcx_pp_0316picturemessaging.html	Another interesting article from *Forbes* Magazine.
New Uses for Camera Phones	www.deviceforge.com/articles/AT5785815397.html	Details lots of R&D efforts to create all kinds of incredible uses for camera phones. Great story!
Election Irregularity Documentation	www.wirelessmoment.com/2004/05/korea_election_.html	Great catch by Alan Reiter detailing South Korea's National Election Commission's call on voters to send documentation via camera phones of any voting irregularities. Maybe Florida can do this next time they hold an election?
McDonald's India using Phones	www.cnn.com/2004/TECH/ptech/05/06/nokia.india.reut/	Children and families buying Happy Meals at McDonald's restaurants in New Delhi and northern India during May 004 got their pictures taken as part of an interesting camera phone based promotion. Do you want flash with that?

(continued)

Article Title	Link	Details
Translation Help with Cameraphones	www.almaden.ibm.com/software/user/infoScope/index.shtml	Researchers at IBM's Almadan laboratory are working on a service that lets people snap pictures of signs in other languages and have the service send back to the phone a translation of it. The Department of Defense is one customer interested in using this feature to help soldiers avoid getting lost.
HP Labs's look at always-on casual photography project	www.hpl.hp.com/news/2004/jan-mar/casualcapture.html	This is a fascinating look at some of the research Hewlett Packard is doing into "always on" photography which of course is what camera phones are all about. Also check out www.hpl.hp.com/research/pirc/ which is HP Labs main link into all their research into imaging.
Photo recognition software gives location	www.newscientist.com/news/news.jsp?id=ns99994857	Same idea as the translation work IBM is doing except you snap a picture of a nearby building and a database recognizes it and sends your phone a map location so you can figure out just where you are.
Lifeblog from Nokia	www.guardian.co.uk/online/story/0,3605,1166303,00.html	Great article on Nokia's Lifeblog project which involves documenting everyday life using Nokia phones.

How-To Information

There are some good tips on using camera phones available if you know where to look. Thankfully, I've tried to compile a number of the best places to bone up on good how-to information—aside from reading Chapters 1 through 10 of this book of course!

Info	Link	Details
Camera Phone Tips and Tricks	www.textamerica.com/asp/tips.asp	Advice and how-to information for the camera phone user.
Silverlight	www.silverlight.co.uk/tutorials/toc.html	Photography tutorial.
Snapshots to Photographs	www.palmettobayinc.com/photo_tutorials.html	Tutorial on basic photography, recommended for the beginner.
Printing tips	www.maxpatchink.com/printer-tips.shtml	Tips for getting the most out of an inkjet printer.
Printing tips	www.rippedsheets.com/faq/faq_23.htm	Tips for getting the most out of an inkjet printer

Camera Phone Etiquette

Every new technology brings with it some form of best practices in terms of polite and acceptable use. Camera phones are no different. I've compiled some of the best etiquette resources here for you to explore.

Title	Link	Details
Mobile etiquette	care.three.com.au/index.cfm?section=Care&pid=1824&pageid=1861&flash=false	General cell phone etiquette including camera phones.
Camera phone dos and don'ts	asia.cnet.com/reviews/handphones/0,39001719,39133939,00.htm	Some common sense camera phone etiquette advice.
Camera Phone Etiquette Abuses	www.cbsnews.com/stories/2003/07/09/tech/main562434.shtml	An article on camera phone etiquette abuses, mostly in Japan.

Games

There are games you can play with your camera phone and here are some links to articles or sites that detail the intersection of games and camera-phones.

Game	Link	Details
Scavenger Hunt	www.dodgeball.com/biggames/index.php	This site hosts a public camera phone scavenger hunt that you can join.

(continued)

Game	Link	Details
Ming Mong	www.mingmong.com.au/	This hilarious site from Australia details the fictitious history of a real game called Ming Mong. It's a game for those of you with a strong sense of humor. You play the game with a friend and message one another back pictures with funny captions. Each time you try to outdo the other person until one of you can't top the other. For example, you might take a picture of a public toilet and send a note saying, "Is this where you live?" Insanity should ensue.
Mobile Scope	www.mobilescope.de/website/index.php?news_details=123&english=1&country=us	This is a really long URL (sorry) but a cool idea. German cellphone game developer Mobile Scope has created a game you control with the camera in your camera phone. Check out their PR for more information on the game titled "Moorhen Camera X."

Moblog Galleries

I covered moblogging in Chapters 7 and 8. However, if you want to see some great examples of moblogging be sure to check out these excellent examples of moblogging galleries that show the power of camera phones in action.

Title	Link	Details
The Bento Moblog	mito.typepad.com/photos/bento	A Japanese mother's documentation of the bento lunches she makes for her two children every weekday

(continued)

Title	Link	Details
MMS Memo	mmsmemo.blogspot.com	A niche blog targeting 2.5G and 3G mobile technology with emphasis on camera phones and moblogging.
Mikan Moblog	www.kamoda.com/moblog	An excellent moblog documenting everyday life in Japan.
Wildfires	fire.textamerica.com	An interesting community moblog on California wildfires.
Blackout	blackout.textamerica.com	A community moblog about the recent blackout in the northeast U.S. and Canada.
t-six-ten	www.sonyericsson.com/t610	Website by Sony-Ericsson featuring the best camera phone photos.
Mobile Phone Photo Show	www.rxgallery.com/mpps/	This site details the work done to organize a gallery show that incorporated hundreds of mobile phone submitted photos.
Sent	www.sentonline.com	The world's first phonecam art show. Very cool—check it out.
Graffiti	graffiti.buzznet.com/cat/	Great moblog phonecam gallery of graffiti from around the world.
Soldiers in Iraq	http://jhong.org/frontline.html	Collection of photoblogs from U.S. Soldiers stationed in Iraq.

It's not exactly a gallery but definitely check out www.Blueherenow.com—a worldwide community blog/moblog designed to capture citizen reported news. Many people submit camera phone-based shots showing the power of community based news, camera phones, and spur-of-the-moment journalism.

Moblog Hosting Providers

There are simply too many camera phone moblogging services if you ask me. It's great that you can sign up for four, five, or even eight of them but be careful at

some point because some of these services will probably not be around after a while. I'd recommend you backup all your photos as much as possible or risk finding a day where you surf to your moblog only to find "Page Not Found" and your photos are gone. A few of the bigger and established operations seem like they might make it so try to focus first on the leaders such as TextAmerica, Buzznet, TypePad, and Eachday.

Tip: Don't also forget about www.moblogging.org, an awesome blog on moblogging that you should definitely bookmark!

Moblog Site	Link
20six	www.20six.co.uk
Buzznet	www.buzznet.com
CamBlog	www.camblog.com
Fotolog	www.fotolog.net
Fotopages	www.fotopages.com
Mlogs	www.mlogs.com
Photokyo	www.photokyo.com
Ploggle	www.ploggle.com
Rare Window	www.rarewindow.com
TypePad	www.typepad.com
Yafro	www.yafro.com
phlog.net	www.phlog.net
Albino gorilla	www.albinogorilla.dk
TextAmerica	www.textamerica.com
Eachday	www.eachday.net
Phlog	www.phlog.net

Tip: Another derivative moblog site to check out is www.upoc.com. This site operates like a giant user community of people available via text messaging. The service lets you post on a number of forums such as NYC Celeb Sittings and more. It also recently added picture posting services. So now when you see your favorite celebrities you can moblog them to Upoc for all others to see and not just read about.

Moblogging Resources

Here are additional moblogging resources for those of you who are going to take a hands-on approach to the moblogging phenomenon.

Resource	Link	Details
Brandt Kurowski	**brandt.kurowski.net/blog/ blog/moblog**	Script resources for hosting your own moblog.
Ben Millaire	**http://ben.milleare.com/archives/ 000133.html**	Presents a tutorial on how to modify the Moveable Type Blog (**www.moveabletype.org**) to function as a moblog.
Joi Ito	**http://joi.ito.com/archives/ 2003/03/12/mail2entry_moblog_ code_update.html**	More assistance for Moveable Type users.
Tutorial	http://nipernaadi.kolhoos.ee/ nipernaadi.root	A tutorial for adding moblogging capability to the Radio Userland software (**www.userland.com**).
Mark Tremblay	**http://pansapien.com/geekstuff/ moblog/**	Details on a PERL script for moblogging.
Moblog scripts	**joi.ito.com/archives/2002/12/26/ mail2entry_script_for_mt_ moblog.html**	Scripts for hosting your own moblog.
kablog	**kablog.org**	Photo and moblogging software for camera phohnes and PDSs.
Moblog scripts	**www.danger-island.com/ ~dav/blogpost.pl**	Home-grown scripts for hosting your own moblog.
Moblog software	**www.fperkins.com/MoblogSoftware writteninVB.Net.html**	Home-grown software in .Net for creating your own moblog host.
Simsi Moblog	**www.rowlff.de/simsi**	Information and resources for those interested in hosting their own blog/moblog using PHP.
pMoblog	**www.sacredsmile.com/moblog/**	An add-on moblogging script for the popular pMachine blog software (**www.pmachine.com**).

(continued)

Resource	Link	Details
Hex Software Moblog System	www.hex.is/products/nr/50	Resource for ISPs and big companies that want to offer moblogging capability to a wide range of users

Online Photo Sharing Services

Moblogs are sort of becoming the default online photosharing service for most camera phone operators but these standalone photo sharing service also warrant a look, especially Flickr which provides some specific camera phone services that I discussed in Chapter 8.

Service	Link
Aspiro Photogallery*	photogallery.aspiro.com
Flickr*	www.flickr.com
Fotango	www.fotango.com
Fotki	www.fotki.com
Fuji Film*	www.fujifilm.net/personality/login/mobile.asp
Funtigo Deluxe	www.funtigo.com
Kodak Mobile	www.kmobile.com
PhotoSite	www.photosite.com
Pictavision*	www.pictavision.com
Run Pics*	www.runpics.com
Sacko	www.sacko.com
SmugMug	www.smugmug.com

* Denotes special sharing and upload features available to camera phone users

Another photo sharing service devoted strictly to camera phones is MyQPU (Quick Photo Upload) which lets you set up social circles of friends and their mobiles to easily send and then re-broadcast photos to a close circle of mobile users. The service costs $2.99 per month and it also features a variety of contests that you can enter.

Tip: A service called **www.hello.com** is also available that lets you share your photos via instant messaging.

Online Print Services

If you want great prints of your photos, online print services are an excellent solution. Don't also forget the various kiosks at locations such as Kinkos and Ritz Camera which also offer great solutions as well.

Service	Link
Club Photo	www.clubphoto.com
dot Photo	www.dotphoto.com
ez Prints	www.ezprints.com
ImageStation	www.imagestation.com
Ofoto	www.ofoto.com
PhotoWorks	www.photoworks
Shutterfly	www.shutterfly.com
SnapFish	www.snapfish.com/infosnapfishmobile/t_=0
Wal-Mart	www.walmart.com
SnapnPrint	www.snapnprint.com

Another cool and different printing service is StickPix (www.stickpix.com) which is only active in the U.K. at the moment. Once you register for the service you send your photos to their site and they will mail you back photos printed on a series of wallet size stickers (3 per sheet) that you can stick up and on anything. The service costs about $5 per image. See Figure A.2 for a look at how your photos will be printed.

For those of you with HP printers, keep an eye out for Hewlett Packard's *Wireless Printing for Mobile Phones*. This includes extensions and drivers for some of their current and all of their future printers to help you print directly from your phone to an HP printer using infrared or Bluetooth. To read more about this exciting technology, visit the following links:

- www.hp.com/hpinfo/newsroom/press_kits/2004/pma/fs_wpp.pdf
- www.sonyericsson.com/spg.jsp?cc=global&lc=en&ver=4001&template=pc1_1_1&zone=pc&lm=&prid=1693
- www.zdnet.com.au/reviews/coolgear/mobiles/0,39023387,20272188,00.htm

The initiative seems to have backing from Sony, Ericsson, and Nokia.

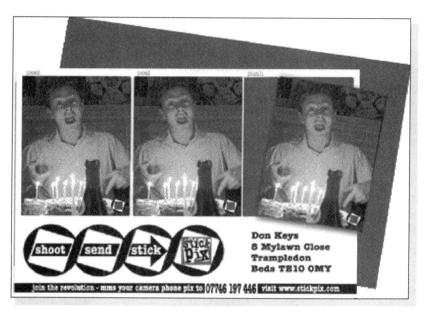

Figure A.2
Photos converted into stickers using the StickPix service.

Software

Camera phone software can be organized into three categories: major imaging packages such as Paint Shop Pro and Photoshop; on-phone applications such as Sozotek; and other PC-based such as Ulead Photo Explorer. I've compiled a list of links to all of these types of useful software here. One final note is that some of the on-phone applications may be limited to specific models of phones or phones which feature application environments such as J2ME/Java, Windows CE, or BREW. You'll have to visit the individual sites to learn which phones each app supports.

Software	Type	Link	Details
PhotoRite	On-phone	www.zensis.com	Automatic photo enhancement/correction. For Sony Ericsson P800/900 or Nokia 6600/3650/7650.
DVD Photo Slideshow	PC Utility	www.dvd-photo-slideshow.com	Software that lets you create a slideshow and distribute it on CD-ROM.

(continued)

Software	Type	Link	Details
Ulead Photo Explorer	PC Utility	www.ulead.com/pex/runme.htm	Create slideshow on CD-ROM.
SendPhotos	PC Utility	www.novatix.com/Products/SendPhotos	Software for creating and sending customized email photo attachments.
PiXPO	PC Utility	www.pixpo.com	Give others access to photo albums on your PC via peer-to-peer networking.
Paint Shop Photo Album	PC Utility	www.jasc.com/products/photoalbum/?	Software for creating photo albums.
SozoTek	On-phone	www.sozotek.com	Software for wireless imaging.
Picostation	On-phone	www.picostation.com/#Start	Software that you can install on your handset that links to Picostation's blogging/moblogging-service.
Paint Shop Pro trial	Major Imaging Package	www.jasc.com	Download a trial version of the Paint Shop Pro graphics program.
Adobe Photoshop	Major Imaging Package	www.adobe.com	This software is more expensive then Paint Shop Pro but it is the granddaddy of image processing programs.
PhotoAccute	On-phone	www.photoacute.com	Available now for certain Nokia camera phones, this software takes several pictures at once and uses them to create an even better single low-res image.
Cognimatics	On-phone	www.cognimatics.com	Great face warping software similar to a product for PCs known as Goo but for phones. Lets you create wacky warped photos right on your phone. Available for several Nokia models.

(continued)

Software	Type	Link	Details
SnapMedia	On-phone	**www.futuredial.com**	FutureDial's Snapmedia software is an integrated PC and on-phone package that makes it easy to upload ring tones and images to your phone as well as download photos from it as well. It is not a library of stock images or ringer tones. You can actually upload your own tones and imagery as well as manage them on your PC. Works with many major phones.
CameraFX	On-phone	**www.wildpalm.co.uk/ CameraFX.html**	CameraFX is wicked cool imaging software for Nokia Series 60 phones.
Earthcam	On-phone	**www.earthcam.com**	When you download Earthcam's Broadcaster software to your phone you can receive Web cam updates to your cell phone.
Photographer	On-phone	**www.openbit.com/ AdSites/Photographer/ en/index.jsp**	Photographer from Open Bit is an application for several Nokia phones and Seimens phones that gives you added on-phone digital photo functionality.
Studio	On-phone	**www.openbit.com/ products/studio/index.jsp**	Extended photo editing software for Nokia Series 60 phones.

Some software isn't for end-users but may still be of interest to those of you wanting to know as much about the world of camera phones as possible. Stoik (www.stoik.com/mobile/index.html) is a Russian-based software company that has developed some imaging software it will license to people who create moblogging and photo hosting services. The company also makes some interesting end user image processing software as well. Lightsurf (www.lightsurf.com) is a company founded by software industry legend Phillipe Khan (founder of Borland and Starfish) that sells backend imaging software to mobile phone companies to power their camera phone services.

Panorama Software

Stitching together photos is a popular past time of digital photography junkies. With their usually low-res photos, this technique is great for camera phone users. I covered this in Chapter X but here are some repeated and extra resources.

Site	Link	Details
PanoGuide.com	**www.panoguide.com/software**	Reviews of different software packages for creating panoramas.
Panorama Factory	**www.panoramafactory.com**	Software for creating panoramas from overlapping photographs.
Photofusion	**www.scalado.com/m4n/?oid=455**	Great on-phone software for several Nokia and SonyEricsson phones that lets you do panoramas right inside the phone.

Tip: Our friends at O'Reilly & Associates (**www.ora.com**) published a great book on digital photography called *Digital Photography Hacks* (ISBN: 0-596-00666-7). They are giving away Hack #82 which covers creating panoramic pictures with your digital camera. Download the free PDF at **www.oreilly.com/catalog/digphotohks/chapter/hack82.pdf**. Be sure to buy the book too—it's a good one!

More Graphics Resources

I can't list everything so I also suggest bookmarking these excellent Web resources for a variety of useful graphics programs and resources.

Resource	Link	Details
Graphics software resources	**graphicssoft.about.com**	Provides summaries and reviews of different kinds of graphics software.
Photography Software Resource	**graphicssoft.about.com/od/ digitalphotosoftware**	Provides summaries and reviews of different kinds of graphics software.
Photography Software Resource	**www.onlinereviewguide.com/ software.shtml**	Provides summaries and reviews of different kinds of graphics software.

Specialty

To print your own photos you'll need to get good inkjet photo paper and perhaps t-shirt/material transfer paper. This set of links will help you if your local office supply store doesn't have what you need in stock.

Store	Link	Details
Ace Indexes	www.acecam.com/inkjet-paper.html	Source for inkjet photo paper information and sales.
Inkjet Mall	www.inkjetmall.com/	Source for inkjet photo paper information and sales.
Red River Papers	www.redrivercatalog.com/browse/spec.htm	Source for inkjet photo paper information and sales.
Specialty papers	www.kelvin.com/ac_inkjetpaper.html	Source for inkjet photo paper information and sales.
BF Printing	www.bfprinting.com	Source for t-shirt printing.
Custom Ink	www.customink.com	Source for t-shirt printing.
Get In Print	users.erols.com/tshirts	Source for t-shirt printing.
Promo Peddler	www.promopeddler.com/Printable/Silk_Screening_Tee_Shirts.htm	Source for t-shirt printing.
T-shirt Pros	www.t-shirtpros.com	Source for t-shirt printing.
BestBlanks	www.bestblanks.com/transferpapers.html	Source for ink jet photo transfer paper.
Soft Expressions	softexpressions.com/software/notions/transfer.html	Source for ink jet photo transfer paper.
Thread Art	www.threadart.com/TS/trnsfr_paper.asp	Source for ink jet photo transfer paper.

Postcards Services

A number of carriers, especially Vodaphone, are now organizing postcard messaging services that let you transfer from your phone to a service. You can take a photo and send it with a message and snail mail address and the service will generate a postcard for you. The cost of creating and sending a photo postcard in this manner is about $2 to $3 tops. There are two independent services starting up I know about.

Service	Link	Details
Dialacard	www.dialacard.com	Coming soon as of this writing.
SnapnPrint	www.snapnprint.com	Works with Symbian compatible phones, offering other handsets soon.

Conferences and Organizations

Most of you won't be such die-hard enthusiasts as to go to a conference on cameraphones but for those of you developing software, services, or other uses for camera phones, the two conferences you might want to know more about are listed here.

Conference	Link	Details
C-Summit	www.c-summit.com & www.pulver.com	Held once so far in Spring 2004. Check www.pulver.com to see if they will repeat it again in 2005 and beyond.
Mobile Imaging	www.mobileimagingsummit.com & www.futureimage.com	Held in both Europe and U.S., this conference focuses on both camera phones and mobile printing and imaging solutions.
CTIA Conferences	www.ctia.org/conventions_events/index.cfm	This trade group's annual conferences are the biggest important industry-wide gatherings. Lots of mobile tech including camera phones are shown and discussed.
Standard Mobile Imaging Architecture	www.smia-forum.org	The SMIA standard is an open standard for use by all companies making, buying or specifying miniature integrated camera modules for use in mobile applications.
CTIA	www.ctia.org	Major North American organization for the wireless industry.
International Moblogging Conference	joi.ito.com/joiwiki/1IMC	Once again moblogging Godfather Joi Ito comes to the rescue with his Wiki of the proceedings from the 1st Annual International Moblogging Conference held in 2003 in Japan. It contains notes and links relevant to the proceedings.

Index

A

Activism, moblogs and, 146
Adams, Ansel, 10
Add-on cameras, 28
Additive primary colors, understanding, 80
Adobe Photoshop
 automatic image adjustment commands in, using, 85
 color adjustments in, 82
 copying images in, 78
 cropping images in, 79
 Document format of, using, 70
 framing images in, 90
 manipulating photos in, 65–66
 monochrome images in, creating, 86–87
 native format of, 70
 online albums with, creating, 127–128
 printing images in, 109
 product information, 67
 Redo command, using, 76
 resampling images in, 77
 rotating images in, 88
 saving images in native format, 71
 special effects in, using, 95
 Undo command in, using, 75–76
 viewing size in, changing, 74
 Web albums using, creating, 132
Albino gorilla moblog service provider, 148
Apertures, understanding small and large, 49
Art, relationship between photography and, 9–11
Artistic journalism, defining, 13
AT&T Wireless Web site, 44

Audiovox Web site, 37
Automatic exposure, lighting conditions and, 51–52

B

Backlighting
 avoiding, 62–63
 defining, 52, 62
 working with, 52
Bandwidth, saving, 118–119
Bans, 191–192
Bar codes, scanning, 84
Basic layout, defining, 32
Battery life
 flash and, 52
 maximizing, tips for, 30
 rating, factors for, 30
BenQ Web site, 37
Blogger moblog service provider, 148
Blogs
 defining, 16
 evolution of term, 141
 moblogs and, 141–143
 popular, list of, 142
 understanding, 141–142
Bluetooth
 connectivity option, 33
 feature, 38
 PDAs and, 31–32
 transfer method for, using, 121–122
 understanding, 27
Blur
 avoiding, 52, 57

common cause of, 52
creative tool, using as, 52
BMP (Windows bitmap), understanding, 71
BoingBoing blog, 142
Brightness, adjusting, 83–84
Buzznet moblog service provider, 149

C

Cabled connection
connectivity option, 33
feature, 38
CamBlog moblog service provider, 149
Camera motion, understanding, 53–54
Camera phones
availability of use, 6
culture, 14–22
digital cameras versus, 23
display, 27–28
effects on world, examples of, 1–2
features of, 23
future of, 8
impact of, 6, 10
impacts on the world, 1–2
international laws for, 15
news photos and, 18
obsession with, recognizing, 8–9
photos, quality of, 10–11
photos taken using, examples of, 4
popularity of, 4–5
sales statistics, 5
service providers and, relationship between, 24
stand-alone cameras versus, 7
technical shortcomings of, 10–11
threats to national security, 43
vendors, list of, 37
Cameras, controlling exposure, 50–51
CD burners, using, 132
CDs (compact discs)
photos on, distributing, 132
slideshows on, distributing, 132
Web albums on, distributing, 132
Cell phones
add-on cameras and, 28
concerts and, relationship between, 17
digital cameras versus, 3–6
popularity of, 3
sales statistics, 5
service providers Web sites, list of, 44
Cellcerts, evolution of, 17. *See also* Concerts
Cellular One Web site, 44
Cingular Web site, 44
Clamshell layout, defining, 32
Cliff's Notes blog, 142
Club Photo print service, using, 115
Color balance, adjusting, 80–82
Colorizing, understanding, 86–87

Commercial printers, ordering photo merchandise from, 203
Community spirit, moblogs and, 147
Composition
controlling, techniques for, 58–61
defining, 58
framing guidelines for, 60–61
general rule of, 58
Compression
format, understanding, 69
variable, using, 69
Concerts, relationship between cell phones and, 17. *See also* Cellcerts
Connectivity options, list of, 32–33
Consumer Electronics Association (CEA), promoting etiquette, 188
Contrast, adjusting, 83–84
Corel Painter
photos, manipulating, 66
product information, 67
Coverage
categories of, 40–41
quality of, 41
testing for quality of, 41–42
voice usage, maximizing for, 41
Crime, fighting, 18–19
Cropping, understanding, 78–80

D

Danger Web site, 37
Data
connectivity options for transferring and sending, 32–33
sending over wireless telephone networks, 25–27
Depth of focus, understanding, 48–49
Digital cameras
camera phones versus, 23
cell phones versus, 3–6
features of, 23
Digital photography, acceptance of, 5–6
Digital photos
documents and publications, including in, 6
free, advantages of, 5
manipulating, ease of, 5
pixels and, relationship between, 24
saving, 69
transferring and viewing electronically, 6
Digital shoplifting, 14–15, 197
Digital shopping, 14–15
Digital zoom, optical zoom versus, 29
Display, 27–28
Display quality feature, 38
dot Photo print service, using, 115
DVD Photo Slideshow program, 133
DVRs (Digital Video Recorders), using, 133
Dye inks, pigment inks versus, 100–101

E

Eachday moblog service provider, 149
EarthCam Mobile, 169
Eastman Kodak Inc., camera phone service from, 116
Email
 attachments, 117
 connectivity options for, 32
 multimedia messaging, 119–120
 sending photos as HTML messages, 125–126
 sending photos using, 124–126
Etiquette
 Consumer Electronics Association (CEA) promotion of, 188
 dos and don'ts of, 196
 guidelines, 193
 resources for, 194
 using, 192–197
EvDO (Evolution Data Optimized)
 transmission speeds of, 27
 vendors, 27
Exposure, understanding, 50–52
ez Prints print service, using, 115

F

Fair Use, doctrine of, 189
Features, simplicity of, 47
File formats
 native, using, 70
 standard, list of, 71
 understanding, 69–71
File names, naming, 122
First Amendment, use of photos within, 190
Flash
 availability of, 29–30
 defining, 52
 working with, 52
Flickr
 sending photos to, 178
 setting up account on, 178
 setting up new blog on, 179
 using, 178–179
Focus feature, 48–50
Form factor
 feature, 38
 layouts, types of, 32
Fotolog moblog service provider, 149
Freeware, manipulating photos with, 66
Front lighting, understanding, 62–63
Fujitsu Labs, bar code scanning by, 84
Fund-raising, techniques for, 216–217
Funtigo Deluxe photo sharing service, 134

G

Gallo, Julián, 8
GIF (Graphics Interchange Format), understanding, 71
Glossy paper, 104
Greeting cards
 creating, 218–224
 front of, creating, 222–223
 images for, creating, 220–221
 messages in, creating, 221
 printing, 218–219, 223–224
 software vendors, list of, 218

H

Handles tool, using, 79–80
Handsets
 carriers and service plans for, comparing, 40–44
 features for, deciding on, 38–39
 gathering information on, importance of, 36–38
 reviews of, sources for, 40
 reviews on, researching, 39–40
 setting, experimenting with, 54
 shopping options for, 45
 vendors, list of, 37
Hedgecoe, John, 62
Hello software, sharing photos on, 139–140
Hitachi Web site, 37
Hypertext Markup Language (HTML)
 sending photos within messages, 125–126
 understanding, 126

I

Images. *See also* Photos
 monochrome, converting to, 86–87
 monochrome, creating, 86–87
 rotating, 87–88
 scenes in relation of space, connecting, 12
 scenes in relation of theme, connecting, 12
 scenes in relation of time, connecting, 12
 size of, changing, 73–74
 size of, understanding, 71–73
ImageStation print service, using, 115
In Network coverage, 40–41
Infrared
 connectivity option, 33
 feature, 38
 transfer method for, using, 121
Ink jet printers
 guidelines for selecting, 99–102
 ink cartridge configuration for, 101
 inks for, types of, 100–101
 low cost of, reasons for, 101–102
 paper and, relationship between, 103–106
 paper size capabilities for, maximum, 100–101
 printing speed of, 102
 printing with, tips for, 111

reviews of, magazine, 99
reviews of, Web site, 99
using, 98
IPhoto application, 132
Ito, Joi, 16, 180

J

Jardin, Xeni, 11
Journalism, defining, 13
JPEG (Joint Photographic Experts Group)
 compression, advantages and disadvantages of, 40
 compression, levels of, 62
 compression problems with, 69–70
 compression problems with, avoiding, 70
 features of, 69
 saving in native file format, 70
 understanding, 61–62, 69

K

Kyocera Wireless Web site, 37

L

Lam, Dr. Tai Khoa, 53
Landscape orientation, selecting, 108
Laser printers, using, 98
Legislation, 187–188
Lens, importance of quality, 39
LG Electronics Web site, 37
Liberty Wireless Web site, 44
Lighting, best and worst, 50–52, 56–57
LightSurf Technologies, Power Media Processor (PMP) service from, 77–78
Lossy
 defining, 61
 format, understanding, 69

M

Matte paper, 104
Medical community, impacts on, 53
Megapixel camera phones
 availability of, 26
 vendors of, 27
Memory
 capacity limits of, 31
 expandable, 31
Microsoft
 Digital Image Suite product information, 67
 Photo Editor, manipulating photos with, 66
 Windows Explorer, email photos using, 124
 Windows Explorer, rotating images in, 87
Microsoft Network, Photo Swap software in, 140
Mik Wright greeting cards, 14
Millare, Ben, 180
Mlogs
 account links on, 175–176
 audio clip feature, 176
 exploring moblogs on, 176–177
 fees for using, 174
 friends or favorites feature on, 176, 178
 moblog service provider, 149
 photos to, submitting, 176
 registering on, 174
 using, 173–178
Mobile printers, using, 98
Moblogging
 culture of, 144
 self-run, advantages and disadvantages of, 150–153
Moblogging For Other People Too (MFOP2), 179
Moblogs
 activism, examples of, 146
 adult content on, 144–145
 blogs and, 141–143
 community spirit and, 147
 creating, 144
 defining, 16
 evolution of term, 142
 examples of, 16
 history of, 16
 of Japan, 143
 photo sharing services versus, 143
 popularity of, 16
 public versus private access to, 145–146
 self-run, hosting, 150–153
 self-run, promoting, 181
 self-run, publicizing, 153
 self-run, resources for setting up, 180–181
 self-run, setting up, 180–181
 service for, choosing, 147–150
 service providers, list of, 148–150
 sharing photos versus using, 133
 understanding, 141–143
Model releases
 photos and, 190–191
 resources for, 191
Monochrome
 colorizing images, 86–87
 converting images to, 86–87
Motion blur, cause of, 50
Motorola Web site, 37
Multimedia messaging, connectivity option for, 33
Multimedia Messaging Service (MMS)
 sending messages using, 190
 using, 119–120

N

Native file formats, using, 70
NEC Web site, 37
News photos, camera phones and, 18
Nextel Web site, 44
Night mode
 feature, 39, 51

understanding, 30
No coverage, 40–41
Nokia
 bar code scanning by, 84
 megapixel phone by, 26
 Web site, 37
Number portability, understanding, 34–35

O

Ofoto print service, using, 112–113
Optical zoom
 digital zoom versus, 29
 understanding, 29
Out of Network coverage, 40–41

P

Paint Shop Pro
 automatic image adjustment commands in, using, 85
 Center on Page feature of, 108
 Circle Brightness parameter, 94
 copying images in, 78
 cropping images in, 79–80
 Custom Offset feature of, 108
 downloading, 68
 Fit to Page feature of, 108
 images in, framing, 88–90
 Light Spot Brightness parameter, 94
 Light Spot Horizontal parameter, 94
 Light Spot Vertical parameter, 94
 manipulating photos with, 66
 native format of, 70
 online albums with, creating, 128–130
 panorama photos in, adjusting, 208–210
 panorama photos in, assembling, 211–213
 panorama photos in, cropping, 213
 panoramas in, creating, 208–213
 Photo Album program, using, 128–130
 printing images in, 107–108
 product information, 67
 Rays Density and Brightness parameter, 94
 Redo command, using, 76
 resampling photos in, 75
 rotating images in, 87–89
 special effects in, using, 91–95
 Undo command in, using, 75–76
 Upper Left of Page feature of, 108
 viewing size in, changing, 74
 viewing size of panoramas in, changing, 210
Paint Shop Pro Image, using, 70
PalmOne Web site, 37
Pan shots, defining, 53
Panasonic Web site, 37
PanoGuide.com, creating panorama photos with, 95
Panorama Factory software
 panorama options in, 207
 panorama shots and, 205

panoramas in, creating, 206–208
Panorama photos
 specialized graphics programs, creating with, 95–96, 205
 taking, 203–204
Pantech & Curitel
 megapixel phones by, 26
 Web site, 37
Paper
 brand made by printer manufacturer, selecting, 106
 fine art, selecting, 105
 ink jet printers and, relationship between, 103–106
 off-brand, selecting, 106
 online resources for researching, 105
 orientation of, selecting, 108
 photo, selecting, 103–106
 specialty, selecting, 105
 surface of, selecting, 105
 weight of, selecting, 105
 whiteness of, selecting, 105
PDAs
 Bluetooth and, 31–32
PDAs (Personal Digital Assistants), transferring photos to, 31–32
Pearl surface paper, 104
People
 identifiable in photos, 189
 photographing, 187–188
 photographing on private property, 186–187
 privacy and, 19–20
 privacy concerns for, 194–196
Personal journalism, understanding, 13–14
Photo albums, creating online personal, 126–132
Photo diary, creating, 217–218
Photo paper, selecting, 103–106
Photo printers, using, 98
Photo sharing services
 fees for, 133
 list of, 134
 locating online, 134
 moblogs versus, 143
 online, using, 133–140
Photo Swap software, sharing photos on, 140
Photographers, defining, 7
Photographing
 people, 187–188
 on planes, 187
 privacy concerns for people, 194–196
 on private property, 186–187
 while driving, 189
Photography
 acceptance of, 5–6
 "anything goes" philosophy of, 186–189
 art and, relationship between, 9–11
 dos and don'ts of, 54–63
 legal concerns of, 183–192

resources for, 62
visual communication and, 8
Photokyo moblog service provider, 149
Photos, 184–185.
See also Images
 Adobe Photoshop, manipulating with, 65–66
 blurry, cause of, 50
 brightness of, adjusting, 83–84
 CDs, distributing on, 132
 close-ups, photographing, 55–56
 color balance of, adjusting, 80–82
 connectivity options for transferring and sending, 32–33
 contrast of, adjusting, 83–84
 Corel Painter, manipulating with, 66
 cropping, 78–80
 defining, 9
 displaying, 20–21, 71
 documents and publications, including in, 6
 fees for online sharing of, 133
 first, photographing, 20–22
 First Amendment use of, 190
 framing, 88–90
 free, advantages of, 5–6
 freeware, manipulating with, 66
 galleries and, 11
 identifiable persons in, 189
 image size of, changing, 73–74
 manipulating, ease of, 5–6
 measurements of, list of related, 73
 Microsoft Photo Editor, manipulating with, 66
 model releases and, 190–191
 naming file names for, 122
 Paint Shop Pro, manipulating with, 66
 panorama, taking, 204–205
 panorama photos, overlapping, 205–206
 PCs, moving to, 121–122
 PCs, sharing from, 123–133
 PDAs, transferring to, 31–32
 Photo Swap software, sharing on, 140
 Photoshop Elements, manipulating with, 66
 physical size of, 71
 pixel size of, 71
 on planes, 187
 printing, 103–106
 private use of, 189–190
 programs for, list of manipulation, 67
 ReplayTV to view, using, 133
 resizing when printing, 74
 sending multiple, approaches to, 118
 sharing from phone, 117–120
 sizes of, changing, 74
 sneaking, 56, 185–186
 T-shirts with, personalizing, 201–204
 TiVo to view, using, 133
 transfer paper, transferring using, 202–203
 transferring and viewing electronically, 6
 use of, immediate, 6
 using moblogs versus sharing, 133
 viewing size of, changing, 74
 words and, relationship between, 14
Photoshop software. *See* Adobe Photoshop
PhotoSite photo sharing service, 134
PhotoWorks print service, using, 115
Physical size, 71–72
Picture capacity
 limitations of, resolving, 31
 understanding, 31
Picture quality, technical specifications and, 39–40
Pigment inks, dye inks versus, 100–101
Pixel resolution
 defining, 24
 feature, 38
 understanding, 24–27
Pixel size
 changing, 74
 understanding, 71
Pixels
 color definition of, 80
 defining, 24
 digital photographs and, relationship between, 24
PiXPO software, sharing photos on, 140
Ploggle moblog service provider, 149
pMoblog, 180
PMP. *See* Power Media Processor (PMP) service
PNG (Portable Network Graphics), understanding, 71
Portrait orientation, selecting, 108
Postcards
 digital, understanding, 16–17
 sending, 120
Posterize effect, using, 91–92
Power Media Processor (PMP) service, understanding, 77–78
Preview screen, using, 101
Primary colors
 additive, 80
 subtractive, 80
Print services
 limitations of online, 115
 local, using, 112
 online, using, 111–116
Printers
 buyers checklist for, 102–103
 installing, 103
 Preview screens for, 101
 selecting, 97–102
 settings for, understanding, 109–111
 types of, 98
Printing
 ink jet printers, tips for using, 111
 money saving tips for, 111
 program settings for, 107–111
 resampling for, 107

resizing photos, 74
settings for, 106–111
size, changing, 109
Prints. *See also* Photos
print services for, using, 111–116
Privacy, camera phones and, 19–20
Private places
photographing people in, 186–188
privacy and, 19–20
privacy concerns for photographing in, 194–196
public places versus, 184–185
Program settings, for printing, 107–111
Programs, list of photo manipulation, 67
Public place, private place versus, 184–185
Public places
photographing people in, 186–188
privacy and, 19–20
privacy concerns for photographing in, 194–196
private places versus, 184–185

Q

QR codes, 84
Quality settings, understanding, 61

R

Radio Userland, 180
Rare Window moblog service provider, 149
Redo command, using, 76
Refrigerator magnets
creating, 213–216
supplies, online sources for, 214
Reiter's Camera Phone Report, 5
Removable memory. *See also* Memory
connectivity option, 33
Resampling
defining, 74
printing and, 107
resizing by, 74–76
resizing without, 76–77
when to use or not use, 77–78
Resolution
camera phones and, relationship between, 24–27
high, using, 61
low, using, 61
understanding, 61, 71–73
RGB values (Red, Green, and Blue)
changing, 82
examples of, 80–81
Roaming coverage, 40–41
Roxio Photosuite, product information for, 67
Rumsfeld, Donald, 43

S

Sacko photo sharing service, 134
creating albums with, 134–136

identifying people in photos with, 137–139
print ordering with, using online, 139
sharing albums on, 136–137
sharing individual photos with, 139
uploading photos to, 134–136
using search tool, 139
Samsung
industrial espionage concerns, 197
megapixel phone by, 26
Web site, 37
Scavenger hunts, 199–201
camera phones and, 19
examples of, 19
resource for public, 201
Verizon sponsored, 200
Screen size, quality versus, 27–28
Semi-gloss paper, 104
Sendo Web site, 37
SendPhotos program, using, 125
Sensors, importance of, 39
Service plans
charges for incoming and outgoing calls/data, 44
duration of, 43
prepaid, advantages and disadvantages of, 35
selecting, 33–46
special rates, 44
trial periods for, 44
Service providers
camera phones and, relationship between, 24
selecting, 33–46
Shutterfly print service, using, 113–114
Siemens
megapixel phone by, 26
Web site, 37
Signal strength, 41
Silhouetting effect, using, 92–93
20six moblog service provider, 148
SixSpace Gallery, 11
Slide layout, defining, 32
Slideshows
creating, 133
distributing on CDs, 133
SmugMug photo sharing service, 134
Snap-n-Print print service, using, 17, 115–116
SnapFish print service, using, 115
Sony Ericsson Web site, 37
Special effects, using, 90–95
Sprint Web site, 44
Spying, 120, 197
Standalone cameras, camera phones versus, 7
Standby time, understanding, 30
Storytelling approach, understanding, 13–14
Strand, Paul, 185
Subjects
centering, avoiding, 58, 60–61

filling frame with, importance of, 55–56
motion of, understanding, 53, 57
Subtractive primary colors, understanding, 80
Sunburst
dialog box, list of parameters in, 94
effect of, using, 93–95

T

T-Mobile Web site, 44
T-shirts
online printing companies, list of, 202
personalizing with photos, 201–204
Talk time, understanding, 30
Technical specifications, picture quality and, 39–40
TextAmerica moblog service provider, 149
account passwords, changing, 159
community moblogs on, 161–162
Control Panel moblog links on, 163–164
experience on, 155–156
favorites on, working with, 165–167
features on, 156–157
free moblogs on, drawbacks to, 161
Instant Messaging help on, getting, 164
logging in to accounts on, 158
Moblog Admin screen on, 159–160
moblog with control panel on, customizing, 162–164
moblogs on, browsing, 164–165
moblogs on, creating, 159
moblogs on, creating and managing, 159
moblogs on, types of, 160
moblogs using templates on, customizing, 167–169
posting notifications on, 160
registering accounts on, 157–158
registering type of service on, 160–161
setting up accounts on, 158–162
using, 155–169
The Agatha Experience blog, 142
The Blogs of War blog, 142
"The Zippo Moment," evolution of, 17
TIFF (Tagged image file format), understanding, 71
TiVo, viewing photos with, 133
Transfer paper
online sources for, 202
using, 202–204
Tremblay, Mark, 180
Tu-Ka Group Web site, 37
TypePad moblog service provider, 150

U

Ulead Photo Explorer program, 133
Undo command, using, 75–76
USB (Universal Serial Bus) ports, acquiring additional, 121

V

Variable compression, using, 69
Vendors
camera phone, list of, 37
of megapixel phones, 27
Verizon
EvDO (Evolution Data Optimized) product, 27
sponsored scavenger hunts, 200
Web site, 44
VGA Resolution Label, understanding, 25
Video clips
capturing, 28–29
feature, 38
sending, 29
Web site collections of, 29
Viewing size, changing photo, 74
Voice recording feature, 38

W

Wal-Mart print service, using, 115
Web sites, creating personal, 126–132
Webcam pictures, receiving, 169
Wireless cell phone networks, data transmission speeds of, 27
Wireless photography, availability of prepaid service plans for, 35
Words, relationship between photographs and, 14

Y

Yafro moblog service provider, 150
friend relationships on, 172
photos on, working with, 171
picture size limit on, 170
profile on, 173
registering for, 170–171
using, 169–173
Yahoo! photo sharing services, 131

Z

Zipping photos, 118
ZoneZero Magazine, 8
Zoom feature, 55, 57
Zooming, 29